The
Morgan & Morgan
DARKROOM
BOOK

The Morgan & Morgan DARKROOM BOOK

Edited By

Algis Balsys

&

Liliane DeCock-Morgan

MORGAN & MORGAN
Dobbs Ferry, New York

For advice, suggestion, and assistance we thank:

Elizabeth Burpee
William Broecker
Grant Haist
Leonidas Hernandez
Linda Hongach
Barbara Morgan
Douglas Morgan
Janet Morgan
Ernest Pittaro
Hollis Todd
Richard Zakia
Harvey Zucker
John Whiting
Cecilia Younce

Amy Stromsten for her chapter on
Special Techniques.

©Copyright 1980 by Morgan & Morgan, Inc.

All rights reserved in all countries. No part of this book may
be reproduced or translated in any form, including microfiling
without permission from the publisher.

Published by Morgan & Morgan, Inc.
145 Palisade Street
Dobbs Ferry, New York 10522

International Standard Book Number 87100-120-9 Softcover
International Standard Book Number 87100-170-5 Hardcover

Library of Congress Catalog Card Number 79-88816

Cover design: John Alcorn
Drawings: John Sagan

Printed in U.S.A.

Table of Contents

The Photographic Process

Few pursuits in life are both immensely satisfying and easy to do. The making of a black-and-white photograph is one of them. It takes no deeper understanding of photographic chemistry and physics to make a good negative or print than it does of internal combustion engines to drive a car well.

The only things needed besides some equipment and photographic materials are the ability to follow instructions and a fair amount of common sense.

Almost every package of photographic film, printing paper, or chemical comes with instructions telling you how to use the contents properly. These instructions are accurate. They have to be, because the various manufacturers want to continue selling their products. You wouldn't buy them if the instruction didn't work or were untrue.

If you follow the manufacturers' recommendations and if you are familiar with the sequence of events that must take place in order to turn exposed film into a print — a photograph, you should have no difficulty at all in producing good prints.

This series of events, from exposure of the film to the making of a print, is called *the photographic process.* Here is a basic outline of the steps, the materials involved, and the changes that occur at each stage:

Photographic film is a piece of transparent plastic covered on one side by an extremely thin layer of gelatin that has millions of crystals of silver salt (silver halide crystals) suspended in it. This gelatin layer is called the *emulsion.*

For some as-yet-unexplained reason, silver halide crystals are chemically sensitive to light. While your camera shutter is open, light passes through the lens and reaches the film. The quantity of the light is in direct proportion to the amount of light given off (reflected) by your subject. This light causes the silver halide crystals in the emulsion to decompose, leaving behind traces of metallic silver. These traces form an invisible portrayal of your subject, called the *latent image.* The latent image is invisible and must be developed, in some way to produce a visible image on the film emulsion.

The chemical used to develop the latent image does to the emulsion what light does, only in a much more powerful way. It makes the silver halides closest to the latent image undergo a similar chemical change, thereby greatly amplifying the image and making it visible.

When the right developer has worked long enough to make the latent image fully visible, a mild acetic acid solution, *stop bath*, is used to neutralize the developer and stop its action. Rinsing the film in water does the same thing, though not as quickly.

After development and "stopping" the emulsion will still contain many silver halide crystals in those places where little or no light reached it. These crystals will decompose if light reaches them, eventually obliterating the image of your subject, unless they are removed. The chemical used for this removal is called the *fixer.*

After fixing, all the remaining residual chemicals on the film must be washed away to prevent eventual destruction of the image. This is done by rinsing the film in water for a few minutes, treating it with a washing aid, then washing it in running water for a longer period. When the film has been fully washed it is hung up to dry, after which a *photographic print* can be made from it.

You will notice that the light and dark tones in the image on the film are reversed from the way they appeared in the camera's viewfinder, giving a *negative* image. Remember that the film's emulsion, when struck by light and subsequently developed, was most affected where the light reaching it was most intense. For this reason, the lighter a part of your subject was, the darker that corresponding portion of the negative will have become. An accurate tonal rendition of your subject is possible only when the tones are put back to their original condition. This is done by printing the negative on photographic paper—a *positive* image will result.

Photographic paper, like photographic film, has a coating of light-sensitive emulsion with silver halide crystals suspended in it. The sensitivity of photographic paper is lower than that of film. This allows the use of dim lights—*safelights,* to be used in the darkroom while paper is being processed. The chemicals used for the process work in the same way as do those for film and are used in the same order: developer, stop, fixer.

The negative is either placed in contact with or projected by way of an *enlarger* onto the photographic paper. Light is made to pass through the negative onto the paper for the appropriate number of seconds. The paper is then developed, stopped, fixed, and washed in much the same way as was the film. In effect, the print is a "negative of the negative"—where the *negative* was dark the *print* is light, and vice versa, and so you get an accurate photographic image of your subject.

The process is now complete. After a thorough wash, the print is dried and put to the use for which it was intended.

The following chapter describes the photographic materials available and a guide to help you use them productively.

The Materials

PHOTOGRAPHIC FILM

Most films used in conventional black-and-white photography are *panchromatic:* They are sensitive to about the same range of colors as is the human eye. Panchromatic films record this range in various tones of gray.

In addition to panchromatic films, some manufacturers produce films that are sensitive to only part of the visible spectrum. *Orthochromatic* film, for example, is "blind" to the color red, and will record it as though it were black. *Blue-sensitive* film is "blind" to both red and green.

These films, along with *infrared, ultraviolet,* and *x-ray* films, all have their special uses. Some of them are good raw material for the experimental darkroom worker.

One of the most important properties of film, from a practical point of view, is its relative sensitivity to light—its *speed.* The American National Standards Institute (A.N.S.I.), formerly known as the American Standards Association (A.S.A.), established a formal testing procedure to determine the level of sensitivity of each film. All film manufacturers use this test (or its German equivalent, the Deutsches Industrie Norm, or D.I.N., test).

The manufacturer assigns an *ASA* or *DIN* number to each kind of film. Films sold in the United States are marked with both numbers. The higher the ASA or DIN number of a film is, the more quickly it reacts to light.

While reading a photographic magazine or talking with other photographers, you may hear of another film-speed designation: the Exposure Index, or E.I. This is a speed rating which, in most cases, differs from that indicated by the manufacturer. It is arrived at by the photographer, whose experience says that the film works better for him at a different rating. Changing the rating of a film arbitrarily will give you nothing but badly exposed negatives unless you know how to modify the recommended development time to compensate for the change. We will deal with this subject in more detail later on.

Each film also has a specific inherent *contrast.* As a rule, slower films (lower ASA rating) by nature tend to be more contrasty than faster ones.

ISO. As this volume went to press, a new film speed rating system was announced by Kodak and other manufacturers; to be known as ISO, it represents test results obtained from the International Standards Organization. The number will be appearing on every box of film. They are expressed in exactly the same way as the familiar ASA number (ISO 400 film is the same as ASA 400 film). For some time, ISO numbers will be listed along with the ASA designation. Eventually the ASA will be dropped completely.

Another characteristic of film is its *granularity.* The more light-sensitive (or faster) a film is, the larger its silver halide grains are. Most films are classified by their manufacturers to indicate their relative granularity. Kodak divides its films into six categories: Coarse, Moderately Coarse, Medium, Fine, Very Fine, and Extremely Fine. The grain

classification of a film is printed either on its box or on the data sheet packed with it.

Graininess is different from granularity. It is a mealy appearance that results from a tendency of light-sensitive silver particles in the emulsion to "clump" together. As a negative is enlarged the graininess becomes more and more apparent. This clumping of the grains is further increased by over-development and by overexposure.

Every film has a specific *resolving power*. This term refers to an emulsion's ability to record minute detail sharply. Films are tested for this ability by being exposed to a special fine-lines test chart. Fine-grained films of inherently high contrast do best in these tests; but all the standard emulsions produced by major manufacturers these days are of such high quality that resolving power should not be the most important thing the beginning photographer thinks of when choosing a film for general use.

Acutance refers to the physical measurement of image sharpness; the word *sharpness* is a subjective judgement about how much detail the viewer can make out in the image.

All the characteristics touched on above are shown in every different sort of film, to greater or lesser degrees and in various combinations. All can be affected by the way the film is exposed and processed and each will in turn affect the photographic print in some way.

PHOTOGRAPHIC PAPER

The characteristics of papers used in the darkroom fall into two main categories: photographic and physical. The photographic characteristic that will be most important to the printer is a paper's *contrast*. Negatives may vary in their respective density range, and so a knowledge of relative paper contrasts allows the darkroom worker to choose one that will give him the best possible tonal reproduction of his negative.

Most photographic papers are *graded*; that is, they are of a specific contrast predetermined by the manufacturer. Each package of graded paper is marked with a number indicating its inherent contrast. Graded papers range from *very low contrast*, or *"soft"* (Grades 0,1), to *very contrasty*, or *"hard"* (Grades 5,6).

A useful and popular type of paper is *variable contrast* paper. By the use of specially colored filters between the light source and this paper, several grades of contrast can be obtained from the same package—or even the same sheet. Marketed under such brand names as *Kodak* Polycontrast and Ilford Multigrade, variable-contrast paper is invaluable to commercial photofinishers and custom printers because they can use the same batch of paper to print negatives of a wide range of contrasts.

Many photographic artists and makers of exhibition prints forgo the convenience of variable contrast papers, believing that graded ones have a higher silver content and therefore will produce richer-looking prints. This may or may not be true; but enough exquisite prints have been made on variable-contrast paper to show that highly skilled printers can produce work of equal quality on both types.

Photographic papers, like films, vary widely in their sensitivity to light. The American National Standards Institute has created a set of paper-speed ratings. Each paper is assigned one of these ANSI numbers to indicate its relative "speed". This information can be found on the package or on the data sheet inside it. The first indicators of a paper's speed, though, are the words *Contact Printing Paper* or *Enlarging Paper* printed on the package. *Contact* papers are designed for use with large-format negatives, are relatively slow, and cannot be conveniently used for enlarging. *Enlarging* papers differ in speed from one brand to the next, but all are suitable for both projection printing and contact printing.

Papers are available in a staggering array of surface textures, base colors, finishes, image tones, and weights. All these physical characteristics have a definite effect on the final appearance of a photographic print.

The *weight* of a paper is determined by the thickness of its base. Most brands are available in *single*, *medium*, and *double* base weights, the emulsion thickness of each being about the same.

Base tone or *tint* refers to the color of the paper stock. This tint is usually expressed by the terms *cold* or *warm*. The basic color is white, but it can vary from "cold" fluorescent white to "warm" rich cream.

Image tone refers to the color of the silver image. This can be anything from reddish brown through warm black and neutral black to blue-black. The tone of the image is also affected by the type of developer, development time, developer temperature, fixing time, and drying temperature. It can be altered considerably by using certain chemical toners, as will be discussed later on.

The most immediately obvious characteristics of printing paper are *surface texture* and *sheen*. Each manufacturer indicates both on the package. These range from *smooth* and *glossy* to *textured* and *matte*. Deciding which texture and which surface to use depends on what you want a particular photograph to look like. Generally speaking, dull-surfaced (matte) papers do not reproduce prints with the same clarity, brilliance, and detail as seen on glossy or lustrous surfaces, but they are often used by portrait photographers and those who like prints to have a "salon" quality.

Most paper bases are of high-quality wood pulp. Some have an added layer of resin to make them more resistant to water. This layer keeps the base of these *resin-coated* papers from becoming saturated with chemicals, making the time required to wash out the chemicals that much shorter.

Resin-coated paper was introduced less than ten years ago and its tonal quality is still not quite equal to that of conventional fiber papers; there is also some question about image permanence. Yet the speed with which a resin-coated print can be made, washed, and dried makes this paper valuable to commercial photographers, newspaper people, and anyone who needs prints quickly for short-term use.

CHEMICALS

The most frustrating decisions a beginning darkroom worker faces when buying supplies are in selecting developers for his film and his paper. There are literally hundreds of formulas available. In view of this, it is useful to know that almost all contain the same four basic ingredients. The ingredients are

the *developing agent,* usually a combination of metol and hydroquinone;

an *accelerator* to make the developer solution alkaline, thereby allowing the developing agent to do its job properly;

a *preservative* to lessen the adverse effect of oxygen

on the developing agent;

a *restrainer,* which keeps the developing agent from attacking unexposed silver halides in the emulsion.

Competing manufacturers often sell the same developer formula under different trade names. For example, here are the formulas for *Eastman Kodak* D-76 and Ilford ID-11 film developers:

generally used with them.

At the other end of the graininess scale one finds *solvent* developers, which reduce apparent grain size by dissolving away part of the exposed silver halide during development. This causes the grain size in the developed image to be smaller than normal. Solvent developers usually require that more

D-76		ID-11
Water (52°C) 125°F.....................	750 ml Water (52°C) 125°F
Elon*....................................	2 grams Metol*
Sodium sulfite (dessicated)...................	100 grams Sodium sulfite (dessicated)
Hydroquinone...........................	5 grams Hydroquinone
Borax (dehydrated)......................	2 grams Borax (dehydrated)
Add cold water to make...................	1 liter Add cold water to make
*Elon and Metol are both trade names for the same chemical compound.		

As you can see, the chemicals and their proportions are exactly the same in both cases. All other things being equal, these two developers would respond to the same film in identical fashion.

Film Developers. The formula found in D-76 and ID-11 works so well it has become the standard by which the performance of other developers is measured. When used properly it will produce negatives with extremely fine grain, full shadow detail, and almost no chemical fog. It is probably the best general-purpose fine-grain film developer available. Correct use of this solution with a film such as *Kodak* Plus-X or Ilford FP4 will give the photographer negatives capable of producing brilliant, fine-detailed prints.

Other types of film developer are available, most of them intended for special purposes. Some are extremely powerful; they were designed to be used with high-speed films that have been exposed under low levels of light. These *high-speed* developers are not suitable for general use because they usually produce negatives of poor sharpness and coarse grain. This characteristic graininess is caused by the tendency these developers have to clump silver grains together in the emulsion, and by the inherently coarse grain structure (granularity) of the films

than normal exposure be given to the film, and their use can easily produce "fogging" of modern emulsions. Film manufacturers warn against the use of this developer type with some of their emulsions — look for such a warning on the data sheet included with every package of *Kodak* Plus-X film.

Some developers promise their potential user extremely sharp negatives. Packaged under such brand names as Tetenal Doku and H & W control 4.5, they are generally referred to as *high-definition* developers. The developing agents in these solutions act mostly on the surface of the film, giving extremely good separation between the different densities on the exposed negative and a high degree of clearly defined detail in the image. High-definition developers work best with extremely-thin-emulsion films, such as *Kodak's* High-Contrast Copy Film 5069 and H & W's VTE Pan. (These are essentially microfilm emulsions that have been modified and packaged for use with 35mm cameras. They are very contrasty and quite slow, which makes them unsuitable for general use. If you are interested in their capabilities and have the high-quality lenses needed for proper use of this film type, however, you can find out more about them on pages 209-218 of the latest *Leica Manual*

[15th Edition], published by Morgan & Morgan.)

The last type of film developer we will touch upon here is a rather unlikely sounding combination of developer, fixer, and various other chemicals called a *monobath*. Impossible as it may seem, developing agents and fixers can, under certain conditions, be put into the same solution, allowing film to be processed in one step. The most important condition to be met when making a monobath is to make sure that the fixer acts slowly enough not to affect the emulsion noticeably until full development has taken place.

Photographic researchers tried since 1889 to come up with a workable single-step chemical for the processing and fixing of film. Patents for workable monobath solutions were finally granted to various researchers in Great Britain and the United States during the 1950s and 1960s. Many different one-bath formulas are now published. The chemicals needed to make monobaths are available in most chemical supply houses and there are also one or two prepackaged solutions being sold.

So far, none of these monobaths gives results quite as good as those achieved with more conventional processing methods. The negatives obtained are usually grainier than those developed and fixed normally, the chemicals are complicated and expensive, and there is a high risk of film fog when using most of them; so they are not very popular. If you already have good experience in the darkroom and are interested in experimenting with one-step solutions, you can refer to Grant Haist's *Monobath Manual* (Morgan & Morgan). This well-written and entertaining book is full of information about the subject.

Paper Developers. The basic composition of general-purpose developers is the same for paper as for film. Paper developer formulas are somewhat modified to compensate for differences in sensitivity between film and paper; yet many paper developers are also used, usually in more dilute form, to process sheet film. Some, such as *Kodak* Ektaflo Type 2 and Selectol, are especially designed to

give best results with warm-tone papers; others, like Ilford Bromophen, are meant to be used on neutral and cold-tone papers. Warm-tone papers can be processed in cold-tone developers and vice versa, often with quite beautiful results. More about this can be found in Chapter 6.

Stop Baths. Some stop baths contain a chemical that changes color when enough developer has been carried into the solution to neutralize the acid in them. They are also available without this indicator. In either case, stop baths are necessary, especially when printing, to stop the action of the developer once it has done its job. *Kodak* Indicator Stop Bath (which contains the "indicating" chemical mentioned), *Kodak* Universal Stop Bath, and *Kodak* 28% Acetic Acid can be bought in any well-stocked camera store. Edwal, Ilford, and many other companies make stop baths, too. All these solutions must be highly diluted before use. All give off unpleasant and hazardous fumes in their concentrated state and *care must be taken not to breathe the fumes when mixing them.* So be sure preparation of these chemicals is done only in a well-ventilated area.

Fixers. Ordinary fixer contains an active ingredient named *sodium thiosulfate.* Another type of fixer, containing *ammonium thiosulfate*, is sold as "rapid" fixer. The latter's effect on film and papers is the same as that of regular fixer, but it takes less time to perform its task. Kodak's version of this kind of fixer is called, logically enough, Rapid Fix. A hardening solution to protect the emulsion from damage is included in certain fixers of both types. Films and papers processed in rapid fixers must be monitored carefully because this type of fixer will attack the developed image if left in too long.

Hypo Clearing Agents and Eliminators. The terms *hypo-clearing agent* and *hypo eliminator* are often used interchangeably. Actually, they are two different chemicals that perform different tasks: A hypo-clearing agent is used to conserve water and time when removing fixer from films and

papers, but it does not do a complete job in removing residual chemicals left in the emulsion after processing. For this, a hypo-eliminator must be used whether the emulsion has been treated in clearing agent or not. Hypo-clearing agents can be bought either as a powder or as a liquid concentrate. Hypo-eliminators also come in both forms and are made by Kodak, Edwal, Hyco, and other manufacturers.

Wetting Agents. Wetting agents are used with film after it has been completely washed. Properly used, they keep water from leaving spots on the film as it dries. The most widely used washing aid is *Kodak* Photo-Flo 200, which is supplied in highly concentrated liquid form. A small bottle lasts for a remarkably long time. No darkroom should be without a good wetting agent.

EQUIPMENT FOR THE BASIC DARKROOM

Photographic darkrooms vary in size and sophistication from fully equipped laboratories more than 1,000 square feet (90 square meters) in size to tiny spaces in the corner of an apartment closet into which the bare essentials needed for film processing and printing have been compressed. Excellent photographs can be produced in a darkened room of any size, provided the equipment has been chosen with common sense and care. The rest of this chapter suggests some things to keep in mind when deciding on the equipment you need.

Enlargers. The biggest single monetary investment you will make when equipping a darkroom will be the enlarger. This can also be the most costly mistake if it is not chosen to suit both the worker and the work to be done.

Condenser Enlargers. Almost all the enlargers sold today for black-and-white printing are of the *condenser* type; that is, they use glass condensers to concentrate the light from an incandescent bulb evenly and precisely through the negative and the enlarging lens, projecting the focused image onto the photographic paper. The best—though possibly most expensive—have *variable condensers.* Variable condensers are interchangeable, allowing you to use lenses of different focal lengths on the enlarger.

Make sure the enlarger is stable. Any vibration while making a print will destroy sharpness; so look for a machine that is solidly enough constructed to stay steady even when treated less than gently. Test the enlarger by tapping the projection head firmly with your hand. If it jiggles for more than a second or two, look for another brand.

The heavier and bigger the enlarger is, the more stable it will be. Even if you use a 35mm camera, it would be best to avoid buying an enlarger that takes negatives only of that size—consider the various 6 × 6cm (2¼ × 2¼ in.) models that accept 35mm negative carriers, as well. Very few enlargers designed for 35mm or smaller negatives are well-made and stable enough to merit serious consideration. A notable exception is the Leitz Focomat 1C, made by the same people who produce the legendary Leica cameras. The Focomat is made in the Leica tradition—superbly crafted, rugged, and very expensive. If money is no object and making negatives larger than 35mm is definitely not contemplated, then this is an ideal enlarger.

The Focomat even focuses itself—almost! It is one of several enlargers that have a special cantilevered mechanism designed to keep the negative in focus while the enlarger head is raised or lowered to change the size of the projected image. It is only necessary to put the negative in, then focus once: The image projected on the baseboard will stay sharp no matter how many times the enlarger head is moved up or down the column.

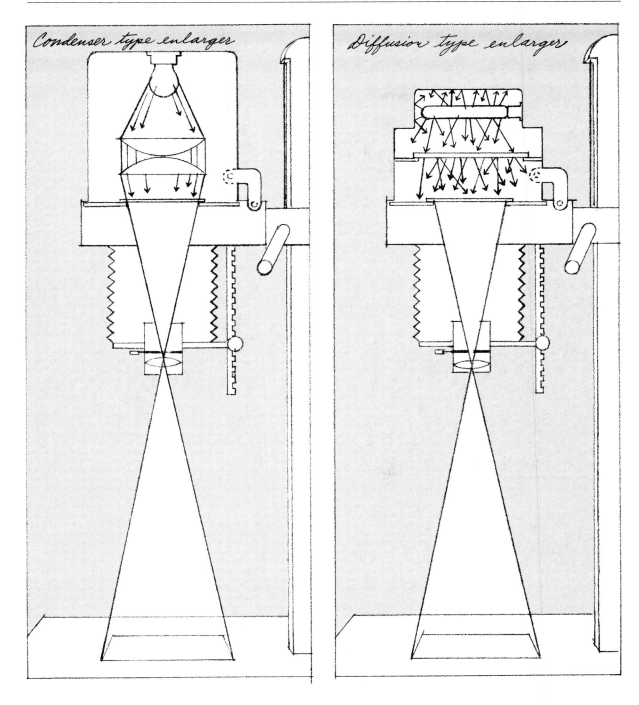

Condenser type enlarger

Diffusion type enlarger

Many professional photographers and printers use large-format enlargers, such as the Omega D2V, to print from smaller negatives. The Omega D2V is *the* classic enlarger: It can accommodate negatives ranging in size from 8×11mm to 10×12cm (4×5 in.); it has variable, movable condensers; it focuses easily and quickly, and it is extremely well built. It is also large and heavy, making it unsuitable for those with little space set aside for the darkroom area.

Many large photographic equipment suppliers carry the updated version, the D5. Other enlargers worth investigating are the various 6×6cm and 6×7cm models made by Durst, Omega, and Beseler.

As you examine the various models, check to see whether their controls fit easily to your hands. The best way to ruin the darkroom experience is to spend time making prints on a machine that is uncomfortable to use. This "human engineering," or ergonomic, consideration is a lot more important than it may seem at first. A machine that "feels wrong" can cause an erosion of morale that may be unconscious but after a while will become noticeable, both in prints and in an ever-increasing reluctance to set foot in the darkroom. So take a lot of time to look — to fiddle with the controls of many enlargers while they are still in the store, to shop around for your price bracket — and a wrong choice will be less likely.

Make sure the enlarger is equipped with the right condensers and carriers for your negative size(s). Most enlarger manufacturers offer a variety of carriers and condensers to fit their machine. Check for filter holders, too, if you plan to use variable-contrast paper.

Diffusion Enlargers. There are enlargers that do not use condensers to direct light through the negative. Instead, they employ frosted bulbs in a reflected housing or a grid of cathode tubes with a diffuser underneath them. Both of these systems give a soft, even light. The majority of these diffusion enlargers are also equipped with a color printing filter system. If you plan to make color prints in the future, you might want to investigate this type of enlarger. If you don't see yourself doing any color work but still want the kind of effect produced by the diffusion system, you should investigate the *cold-light head* made by such companies as Aristo. This head is comprised of the cathode tubes and diffuser mentioned earlier. Models are made to fit various condenser enlargers. The cold light head costs about $100.00 — much less than a diffusion head with color filters. Enlargers equipped with diffusion or cold-light sources produce slightly less contrasty prints than condenser enlargers do, but tones on the print — especially in the highlights and in the middle range — can be manipulated more easily. Dust spots and scratches are not as noticeable on prints made with a diffusion enlarger.

ENLARGER CHART

The following is by no means a complete list of all the enlargers available for black-and-white photography (nor do we list all the features and accessories) —there are far too many and new models are being introduced to the marketplace all the time. The list is a cross-section of different types, models, and price ranges. All of the machines will serve you well, provided you select one suited to your needs.

BESELER

67C, 67C XL. Condenser types with three piece interchangeable condenser. Accepts negative sizes from 8×11mm to 6×7cm; filter drawer above the lens stage and swinging filter holder for use underneath the lens; glassless negative carriers. Negative carriers are hinged allowing movement of the negative without having to remove it from the enlarger. Focusing can be done from either side of the machine making focusing easier for left-handed workers. Head can be turned 180° for wall projection; the XL model has an extra long girder so that prints up to 41×51cm (16×20 in.) can be made directly on the baseboard. Takes a PHIIIA enlarger bulb. Easily assembled and sturdily constructed machines which retail for about $250.00 depending on accessories.

23C, 23C XL. Similar in details to the 67C and 67C XL models but has a double girder, triangular truss construction, and accepts negatives up to 6×7 cm ($2\text{-}1/4 \times 3\text{-}1/4$ in.). Lens stage tilts, allowing some correction of linear distortion, a helpful feature especially for architectural photography. Well constructed, retails for about $300.00, the XL version is slightly more.

45MCR X. Condenser type with interchangeable heads. Accepts negatives up to 10×12cm (4×5 in.); the negative stage can be raised or lowered depending on negative size, allowing optimum illumination of the image; lens stage tilts allowing for correction linear distortion; triangular truss, double

girder construction. Head can be tilted vertically for wall projection. This is a professional machine and extremely well built. Sells for about $700.00 with condenser head but without lens and accessories.

BOGEN

Bogen manufactures a number of small, lightweight enlargers for amateur use. The most notable among them is the 22A Special, which will accept negatives up to 6 cm sq ($2\text{-}1/2$ in.); takes a #211 enlarging lamp; has a non-interchangeable condenser system; above-the-lens filter stage; heat absorbing glass is offered as an accessory; head tilts for wall projection; takes Leica thread enlarging lenses; and will make up to 20×25 cm (8×10 in.) prints on the baseboard. This is a good enlarger for occasional use. Sells for about $125.00 with lens.

DURST

A300. Designed for autofocus use with 35mm or smaller negatives; condenser type; takes a PH 211 or 212 bulb (212 gives brighter illumination); is equipped with a matched 50mm El-Nikkor lens which provides a maximum baseboard image just under 36×44 cm (14×17 in.); glass negative carrier; filters can be placed above the lens stage. Very sturdy and compact it sells for about $400.00 complete. A good machine if you do not plan on printing negatives larger than 35mm.

M601. Not as sturdy as the A300, but more versatile. Condenser type; takes negatives from 8mm to 6 cm sq ($2\text{-}1/4$ in.); head can be adjusted laterally for distortion correction; glass negative carrier has provision for masking; focusing is geared; the enlarger can easily be converted into a copy camera; filter stage is above the lens. Price with 2 condensers is a little over $250.00 without lens.

Laborador 900. A sturdy machine, designed for extensive use. Condenser type; for negatives from 8mm to 6×7 cm ($2\text{-}1/4 \times 3\text{-}1/4$ in.); interchangeable condensers; takes Leica thread lenses, allow-

ing up to 31×38 cm (12×15 in.) prints on the easel; girder can be turned around for projection onto the floor, for larger prints; glassless and glass type carriers available; hinged carriers permit negative movement without removal; built in negative masking device; cold light head available. About $1,000.00 with condenser head, without lens.

PRO 4×5. Condenser type, accepts negatives up to 10×12 cm (4×5 in.); fan cooled; takes Leica thread lenses; interchangeable condensers; filter drawer above lens stage; glass and glassless carriers available; can be converted into a copy camera; built in heat absorbing system. Sells for about $500.00 less lens. Built for hard, professional use.

LEITZ

Focomat 1C. Described in text. Discontinued as of 1979, and replaced with a more, streamlined version, the V35 autofocus. Both models are fabulously designed and very expensive, though a number of Focomat 1C's are appearing as used items in camera stores. These are a bargain, even at their rather steep "used" prices (about $600-750, depending on condition). See text for details.

V35 Autofocus. Autofocusing, diffusion/light source enlarger; operates by using a rather formidable sounding "Ulbricht sphere type mixing chamber" for its light output; accepts negatives to 35mm; extremely rigid construction; equipped with a specially designed 40mm Wide Angle Focotar enlarging lens, which permits up to 41×51 cm (16×20 in.) enlargements on the baseboard; negative carrier is glassless, but with anti Newton-Ring glass plate on one side; carrier has a cutout permitting you to see the frame number of the negative you are printing; has a patented and extremely efficient cooling system; many accessories available, including electronic times, automatic exposure devices, film trip carriers, and so on. An exquisite machine, selling for well over $1,000.00.

OMEGA

Omega manufactures more models than anyone. Many of their latest models are loaded down with built-in items such as light reading probes, automatic exposure devices, and borderless easels on the baseboards. However, generally speaking, Omega's less exotic models seem to be better constructed and stronger. Omega's professional equipment is very fine indeed and they make some of the best large-negative size enlargers around. These and a few of their basic smaller models are outlined below.

B66XL. Condenser type; accepts negatives up to 6 cm sq ($2\text{-}1/2$ in.): Two condensers; very sturdy construction; allows 41×51 cm (16×20 in.) prints on the baseboard (with 50mm lens); can be wall mounted. Girder can be turned around for projection onto the floor for larger prints; built-in heat control unit; glassless carrier; lamphouse lifts and lowers easily. Sells for about $250.00 without lens.

C67 XL. Condenser type; accepts negatives up to 6×7 cm. Condenser is adjustable, two element design, with a third element added for 35mm work; filters fit in housing above lens stage; supplied with heat absorbing glass; both types of negative carrier are available; lens board is standard equipment. Sells for under $300.00 without lens.

Pro Lab D5, D5XL. The updated versions of the classic D2-V described in the text. Condenser type, accepts negatives up to 10×12 cm (4×5 in.). Extremely rigid, massive construction. Uses PH 211, 212 (standard) or 213 bulbs. Filters and/or absorbing glass can be placed between condensers, above lens stage. Accepts numerous accessories, among them glass and glassless carriers; cold light head; fan cooling system; three lens turret, etc. This enlarger, in its many incarnations, is the standard workhouse of the photo industry. You will find them in most schools, commercial labs, military installations, and in many a private darkroom as well. Sells for about $650.00 without lens.

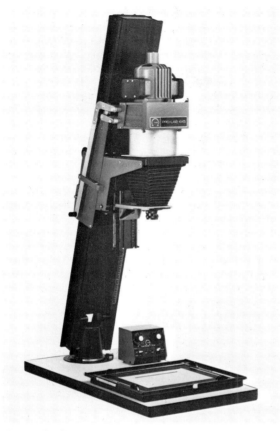

Omega Pro Lab

VIVITAR

Vivitar has only recently entered into the enlarger market, they have come up with a beautiful, well designed and constructed modular enlarger capable of truly fine results.

The Vivitar VI. Condenser type, with optional "Light Pipe" light source; very fast exposure times; when used with "Light Pipe", very little heat is generated; accepts negatives up to 6 cm sq (2-1/4 in.); three piece condenser, changeable by focusing; head can be tilted for wall projection; 35mm and 6 × 6 glassless carriers are supplied with enlarger, can be interchanged with optional glass type carriers; rack and pinion focusing; strongly made. Priced at about $300.00 with condenser head. Lens extra.

PATERSON

Although primarily known for its fine line of photo accessories, this British firm also makes an inexpensive, compact enlarger that will serve the occasional printer on a budget quite well. The Paterson 35 is a condenser enlarger for use with 35mm or small negatives. Takes a 211 bulb; will give a slightly larger than 28 × 36 cm (11 × 14 in.) enlargement on the baseboard; head pivots for floor projection; above the lens filter stage; lens supplied with enlarger will give adequate results if stopped down; machine accepts Leica thread lenses. This enlarger can be had for under $100.00 with Paterson lens.

Paterson 35

The Enlarging Lens. Most high-quality enlargers are sold without the lens. This must be bought separately. Enlarger makers produce adapters to fit the various lenses onto their machines.

Under normal circumstances, using your camera lens to make enlargements is not recommended. The two types of lenses are designed for different purposes. True, certain lenses made for the old screw-mount Leicas can be adapted for use with an enlarger, and will give fair results; but really good sharpness in the print can only be obtained with a lens specifically formulated for enlarging.

Buying a good enlarging lens is quite simple. Generally speaking, the more you pay, the better the lens will be. Excellent enlarging lenses are made by Nikon (the El-Nikkors), Leitz (the Focotar line), Schneider (Componons and Componars), and Rodenstock (Rodagon lenses).

Make sure the lens is appropriate to the size of negatives from which you plan to print. The enlarging lens should be of roughly the same focal length as the "normal" lens of the camera—about 50mm for 35mm film users, 80mm for those using 6×6cm (2¼×2¼ in.) film, and so on. If two cameras of different film formats are used but only one enlarging lens is planned for at the start, choose the one appropriate to the bigger negative. It will be capable of making prints from the smaller negative even though the maximum possible degree of enlargement will have to be sacrificed. *For example:* If the enlarger gives you a 41×51cm (16×20 in.) print at its fullest extension while using a 50mm enlarging lens with a 35mm negative, then the same extension will produce about a 28×36cm (11×14 in.) print using an 80mm lens with the same negative. With a 6×6cm (2¼-in. format) negative, the 80mm lens at the extension will give a 41×41 cm print. It is not possible to enlarge a negative properly with a lens too small for the format—using a 6×6cm negative with a 50mm lens will usually produce a roundish looking print with all four corners missing. This happens

because the focal length of the lens is too short to "cover" the whole negative.

Good enlarging lenses are expensive, but they are a must for the production of quality prints. A mediocre enlarger with an excellent lens will give you far better prints than an excellent enlarger with a mediocre lens. If the budget is tight, it is better to buy a less elaborate enlarger and invest in the best lens possible. Remember: In printing, as in making the negative, the image is only as sharp as the lens that produces it.

Fall-off caused by insufficient lens coverage.

OTHER DARKROOM EQUIPMENT

Timers. The most efficient timer is an electric one that has cross-coupled outlets for the enlarger and the safelight, so that the safelight turns off while the enlarger is on, and vice versa. An arrangement of this sort helps to keep the photographic paper from fogging during exposure.

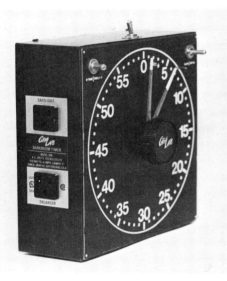

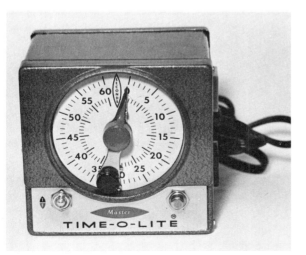

Buy an enlarging timer that is calibrated in seconds and that will reset itself after running down. GraLab and Time-O-Lite both make excellent models. These two companies also make timers that are calibrated in minutes and have sweep second hands. These are useful for timing the development of film and paper and are highly recommended. Some timers have loud ticks, which help with accurate timing of both film-developer agitation and printing manipulation.

Safelights. Safelights are only safe when they are the right size for the room they are in; when they are equipped with the correct filter for the paper you use; and when they are hung far enough away from the paper so as not to fog it.

Choose a safelight with changeable filters. Make sure that it can be hung easily from a wall or ceiling and that no white light leaks out around the filter when the light is turned on. If you are going to work in a very small space, then the *Kodak* Darkroom Safelight is probably suitable. This strongly made model is acorn-shaped and uses a 15-watt bulb. The front of it unscrews to accept circular safelight filters.

Since most general-purpose enlarging papers require the use of a light amber (OC) safelight filter, get one of these, too, to fit the safelight you select.

Stay away from "fireball" safelights. These look like large red or amber-colored globe lights: They are usually too bright for home darkroom use, their coatings have a tendency to chip off, and they have been known to shatter.

Large safelights and those using sodium-vapor bulbs are meant for full-time darkroom use and are discussed in Chapter 11.

Thermometers. An accurate, consistent thermometer is an absolute necessity in the properly equipped darkroom. The two types best suited for darkroom use are *indicator thermometers*, which have a dial, and *process thermometers*, which are the steel-sheathed-rod type designed for monitoring of various chemical processes.

Kodak makes one of the latter for darkroom use.

It is expensive, but a worthwhile investment. If you prefer the easier-to-read dial type, look for one made by a well-known photographic manufacturer such as Beseler, Weston, Ciba, Brooks, etc. Find one that can be recalibrated if it becomes inaccurate.

Even the best thermometers can be inaccurate, but there is a much better chance of getting *consistent* readings from one made by a leading manufacturer. Consistency is the most important attribute a thermometer can possess: Even if it is off by a degree or so, it is possible to determine the correct temperature of solutions if the thermometer readings are predictable and consistent.

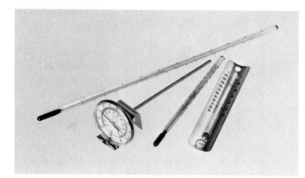

Film Tanks and Reels. Tanks and reels for film processing are discussed at length in Chapter 2. Common sense should be used when shopping for these, and for all other items. The lids should fit snugly and the reels should not be bent or warped. If you want stainless-steel tanks, get seamless ones: Seams in tanks will collect various chemical particles, which are almost impossible to remove completely. This chemical residue could eventually build up and have a bad effect on your film.

Trays. Photographic trays are made of stainless steel or plastic. The steel ones are beautiful, easily cleaned, heavy—and expensive. Plastic trays are light, reasonably priced, and the best choice for the beginning darkroom worker.

At least four trays are needed: Three should be large enough for the paper size you will be using and the fourth should be one size larger. Proper marking and use of photographic trays is discussed at length in the chapter on basic printing.

Print Washers. Print washers are available in various styles, sizes and price ranges. More on washers can be found in Chapter 7. For the time being, however, a large tray can serve to wash your prints, in the way described in Chapter 3.

Contact Printing Frames. These consist of a piece of glass held securely by a plastic, wooden, or metal frame with some kind of removable back—often either hinged or split in the middle. These frames are used to hold negatives in close contact with photographic paper when same-size prints of the negatives are to be made. Large-format photographers can use them for final prints. Roll-film and 35mm-film users make "proof prints" or their strips of negatives in contact-print frames. These proof prints, when properly made, help tell the photographer whether his exposures were accurate and help him decide which frame to enlarge.

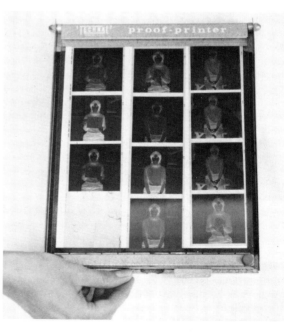

Some of the metal contact-printing frames come equipped with clips or slots to hold the negative strips neatly in place. Many models, from various manufacturers, are advertised in magazines, and can be seen at any well-stocked camera store. While proof or contact-print frames are convenient, they are not essential. You can make contact prints and proof sheets easily with a piece of plate glass, as you will see.

Easels. There are four basic types of enlarging easels: Two blade, four blade, multiple and single size. Two blade easels come in various sizes; their blades allow adjustment for different paper sizes. Their disadvantage lies in the fact that major adjustments can only be done on two sides, where the movable blades are. This means that if you want to place a 10×12cm (4×5 in.) image on a 20×25cm (8×10 in.) piece of paper, you will not be able to center the image: It cannot be done without the addition of a homemade, L-shaped mask for the other sides.

Four blade easels, on the other hand, are designed to allow centering of the image, no matter its dimensions, on any size of photographic paper, the only limit being the largest paper size the easel will hold. If you like large white borders around your photographs, this is the kind of easel you will find most useful. They are more expensive than the two-blade variety, but on the whole are better made.

Multiple easels are trapdoor-like affairs with various sized openings which enable the user to make a number of small prints on one larger sheet of paper. After each exposure, the paper is moved under the easel so that an unexposed piece of the paper is brought under the size opening desired.

Single size easels are simple "paper carriers" that are not adjustable. They are available in all common paper sizes, and produce prints with a 6mm (1/4 in.) border. They are by nature sturdy —no moving parts—and are used extensively in commercial photofinishing houses.

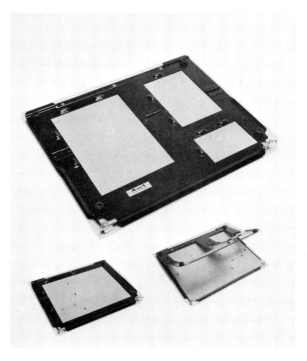

One more easel type exists—the borderless easel. This type consists of a board with either a vacuum base or a tacky surface on which the paper is held flat by suction or adhesive. Since the edges of the paper don't have to be held down, the image can be made to "bleed" to the edge of the paper.

Just about all of these easel types can be obtained with thin 12mm (1/2 in.) or thicker 25mm (1 in.) base. The 25mm base easel is necessary for autofocus enlargers, since a 25mm standoff is required for the autofocus mechanism to work. If your enlarger is not the autofocus type, you'll save some money by buying the shorter model.

Whichever type of easel you decide upon, avoid models made from thin, pressed metal parts. On adjustable easels, examine the blade for smooth movement and precise alignment. Check all hinges and closure for sturdiness and reject anything that wobbles.

Miscellaneous Items. A vast array of photographic accessories is available to the darkroom worker. Some items are quite useful, while others are a waste of time and money. Some of the more useful items are discussed in the chapters to which they apply. The basic list would include

- graduates in assorted sizes from 30ml (1 oz) to quart or even gallon sizes, depending on your needs
- fine-textured sponges (photographic, *not* supermarket type)
- stirring rods
- print tongs (a pair for *each* tray of different chemicals)

- funnels
- electrostatic brush, or cloth, to clean film before printing
- grain-focusing device
- print trimmer (paper cutter)
- blotter roll or book, heat dryer, or screens for air-drying of prints

and of course such things as

- a waterproof apron or smock, and possibly rubber gloves
- old or paper towels to wipe up spills

Such fundamentals as ventilation, power, and running water are discussed in Chapter 11.

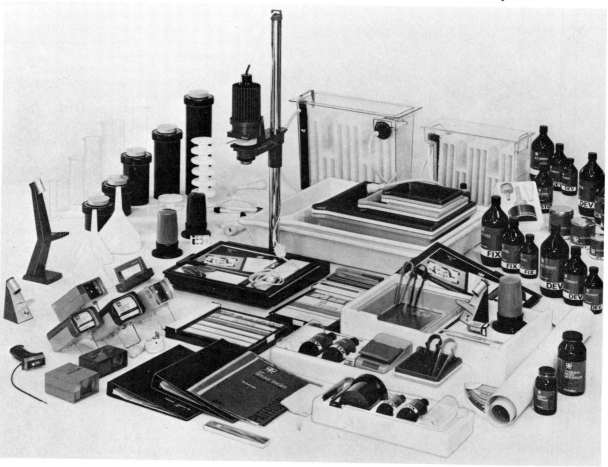

Basic Film Processing

The processing of film is easy to do, requires few pieces of equipment, and can be guaranteed—when done right—to give negatives from which good prints can be made. Before actually doing any processing, though, you will find a basic exposure test useful.

No two camera shutters are alike. Your camera might have "1/500" engraved on the dial but may actually be going off at either 1/350 or 1/750 of a second. This does not necessarily mean that your camera is defective. Manufacturers allow for a certain margin of error in the performance of their shutters, since absolute accuracy is hard to come by. Then, too, the light meter you are using, whether it is built into the camera or hand-held, may be slightly inaccurate.

Either or both of these possible variances can cause you to give your film improper exposure even though you follow the instructions of the camera and film manufacturers. If you do the test that follows, however, you will be able to make any slight adjustments necessary to get consistently more accurate exposures. This is also a useful test for any new camera or light meter you acquire.

BASIC EXPOSURE TEST

1. Buy 2 rolls of a medium-speed film (ASA 125), such as *Kodak* Plus-X or Ilford FP4, in 35mm 36-exposure cassettes or 120-format rolls. (Note: 120 size Plus-X is called Plus-X Pan Professional.) If you plan to use 20-exposure cassettes of 35mm film, make a separate test for this; the final results will vary a fraction because there will be proportionately more developer working on each square inch of exposed film.

2. While you are in the store for the film, buy a Neutral Test Card (18% gray card), as well.

3. Load the camera with the first roll of film. *Save the data sheet* packed with the film. Take the loaded camera, a tripod, and the gray card with you to an evenly lit outdoor location.

4. Find a patient, willing helper to take along, too.

5. Set your meter to ASA 125.

6. Have your helper hold the gray card. Move close enough to take a meter reading *of the gray card only.* If you are using an in-camera meter, don't be worried if your lens won't focus close enough—the meter will make a reading anyway. *Make sure no shadows are cast on the card.*

7. Set the camera's aperture at f/8 and adjust the shutter speed until you get the "correct" exposure indication on your meter for the gray card.

8. Mount the camera on the tripod and compose your picture.

9. Put your lens cap on the lens and press the shutter to get a blank exposure on the first frame. This blank frame will be used later on, when you learn to make a contact sheet. Make a note on your piece of paper, saying "Exposure Test, Plus-X, Frame #1—no exposure."

10. Take the lens cap off and attach your lens hood, instead. Wind the film on to Frame #2, focus on your assistant holding the gray card, and make an exposure at the shutter speed you set in Step 7. Make a note of this exposure, marking it "Frame #2, __sec, f/8."

11. Change the lens stop to f/11. *Do not change the shutter speed.* Expose. Make a note saying, "Frame #3, __sec, f/11."

12. Change the aperture to f/5.6, leaving the shutter spead alone. Expose and make a note of #4, __sec, f/5.6."

13. Now repeat Steps 10 through 12, but this time have your assistant put down the gray card. Keep noting the frame numbers, shutter speeds, and f-stops, as before.

14. With the rest of the first roll of film make exposures of anything that interests you. Take meter readings the way you usually do.

When all the frames have been exposed, wind the 120 roll film onward or rewind the 35mm film back into its cassette, remove the film from your camera, mark it *Exposure Test,* and put it aside. You will develop this roll of film later.

Now load your camera with the second roll of film and shoot the roll as you would normally. Remove this roll from your camera and mark it *Film Processing Test.* You will process this roll first.

PREPARATION FOR PROCESSING

Successful film processing calls for three things besides well-exposed film and the right chemicals: Good working habits, especially in using clean equipment; proper mixing of chemicals; and a consistent work routine, so that mistakes can be traced, identified, and corrected.

Let us outline the production of a black-and-white negative and later fill in the detailed steps. You can turn to the step-by-step guide and begin processing your exposed film right away, but we

suggest you read this chapter all the way through before you do so.

Finding True Darkness. Your first darkroom job is to make sure the room you are using is actually *dark.* Light-sensitive film has to be taken from its protective covering in order to be loaded onto reels and processed, so *make absolutely certain that no light will reach it* from that time until the major processing steps (development, stop-development, fix) have been completed.

To test for light leaks in your processing area, close the door, block off the window (if there is one), turn out the light, sit down, and wait for a *full ten minutes.* That is roughly how long it will take for your eyes to become adjusted enough to notice very small light leaks. Ten minutes can seem like a very long time when there is no light. Just be patient and bear in mind that the health of your film is at stake. Do not smoke to pass the time: The glow of the cigarette or pipe will make your eyes less sensitive. If at the end of ten minutes everything still seems to be pitch black, your film-loading area is light-tight enough. If you do notice light coming in around the door or windows, you must plug the leaks to keep your film from being light-struck. If this is not possible, find another place to load your reels.

A changing bag.

If all the areas available to you are riddled with light leaks, buy a changing bag. A film-changing bag is double-jacketed to make it light-tight and is designed for the handling of films outside the darkroom. You can use this bag to remove film from its protective cassette or its paper backing, load it onto developing reels, and place them in a tank for processing—all in broad daylight, if necessary. There are drawbacks, however: Changing bags are made of a rubberized cloth and so can make your hands perspire a lot; they usually are too small for comfortable and efficient manipulation of the film; and retrieving a loading mistake is much harder in a changing bag than in a proper darkroom. Besides, a bag needs vacuum cleaning from time to time or it will turn into a dust trap and cause white flecks on the developed negatives. A bag should be only a last resort for loading developing reels.

Once you have found your light-tight area you can process your film. The lists that follow sketch out the equipment and chemicals you will need to do so efficiently. The step-by-step description of darkroom procedures refer to many products by brand name. This is done simply because the authors have used them and are familiar with them —there are many other good, standard brands the darkroom worker will want to explore once the basics are familiar.

EQUIPMENT

- One 473ml (16-oz) film developing tank and one 120-size or two 35mm size reels (this is not the only size tank there is, but it is a practical one)
- A hook-type bottle opener, if you use factory-packaged 35mm film.
- Timer, or a clock with a sweep second hand
- Scissors
- Thermometer
- One-liter (34-oz) measuring/mixing beaker or graduate (quart size will do)
- One-liter (34-oz) opaque storage bottles (two-

quart size will do)
- Funnel
- Stirring rod for mixing chemicals
- Film clips or spring-type clothespins
- Film sponge or squeegee

CHEMICALS

- Package of standard film developer such as D-76 (powder to make 946ml or 1 quart of liquid stock solution)
- Quart (or liter) of *Kodak* Rapid Fixer, with hardener (liquid), or other hardening fixer
- Small bottle of hypo-eliminator such as Perma Wash
- Small bottle of a wetting agent such as Photo-Flo 200
- Quart or liter of distilled water (recommended, and essential in hard-water regions)

The Film Tank. Almost all of the many film tanks available for "daylight" processing work on the same general principle: They are cylinders into which spiral reels wound with exposed film are placed for processing, and they have lids equipped with a baffled entry port through which chemical solutions can be poured but which will not allow light to enter.

The first step in processing negatives is to load the exposed film onto the spiral reels, place them inside the developing tank, and close the tank with its special lid. This is the only step in this developing method that must be done in *total* darkness.

Tanks and reels are made of stainless steel or of plastic. Each type has its advantages and its faults. *Plastic reels* are highly resistant to warping, easy but slow to load, and very difficult to clean. *Stainless steel reels* can be loaded faster once you have gotten used to them, clean readily, dry very fast, but—bend easily, especially if dropped.

Plastic tanks have the same advantages and disadvantages as plastic reels. Some are equipped with screw-on lids that stay secure until you want

them to come off. They are harder to keep clean than stainless steel tanks, though, and they do not permit easy adjustment of solution temperatures because plastic is a poor conductor of heat; yet some accept thermometers through the lid, and that can be a help. *Stainless steel tanks,* on the other hand, are easy to clean, virtually indestructible, and fast-drying, and they allow precise control of solution temperatures. They also have the exasperating habit of sometimes not letting go of their pouring-spout caps when the time has come for you to pour out the developer.

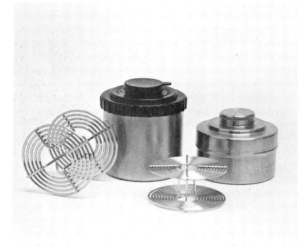

Most experienced darkroom workers use stainless steel tanks and reels, adding a screwdriver to their darkroom hardware list for use if the stainless steel caps turn stubborn.

A German company, Kindermann, has designed what many consider to be the ideal tank-and-reel combination: The tanks and reels are of high-quality stainless steel, but the cores of the reels contain a plastic collar that takes hold of the film and keeps it firmly in place, making loading easy and fast; the tank lids and caps are made of a snug-fitting flexible plastic that will hang on securely until there is a need to remove them, when they come off easily. These tanks and reels have now been imitated by various manufacturers, and steel-and-plastic com-

binations are readily available at major photographic-supply houses.

Whether you already own reels and tanks of another type or are about to buy a set for the first time, you will have to practice loading them until the procedure becomes second nature to you. The best way to do this is to use a dummy roll of film, first in room light, then in the dark. The dummy roll can be an outdated roll of film or an uncut roll of old, unwanted negatives—in either case, it should be film that you don't care about ruining.

FILM PROCESSING

Step 1—Loading the Reels. Your first step in learning how to load a reel should be to *read the manufacturer's instructions,* making sure you understand them. The illustrated guide in this chapter shows proper loading of both stainless and plastic reels; so study the illustrations carefully. When you have gone through the procedure a number of times with the lights on and think you can do it without crimping, bending, folding, or mutilating the film, close your eyes and try it again. Doing this will give you some idea of how it feels to work in the dark, yet if you get stuck you will be able to open your eyes and see immediately what is wrong.

Once you feel confident about your ability with eyes closed, turn out the light and go through the entire proceeding a few more times. Try to *see* with your fingertips. *Listen* for the sounds the film makes against the reel, keep a very light *touch,* and have patience with yourself. It takes some practice to develop the technique perfectly; but once you have it you will have mastered the most difficult part of the film processing procedure—and you will never forget it. Also practice cutting the narrow leader off the film and the film off the spool (see illustrations).

When you can reel up your dummy film several times without a mistake you should be ready to load the *Film Processing Test* roll you exposed earlier. Remember that the *loading of this film*

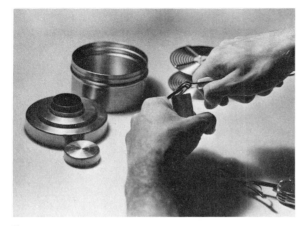

Open cassette

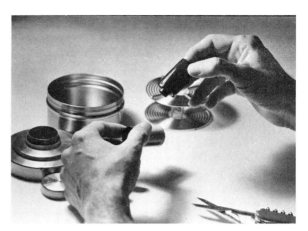

Remove film

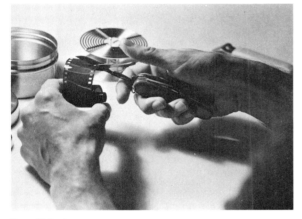

Cut off leader

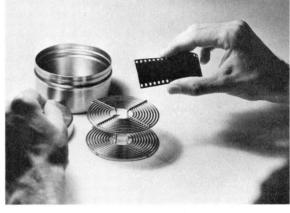

Extend about 2" of film and bow gently

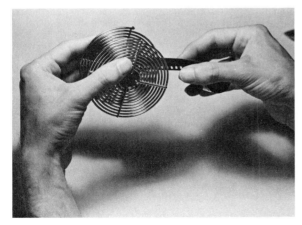

Place film into reel's core

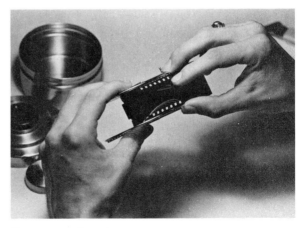

Start turning the reel

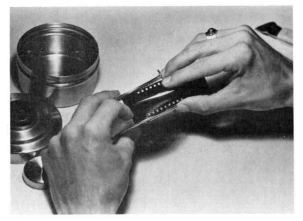

Makes sure film is properly engaged

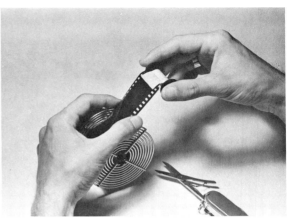

Wind until you reach the film spool

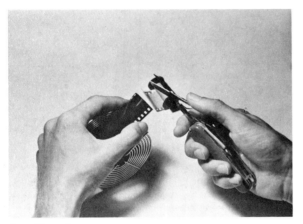

Cut off spool

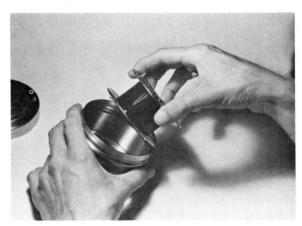

Place film in tank

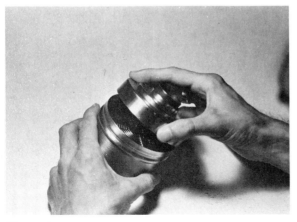

Close tank

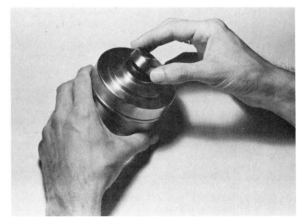

Put safety cap on lid

must take place in TOTAL darkness — no safelight. If you make a mistake while loading and are not aware of it until the film has been developed and fixed, you will be able to trace the fault with the help of Chapter 4, *Common Problems.* Practice will eventually correct any loading mistakes you might make.

Place the loaded reel in the tank. When processing 35mm film be sure to put an empty reel in the tank, too, to keep the loaded reel from sliding up and down. Put some masking tape over the edge of the lid to remind yourself the tank is loaded.

Step 2—Preparing the Chemicals. Before the film can be developed, the developer solution must be prepared. *Kodak* D-76 is recommended for your first tries because it is one of the best general-purpose film developers and readily available. D-76 is sold as a powder and comes in various quantities. A package to make 946ml (a quart) of stock solution will be enough to start with. Usually you can dissolve the powder in ordinary tap water, but if your local water is hard and has an especially high mineral or chemical content, you will get better results using distilled water.

Follow the mixing directions on the package faithfully. It is a good idea to do the mixing away from the processing area, so that airborne particles will not settle in darkroom areas. Measure the water accurately, using clean measuring and mixing vessels. Read your thermometer with care and make certain the temperature is within the limits printed on the package. Trickle the powder in; stir gently, but without stopping; avoid splashing. Once the powder is dissolved according to the package instructions, you will have one quart of D-76 stock solution. Pour it into one of your bottles and label it "Film Developer". Allow this solution to cool. You can speed up the cooling process by putting the bottle in the refrigerator. Since this is stock solution, it will not have to cool all the way to 20°C (68°F).

While you wait, mix a working solution of fixer. Follow the directions on the package, being sure to use the *dilution for film.*

Just before you are ready to develop the film, dilute the D-76 stock solution with an equal quantity of water. This will give you what is known as a one-to-one (1:1) solution. If you did the exposure test, you are developing either one roll of 36-exposure 35mm ASA 125 film (Plus-X Pan) or one roll of 120 film (Plus-X Pan Professional). In either case, 473ml (16 oz) of solution are needed; so take 237ml (8 oz) of the stock solution and add 237ml (8 oz) of water. Try to adjust the temperature of the water you add to bring the final solution as near 20°C (68°F) as you can. (Note that a roll of 20-exposure 35mm film will need the same amount of developer, too, in order to fill the tank).

Remember that *all solutions should be used at the same temperature,* or as close as possible. Control of temperature is very important, because changes of more than two or three degrees Fahrenheit as the film goes from one solution to another will hurt the quality of the negative.

Kodak's recommended development time for Plus-X in D-76 1:1 solution at 20°C (68°F) is 7 minutes.

Have the right amount of fixer at the right temperature ready, and running water at the same temperature at hand, before you begin development.

Step 3—Developing the Film. When you have the developer at the correct temperature, pick up the film tank with your "loaded" reminder tape, tilt it slightly to allow a free flow of the solution into the tank and pour in the developer.

- Fill the tank until the developer is just about to overflow. This should take no longer than 15 seconds.

- Check your timer or clock and begin timing development.

- Put the cap on the opening in the tank, then tap the tank smartly against a countertop or the side of the sink. This tapping dislodges any air bubbles that might have formed on the film while

Proper agitation is very important *turn tank upside down* .

the developer was being poured into the tank.

- Agitate for 10 seconds.

- During each minute the film is developing, agitate the solution for another 10 seconds by turning the tank *slowly* upside down and back again twice (keep one finger on the cap as you do this) if it is a stainless steel one or by gently swirling the reel if you are using a plastic tank that has an agitation rod. You will find it easier to keep track of your agitation if you do it at the start of each minute.

- 10 seconds *before the end* of 7 minutes start pouring the developer out while slightly rotating the tank (an easy twist of the wrist)—*Do not open the tank.*

Step 4—Stopping Development. As soon as the developer has been poured out, fill the tank with running water at a temperature as close to the developer's as you can make it. When the tank is full of water, empty it and fill it again. Repeat this procedure for about 30 seconds. This will stop the action of the developer.

Step 5—Fixing the Image. After the exposed film has been developed and rinsed, the image must be fixed, or made permanent. To do this, pour the working solution of fixer that you prepared in Step 2 into the tank and agitate for 10 seconds, rest for 30 seconds, and repeat twice (total time: 2 minutes). *Note:* Do not use *Kodak* Rapid Fix straight from the bottle—read the mixing instructions on the package and use the right dilution.

After 2 minutes of fixing, empty the fixer into a storage bottle for future use (a funnel is a real help here) and label it "Fixer for Film". Rinse the fixed film in water. The lid may now be taken off the developing tank.

Step 6—First Wash. Place the tank, with the lid removed, under running water for about 5 minutes. The temperature of this water must be as close as possible to the temperature of all the previous solutions. In any case, do not let the water temperature get below 18.3°C (65°F) or proper washing will not take place—or above 26.7°C (80°F)—the emulsion will soften too much.

and back again .

Do this twice in 10 seconds

Step 7—Hypo-Eliminator and Final Wash. Many of the chemicals that have been acting on the film emulsion will have been removed by the first wash. Any residual chemicals will cause the negative to deteriorate in a few years if they are not removed. An additional 15 minutes of washing would probably eliminate most of them, but to ensure their removal—and to conserve water—you will need to put the film in a hypo-eliminating solution. This will shorten wash time considerably and will make it certain that the negative lasts. One of the best-known hypo-eliminators is Perma Wash. The film should be put into a correctly diluted solution of Perma Wash for 2 minutes, gently agitated, then washed again in water for a full 5 minutes.

Step 8—Wetting Agent. When the final wash is completed, place the film reel in a solution of wetting agent such as *Kodak* Photo-Flo 200. Two or three drops of Photo-Flo in a 473ml (16 oz.) developing tank full of water will give you the proper dilution. Leave the film reel containing the

washed negatives in the solution for about 30 seconds. The wetting agent will make the water still on the film surface "sheet" off and evaporate evenly without leaving water spots.

Step 9—Hanging the Film to Dry. Remove the film from its developing reel, hang it up with a film clip, and *gently* pass a film squeegee or sponge down its length. This will remove excess water from the film surface and let it dry more rapidly. Hang the film to dry in a clean, draft-free place. The film is extremely sensitive to dust at this stage, and particles can become imbedded in the emulsion if there is any air movement around it.

If you can't find a spot in the house away from daily traffic, use the shower stall. First attach a thin wire across the top of the stall, then run the water for a few seconds to clear the air. Hang your film on the wire with a film clip or a spring clothespin. Attach another clip to the bottom of the film. This will keep the film from curling while it dries.

Step 10—Handling the Dry Negatives. After the film is completely dry, it should be cut into

Prepare chemicals

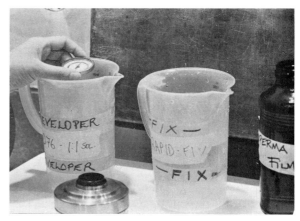

Bring all chemicals to the correct temperature

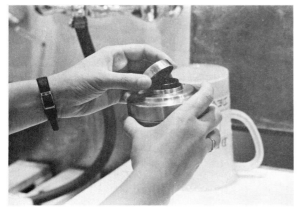

Remove safety cap

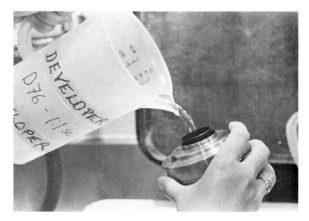

Pour in developer, replace cap and develop

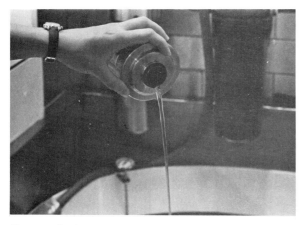

Pour out developer

Rinse for about 30 seconds

Pour in fixer and fix for recommended time

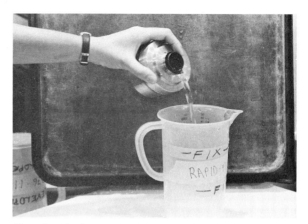

Pour fixer back in container

Tank can now be opened, rinse for a few minutes

Treat film with a washing aid

Wash film for recommended time

Treat with a wetting agent and hang to dry

strips and stored in glassine or plastic negative-storage envelopes. *Do not use ordinary paper envelopes* for negative storage. Most paper contains chemicals—sulfur, for instance—that are harmful to negatives. Polyethylene envelopes especially designed for negative storage are available at most well-stocked camera shops in sizes to fit the film you are using. If you use 35mm, cut your negatives into strips of five or six frames. 120 roll film can be cut into strips of three or four frames. Paterson and other manufacturers make negative storage envelopes in sheet form, punched with holes to fit into a loose-leaf ring binder. These are ideal for setting up a negative filing system.

When you have processed your first roll of film successfully, go out and expose two or three more rolls of film and process them, too. Then, when you are sure of yourself in the darkroom, process the *Exposure Test* roll you made earlier. The negatives from this roll will give you a lot of information about the way your camera and meter behave as will be explained in the next chapter.

In the next chapter you will learn how to make a good contact sheet and how to use it to discover important information, not only about what your pictures will look like, but also about how well you have exposed your film. You will also learn to make a basic photographic enlargement, then to make changes while printing to get the most out of your negatives. Most important, the prints you make from your *Exposure Test* will show you how to adjust your ways of exposing and processing the film to achieve more accurate exposure in the future.

Basic Printing

The printing of a photographic negative is no more difficult than the developing of the negative itself, even though a few more steps are involved. This chapter will describe the making of a photographic print and give you a step-by-step guide to the procedure.

Before a print can be made, a darkroom area must be set up. If you are lucky enough to have a spare room to set aside for this purpose, read the rest of this section, then turn to Chapter 11, where you will find information about installing a permanent darkroom. If you have neither space nor inclination for a permanent darkroom, you can still set up a perfectly efficient and workable printing area.

THE DARKROOM AREA

The bathroom, a large closet, or a basement storage area can all be temporarily converted into darkrooms without too much trouble, as long as they meet a few basic requirements. These needs are the same for all darkrooms, permanent or temporary, and are as follows:

1. they must be light-tight, or easily made so
2. they must have adequate ventilation
3. they must be large enough to hold an enlarger, trays, and the darkroom worker, with enough room to spare for comfortable movement between the trays and the enlarger (this sounds like a lot of room, but a workable darkroom can be installed in a 1.2×1.5 meter (4×5-foot) area

4. they must have access to electrical current
5. they must be easily cleaned and kept as dust-free as possible
6. they must be reasonably close to a supply of water.

Running water is a great convenience in the printing darkroom, but is not essential.

Darkness is. You must make certain your printing area is, or can be made, light-tight. Check this the same way you checked for light leaks in your film-loading area: Close the door, shutter the windows, and turn the lights out. Sit in darkness for a full ten minutes, then look for any stray chinks of light. Every one you find will have to be plugged.

If you are not able to black out your area completely in daylight you may find that it can be made dark enough after sundown. In this case, you will have to print in the evening or at night to avoid fogging your paper.

When your area has been made sufficiently light-tight, set up the equipment necessary for printing. The list below assumes you will be working with paper up to 20×25cm (8×10 in.); later you may want to get bigger trays for the larger standard paper sizes.

EQUIPMENT

- *Enlarger* with negative carrier and lens appropriate to your film size.
- *Contact print frame* or a sheet of clear, blemish-free quarter-inch (6mm) plate glass, 28×36cm (11×14 in.) in size.

- *Safelight* with correct filter for the paper you will be using.

- *Enlarging timer* within easy reach of the enlarger.

- *Darkroom clock or timer,* the same one you use to process film.

- *Easel,* preferably one that can take 28×36cm (11×14 in.) paper and has moveable blades.

- *Thermometer,* the same one you use for film is fine: Just remember not to use water that is hotter than the limits of the thermometer—and make sure to *wash it thoroughly* after every use.

- *Four plastic or stainless steel trays,* three of them 20×25cm (8×10 in.), the fourth, 28×36cm (11×14 in.). With a water-proof permanent marker write the word "Developer" on the outside of the first 20×25cm tray and "Stop" on the second; the third should be marked "Fix". *Never use these trays for any chemical other than the one marked.* The larger tray will be used to remove fixer from the prints, and to wash them. This will be the *only* tray to serve more than one purpose.

- *A tray siphon* to use for washing prints in the large tray.

- *Three print tongs,* preferably plastic ones in three different colors. Mark these as you did the trays, and never use them in any chemical other than the one designated.

- A 28×36cm (11×14 in.) piece of *sturdy, flexible cardboard.* A Projection Print Scale, the scale and its use are described later on.

- *Camel-hair or electrostatic negative cleaning brush*—not the same brush you probably already have for you camera lenses, but one made for keeping negatives free of dust. (Your enlarging lens should be cleaned with your camera lens brush and not with the one you buy for negatives.)

- *Compressed air,* such as Falcon's Dust-Off or any of several similar products; or a *large ear syringe* with a plastic nozzle, which can be bought at a pharmacy. Both items are used to blow dust away from the negative, the enlarger, and the enlarging lens. Many photographers prefer the ear syringe because it works as well as "canned air", is cheaper, and will never spray propellant onto your negatives or lenses.

- *A roll of black masking tape.*

- *A towel*—an old, clean towel will do; wash it at the end of each printing session and keep it with your darkroom supplies.

- *Storage bottle for developer,* of brown glass or opaque material, in half-gallon or 2-liter (68 oz) size.

- *Measuring/mixing beaker,* graduate, or measuring cup in quart or liter size—those made of Pyrex or some other strong glass are easier to clean than the plastic ones and will give years of service if a little care is taken with them.

- *Four or five large coins*—quarter or 50¢ pieces will do—for a safelight test, described later.

- *A print squeegee* or *large photographic sponge,* to remove excess water before drying.

- *A photo blotter book.*

PAPER

As noted in an earlier chapter there are many different papers available. For the purpose of the procedure described in this chapter, we recommend that you choose one of the following.

- One 25 sheet package each of Grades 2 and 3 20×25 (8×10 in.) *Kodak* Kodabromide, Double-Weight; OR *Kodak* Medalist; OR Agfa Brovira; OR Ilford Ilfobrom.

There are slight differences among the papers suggested, but all are of high quality and will produce excellent results if used properly.

CHEMICALS

- Package to make about 2 liters (half-gallon) stock solution of *Kodak* Dektol or Ilford Bromophen developer.
- Bottle of stop bath (Note: The dilution of stop-bath may be different for paper than it is for film, so check the instructions on the container.)
- Fixer (hypo)—you already have this chemical if you have processed film; but fixer has to be diluted twice as much for paper as it is for film, so read the package instructions. (Any fixer will do, but the times given here are for *Kodak* Rapid Fix.)
- Bottle of Perma Wash, or some other washing aid (or hypo-eliminator).

PRINTING PROCEDURES

Step 1—Setting Up. When you have the above supplies at hand, you can prepare your darkroom area.

First, make sure the enlarger and the trays are at a comfortable working height. If you are right-handed, arrange the darkroom so that you work from left to right (enlarge ▶ develop ▶ stop ▶ fix ▶ holding tray); if you are left-handed, arrange your room the other way, if possible. Mount your safelight at least 1.22 meters (4 feet) away from the trays and in a position that will illuminate the processing area evenly. Make sure the bulb in it is the right size (15 watts in most cases).

Plug your enlarger into the timer. If your timer is cross-coupled, plug the safelight into it, too. You will probably need extension cords to do all this: Get industrial weight ones because regular "household" extension cords are a bit flimsy and can be dangerous to use. (See Chapter 11 for additional information.)

Place the enlarger timer within easy reach of your enlarger and the darkroom clock or development timer in clear sight of your processing trays.

Step 2—Mixing the Chemicals. You are now ready to prepare your chemistry. Do this away from the enlarger: The powder and fumes of some chemicals can be damaging to your equipment.

Mix the developer carefully, at the temperature recommended by the manufacturer. Pour it into a storage bottle. Label the bottle "Print Developer—Stock Solution" and put it aside to cool.

Now mix the stop bath and fixer solution and label them, too. Make sure you *wash and rinse* your thermometer after mixing *each* chemical.

Note: The developer, in this case Dektol or Bromophen, must be mixed at a high temperature—51.7°C (125°F). Even though the working solution is made by mixing one part of the stock solution with two parts of water and can therefore be brought down to 20°C (68°F) easily by using very cold water, wait for the stock solution to cool somewhat before diluting it further for use.

When the chemicals are properly mixed and cool enough, make a working solution of Dektol or Bromophen in the tray you labeled "Developer" by mixing one part of it *into* two parts of water. (**Note:** *Always add a chemical* to *water, never the reverse.* Some chemicals react violently to disobedience of this rule; so it is a good habit to get into right at the very start.) Make enough developer working solution to fill the tray about a third full. If you hold the bottle close to the tray and pour gently, you will prevent contaminating one tray by splashes from another.

Now, prepare a working solution of stop bath, following the manufacturer's recommendation (usually, stop bath for paper is about 50% more concentrated than it is for film).

The fixer is next. Dilute it by the package instructions for print processing.

Fill the fourth (larger) tray about half full of water. This will be your holding bath.

Hang the three pairs of tongs on the edges of the trays for which they are labeled.

Step 3—Safelight Test. Now test the "safeness" of your safelight. Close the darkroom

door, turn on the safelight, and *turn off the white light.* Take out a piece of photographic paper, put it on the easel shiny (emulsion) side up, and put the four or five coins on the paper. (If you have trouble deciding which is the emulsion side, here are a couple of tips: Paper—and film, too—usually curls in toward the emulsion; so look for the concave side. Some papers—RC papers, especially—have very light printing on the back, or nonemulsion side. On matte papers it is far harder to tell, which is another reason for the beginner to start with glossy papers.) Leave the paper on the easel about 3 minutes. *Do not turn on the enlarger.* After 3 minutes remove the coins, take the paper out of the easel, and gently slide the paper into the developer, emulsion side up.

Step 4—Developing and Fixing the Print. The developing, stopping, and fixing of this safelight test are exactly the same as the development, stopping, and fixing of contact proof prints and photographic enlargements you will do next; so follow the steps carefully.

1. Set the developing timer (or note the sweep second hand of your darkroom clock) for 2 minutes.

2. Agitate the print by sliding it gently through the developer, then lifting it out and putting it back in again or by *gently* rocking the tray by lifting one corner. This will allow fresh developer to reach the print constantly. Do not rock the tray roughly from side to side or up and down—this could change the tones of your print and, worse, splash some developer in the stop bath.

3. When the 2 minutes are up, lift the paper out of the developing tray grasping it by one corner with the tongs marked "developer". Let the print drain for about five seconds over the developer tray, then gently let it slide into the stop bath. Do not let the developer tongs touch the stop bath, but put them back in the developer tray.

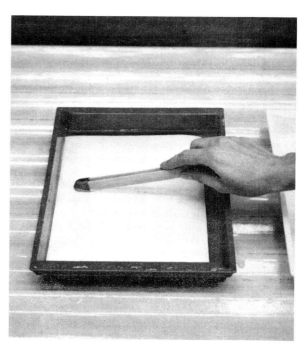

4. Agitate the print, as before, for about 30 seconds. Use the stop bath tongs to lift the paper from the tray by one corner and drain it. Hold it close to the tray to prevent any splash back into the developer.

5. Place the paper in the fixing tray. Agitate in the prescribed manner for at least one minute. Leave the print in the tray for the moment and go back to your enlarger. Make sure your photographic paper box or packet is closed, and that you have no unexposed paper outside of the package.

6. Turn on the white light. You will now be able to see whether or not the safelight has affected your photographic paper. If the paper is white all over, your safelight is really safe. If you can see an impression left by the coins, your safelight is too powerful or too near the paper, and is fogging it.

It is impossible to make good prints if your

safelight is fogging the paper emulsion. Move the safelight farther away, change the bulb to a smaller one, or block off part of the safelight filter with a piece of cardboard. Perform this test again and make whatever safelight adjustments are necessary before you go any further.

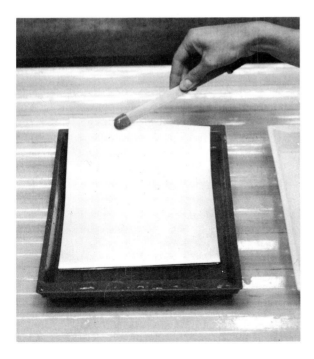

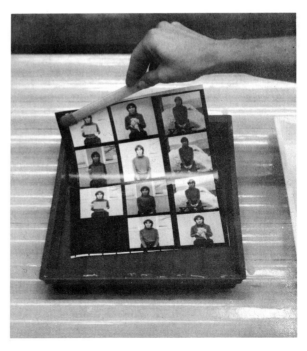

CONTACT PRINTING

Once your safelight test is successful you can make a *proof sheet.* Get out the negatives of your Exposure Test, when you photographed the Neutral Test Card. The best way to determine correct exposure for the proof sheet is to make a test strip.

Step 5—Contact Printing: Test Strip. Place the empty negative carrier in the enlarger. Turn the enlarger on and raise the enlarging head up the column until the light projected covers an area of about 28×36cm (11×14 in.) on the baseboard. Now focus the enlarger until you see sharp edges in the projected rectangle (or 36cm [14 in.] square, in the case of a 6×6cm [2-1/4 \times 2-1/4 in.] carrier). Position your contact print frame or piece of glass in the center of this illuminated area. Mark the boundaries of the projected light with black masking tape. Turn off the enlarger. SAFELIGHT ON.

TURN OFF THE WHITE LIGHT. Take out a piece of photographic paper (Grade 2) and cut a strip from it large enough to accommodate one strip of negative (5cm [2 in.] wide for 35mm, 7.5cm [3in.] wide for 120-size film).

Now, take out the first negative strip from the Exposure Test roll—the one with the blank first frame. Place this on top of the strip of paper. *Make sure the emulsion (dull) side of the film is placed against the emulsion (shiny) side of the paper.* Place this negative/paper sandwich in the contact-printing frame, or lay it under the piece of glass, within the boundaries taped on the baseboard. Set the enlarging lens to f/8 and the enlarging timer for 5 seconds.

Place a cardboard on top of the glass over the negative so as to cover about one-fifth of the entire negative strip *lengthwise* and make the first 5-second exposure. Then move the card up one more fifth of the negative strip and expose for 5 more seconds. Repeat this procedure until you have exposed the last fifth of the negative.

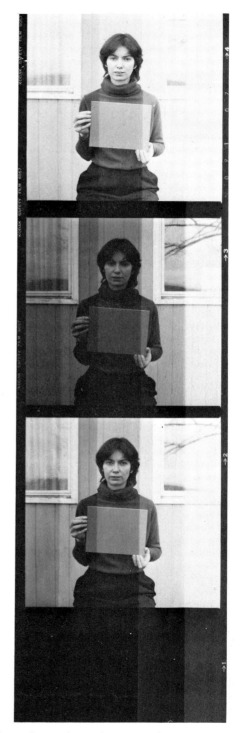

A 5-second exposure is indicated, which is too short.

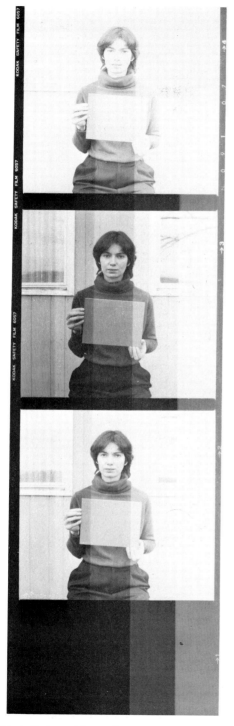

This strip indicates a 15-second exposure.

Remove the paper strip from the contact print frame, or from under the glass. Develop it the same as you did the safelight test in Step 4. To review:

Place paper in the developer for a full 2 minutes, agitating gently the whole time.

At the end of two minutes, drain paper and place in the stop bath; agitate gently for 30 seconds.

Using the stop-bath tongs, remove the strip, drain, place in fixer, agitate for a full minute; after which you can examine it—first, *make sure all photographic paper is safely back in its package,* then WHITE LIGHTS ON.

Step 6—Reading the Test. When the strip is fully fixed, take it out, let it drain, and look at it. You will see that the entire strip is made up of a light section followed by increasingly darker ones. Start at the blank frame, and you should see a series of steps from light gray to jet black. Find the first *totally* black one—not almost black, but completely dense. Count the number of steps from the lightest to this first black one, including both the lightest and this first black one, multiply the number of steps by 5, and you will have the correct exposure time, in seconds, for an accurate proof sheet. If the total time is 20 seconds or more, open the enlarging lens one stop to f/5.6 and do the test again; if the total time is 5 seconds, close down the enlarging lens one stop to f/11 and do the test again. That is, make another test: If the whole print looks too dark, cut the exposure by reducing the time or by stopping the lens down to reduce the amount of light. Conversely, if the whole print is too light, increase the exposure by leaving the enlarger lamp on longer or by opening the lens more to increase the amount of light. Also, if the print develops before the normal developing time or is slow in coming up, overexposure or underexposure, respectively, is indicated.

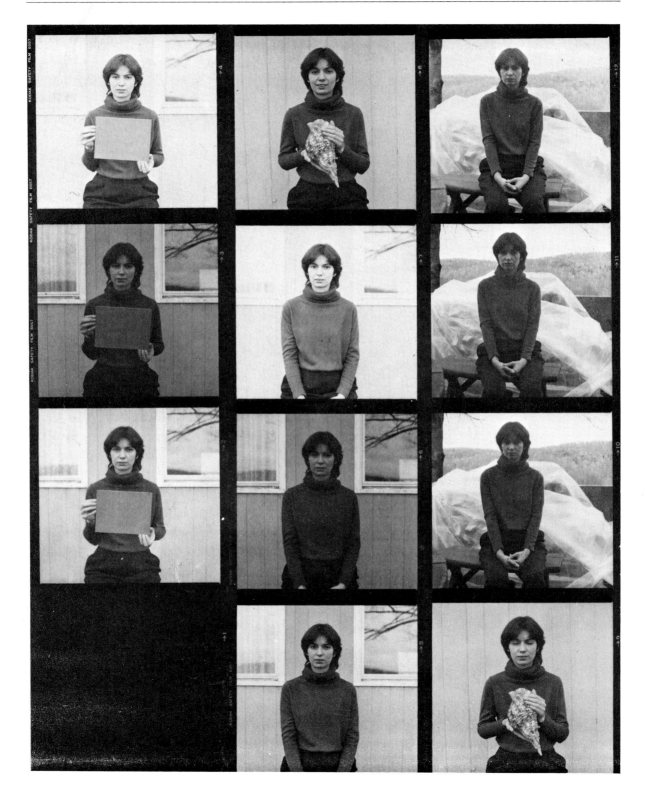

Step 7—Making and Fixing the Proof Print. If the exposure that gives you the first black section on the blank negative is somewhere between 10 and 20 seconds, make a note of the time. You can now make a full contact proof print.

> Turn the safelight on, TURN THE WHITE LIGHT OFF, and place the whole series of negative strips (from the same roll of film) in the proof-printer, along with a full piece of Grade 2 paper, emulsion-to-emulsion, with the negatives between the paper and the glass.
>
> Make an exposure from the time chosen on the basis of the test.
>
> Remove the paper from the proof printing frame or slide it out carefully from under the glass sheet and the negatives.
>
> Develop, stop, and fix as before.
>
> When the proof print is fully fixed put it in the holding bath.

Go back and make contact proofs, using the same exposure, of the other roll of film you exposed earlier. When this is done, and all the proofs are in the holding bath, check to make sure the rest of your *photographic paper is put safely away* and TURN ON THE WHITE LIGHT. The contact proof prints are now ready to be washed.

WASHING AND DRYING

Photographic paper must be washed in order to remove any chemicals remaining in it after fixing. One or two hours of thorough washing in constantly moving water is necessary for effective removal of harmful substances from fiber-based papers. Even resin-coated paper should be washed carefully according to the manufacturer's instructions. In order to conserve water follow the steps below.

Step 8—First Wash. Move the holding tray to a sink or bathtub. Take the unattached tray siphon and fasten it to the faucet. Adjust the water temperature to about 21°C (70°F), and then at-tach the siphon to the holding tray. Once the siphon outflow starts bubbling, leave the prints washing while you mix a working solution of Perma Wash or other hypo-eliminator or washing aid.

Step 9—Washing Aid. When the solution is mixed, or after 10 minutes, turn off the water in the wash tray and pour out the water (keep your hand on the prints as you do this, so they do not fall out of the tray) and detach the siphon. Now, lift out the prints together and hold them in one hand while you pour the washing-aid solution into the tray. Put the prints into the solution one-by-one, making sure each is submerged before the next one is put in. Put the first print in with the emulsion (image) side up, the second one with the image side down, and keep alternating so that they all end up front-to-front and back-to-back. This will lessen the chances of their clinging to one another (which would keep the washing aid from doing its work). Keep the prints moving for the recommended time—at least 5 minutes in Perma Wash. To

agitate a number of prints at the same time, interleave them: Take a print from the bottom of the tray, place it on top, turning it over as you do so, then gently rock the tray. Repeat this with the next print from the bottom, and so on continuously for the full time, keeping the emulsions separated and covered by the solution.

Step 10—Final Wash. When 5 minutes are up, pour off the washing-aid, attach the siphon again, and turn on the water. Check the temperature of the water, since prints will not wash properly if the wash water is below 18°C (65°F). Keep it as near to 21°C (70°F) as you can.

The makers of Perma Wash say that a 5-minute final wash is sufficient to remove harmful residues. Under ideal conditions this may be true; but a more realistic figure would be up to about 20 minutes in rapidly running, constantly changing water. The time needed will depend in part on the number of prints—a full tray will need a longer time than 2 or 3 prints. Move the prints around while they wash to be sure they do not cling together while they wash.

Step 11—Drying. When the final wash is completed, turn off the water, put your prints on a flat, *clean* surface (a piece of plexiglass, saved for this purpose, works fine) and firmly but gently sponge the excess water from them or press it out with a squeegee. Then place the prints in the blotter book, at the center of the page. Use one page for each print and leave a blank page between prints: This will let the blotter paper absorb moisture quickly. If you are using a roll, make sure the prints will face outward when the blotter is rolled up: This will help flatten them. Close the book, or the roll, and put it in a dry place. The prints will dry within four or five hours if the air is dry and warm; if it is very humid, it may take as long as a day or so.

There are other ways to dry prints: They can be air-dried on screens, for example. Drying screens can be easily constructed using plastic or fiber-glas mesh stretched over wooden frames. *Never use metal mesh:* It will corrode and eventually ruin

your prints. Or you can order screens in the size most appropriate to the space you have available, preferably large enough to dry a number of print at once. A screen 47×62cm ($18\text{-}1/2 \times 24\text{-}1/2$ in.) would be suitable, since it would allow you to dry four 20×25cm (8×10 in.) prints at one time. Frames can be stacked in a simple wood rack with a few inches between the frames to allow for air circulation. (See Chapter 7 for details.)

When using drying screens, place your prints *face down* for fiber-based papers, *face-up* for resin-coated papers. Depending upon the paper, the humidity and the air circulation, your prints will dry in 10 minutes (for RC paper) to 2-or-3 hours or overnight. If you have a problem with curling prints, place the dry prints under a few books or a weight larger then the prints for a while (say, overnight) and they will flatten out. If you live in a dry climate or have steam heat, you may want to try soaking the prints in a "print-flattening" solution just before drying them.

EVALUATING THE CONTACT PROOF

Judging a wet print is difficult, because the tonality changes as it dries: It will usually look a little darker and a little less contrasty when dry than it did when wet. The common name for this change is *drying down.* Wait for your proof prints to dry, before studying them to find out the results of your Exposure Test.

Take out the proof sheet of your Exposure Test roll of film. Frame #1 should be black; Frames #2, #3, and #4 should each have a picture of your assistant holding a gray Neutral Test Card. Frame #3 should be darker than Frames #2 or #4, and Frame #4 should be the lightest of the three.

Take your gray card and compare it, in good, even light, with its picture in Frames #2, #3, and #4. If your camera, meter, and film developing procedure were all handled correctly, the gray card in Frame #2 will be the same tone as the gray card in your hand. If Frame #4 looks more like the real gray card, then either your meter is reading, or your shutter speed is reacting about one f-stop too low (underexposure). The easiest way to correct for this is to set your meter at ASA 64 instead of ASA 125 when using Plus-X film. If Frame #3 looks more like the actual gray card, then your meter or shutter is reacting about a stop too high (overexposure), and you should set your meter to ASA 250 instead of ASA 125 for Plus-X. Remember that this test applies *only* to the camera, meter, film, and developing procedure you used for the test; if you change any of these things you will have to make a new exposure test for each combination.

In this strip Frame #2 best matches the gray card indicating that camera, meter, film, and developing time are giving correct results.

THE STRAIGHT PRINT

The first thing to do before printing is to get rid of any dust that has found its way onto the enlarging lens or inside the enlarger, on the condensers. When this is done and you have checked that the condensers are in their proper place, clean the negative. First brush it carefully with a camel-hair brush, or use an electrostatic brush, or blow the remaining particles away with the ear syringe or the can of compressed air (being careful *not to tilt the can—read the manufacturer's instructions).* Any remaining dust specks will show up as small white marks on your print and will have to be removed by *spotting.* It is much easier to remove dust from the negative than to spot if off the print.

When the negative is clean, put it into the negative carrier, emulsion (dull side) down, and place in the enlarger.

Focusing. With a printing easel on the baseboard, turn the enlarger on. Adjust its height until the image is the desired size, and focus. To focus the image sharply, you will find a grain magnifier helpful. If you use one, place in the easel first a sheet of photographic paper the same thickness as that you plan to print on—the sheet you processed for the safelight test would do—or some other "spoiled" but fixer free sheet. This *focusing sheet* is necessary because the surface of the easel is lower by just that much—the paper thickness—than the point where you want accurate or critical focus.

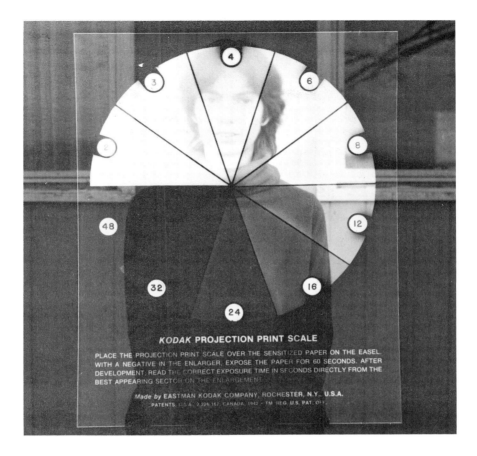

KODAK PROJECTION PRINT SCALE

PLACE THE PROJECTION PRINT SCALE OVER THE SENSITIZED PAPER ON THE EASEL.
WITH A NEGATIVE IN THE ENLARGER, EXPOSE THE PAPER FOR 60 SECONDS. AFTER
DEVELOPMENT, READ THE CORRECT EXPOSURE TIME IN SECONDS DIRECTLY FROM THE
BEST APPEARING SECTOR ON THE ENLARGEMENT.

Made by EASTMAN KODAK COMPANY, ROCHESTER, N.Y., **U.S.A.**
PATENTS: U.S.A. 2,226,167. CANADA, 1942 · TM REG. U.S. PAT. OFF.

A Test Print. Once the image is sharply focused remove the focusing sheet and put it aside for future use. Make a *test print* to determine the correct exposure time. This is made in much the same way as the contact test strip (Step 5). Make an overall exposure of 5 seconds, then cover an inch or two of the paper and make another 5 second exposure until you have reached 30 seconds total exposure. Some photographers make test strips on a thin strip of paper, placing it across the "important" parts of the image. But since *all* of the negative is "important" or ought to be, full information about correct print exposure can best be learned from a test of the whole negative. So at least until you are really proficient use a full sheet of paper—the experience you gain and the time you save in the end outweigh the cost of the paper. After you have exposed the test sheet, process the sheet and evaluate it to determine the best overall print exposure. Remember that because prints dry down you should not judge tones from a wet print until you have some experience. At first, fix, wash, and dry test prints, at least surface-dry.

The Step Wedge. Another method of determining print exposure is by using a *Kodak* Step Wedge (see illustration). This piece of plastic is imprinted with a circle divided like apple pie into wedges of different densities. Put this plastic sheet on the paper where the projected image will include the greatest possible range of the tones in the negative. Set enlarger lens at its middle aperture (usually f/8). Expose for one full minute, process,

wash, and surface-dry the print. You will have a black print containing a pie neatly divided into wedges of different densities (appearing as shades of gray), each one with a number. Read the best exposure from this test strip — the number shows how many seconds to expose at the aperture used.

Exposing the Straight Print. Set your enlarger timer for the number of seconds you decided on as a result of your test print. Place a sheet of Grade 2 paper in the easel and expose. Develop for two full minutes, stop, fix, and put the print in the holding tray. Turn on the white light and look at your print.

As you examine the print, you may find that its overall appearance is a little dull. Even though it is not too light or too dark — its tonal range is narrow, so that it seems to lack contrast. If this is the case, make a test sheet on Grade 3 paper. Find the correct exposure time and make a straight print. If the print is still too dull, or "flat", you may need to use Grade 4 paper, but Grades 2 and 3 will cover most situations quite well.

While looking at this regular straight print, you may also discover that, even though overall exposure is good, there are certain small areas that look either "washed out" or too dark. You will need to give more exposure to the areas that are too light and less to those that are too dark. The adjustments made to these overly light or overly dark areas in a print are called, respectively, *burning in* and *dodging*.

The sequence of four illustrations starting on page 50 shows; two ways of making a test print; a straight print, opposite; the same straight print exposure above, but with the sides burned-in for better balance.

The test print on page 50 (5 seconds all over, each strip an increment of an additional 5 seconds) indicates that a15 second exposure (second strip from left) would be too light, but 20 seconds (third strip) would be too dark. So a basic exposure of 18 seconds was decided on. This same information can be obtained from the test print on page 51 although not as easily because only the darker part shows the "correct" exposure range.

The print opposite was exposed at 18 seconds without manipulation. The print above had the same basic exposure of 18 seconds but the sides were given an additional 7 second exposure. (By studying the test print on page 50 you can see that 25 seconds is about right for the window frames and sides.)

Dodging. This holds light back from parts of the print that appear too heavy or dark. If you want to make an area less dark, make a dodging tool (see illustration) from some thin wire and a piece of cardboard or tape, and wave it, with continuous movement over the dark area for part of the normal exposure time. Remember to keep the wire of the dodging tool moving or you will end up with a light line across the print.

Burning In. This is the reverse of dodging, as it adds more exposure to an area within the print than is required for the overall print. The way to do this is to make your overall exposure first; then to hold a large piece of cardboard with a hole in it about halfway between the lens and the printing paper, with the hole over the area where you want more light to reach the paper (see illustration).

Set the timer for roughly the amount of time you think is necessary to darken the area, and expose through the hole, moving the cardboard slightly all the time during the exposure. This movement will prevent you from leaving a noticeable edge where you have burned in.

Some experimentation and practice will be necessary before you can use these techniques successfully every time, but the increased depth and beauty of your prints will be worth the trouble you go to. Avoid "overburning" and "overdodging", or your prints will have an artificial quality. These techniques work only when no one can tell that you have used them.

Common Problems

Faint image: Clear, sharp frame numbers

Negative normally developed but underexposed — — Verify the A.N.S.I. (A.S.A.) E.I. setting of your exposure meter and check the meter for accuracy; set camera's shutter speeds and apertures as indicated by the exposure meter.

Cloudy, milky negative

Negative not fixed long enough; or fixer exhausted. — — Refix in fresh solution and wash for the proper time. This should clear the negative.

Reticulation

Negative subjected to sudden extreme changes in temperatures during the developing process. — — No remedy — Next time make sure that developer, shortstop, fixer, and washwater temperatures do not fluctuate more than 3° either way.

Streaks at sprocket holes

Too much agitation. — — No remedy but the negative may still be printable, with cropping. Next time, agitate the developing tank for the prescribed time.

Mottling or streaks: Uneven density

Negative unevenly or underdeveloped. — — Develop for the proper time; check dilution and instructions; agitate sufficiently; adjust temperatures so that the development time is longer.

Extremely dense negative: Sharp, clear frame numbers

Massive overexposure, normal development. — — Check meter settings; check camera settings; when printing, allow for long exposures. (Print's tonal range will not be very good.)

Extremely dense negative: Fuzzy, thick frame numbers

Massive overexposure plus overdevelopment. — — Check meter and camera settings, check development times. It is almost impossible to get an acceptable print from this kind of negative.

Air bubbles: "Pinholes" in emulsion

Air bubbles clung to emulsion during developing, tank not tapped to loosen them. — — White spots on print resulting from air bubbles in the negative can be retouched, but if they are large, it can be a thankless task; make sure to tap the tank next time.

Fine lines lengthwise of negative

Scratches can appear black or white, depending on nature and depth of scratch and whether it is dirt-filled or clean. Scratches on either side of negative are caused by some sharp or gritty material touching the film at some stage—either in the camera (on the camera pressure plate), in the cassette felt light trap, while loading the film onto the developing reel, dust on the squeegee, and so on. — —Remedy is not easy; lines can be spotted on prints (with care and skill). For next time: Check for dust at all stages of process.

Image is not equally sharp throughout the plane of focus

Lens elements out of alignment; pressure plate out of alignment. — —Camera needs to be professionally repaired.

White or clear triangle or stripes across film

Film reeled improperly touched and stuck to itself, preventing development in some spots. — —Refix until white patches are clear, wash thoroughly: Depending on size and location of patches, negative may be printable, with cropping. Check that developing reels are not warped; load reels carefully (practice with an old length of film).

Crescent moon-shaped dense areas

Film crimped while loading on the developing reel. — —There is no way to elimate mutilations caused by rough handling. Load more carefully in the future. Some crimp marks can be retouched on the print.

Film edges totally dense (black)

The film was "lightstruck" at some point (light may have been turned on while loading film onto reels). — —No remedy; parts of image may be printable with cropping. In future, protect film after unloading from camera, handle exposed film in *total darkness only* while winding from cassette to reel and to tank.

Water spots

Water spots, caused by uneven drying of film. — —Try rewashing, although it seldom helps. Next time use a wetting agent and wipe the film carefully as soon as it is hung to dry.

Fingerprints, dust spots, uneven scratches

Sloppy darkroom habits, resulting in a mess that may be unsalvageable. — —Try film cleaner. In future handle negatives only by the edges and keep it safe from scratches by using protective sleeves for storage.

Contact prints, proof sheets fuzzy and unsharp

Film is not being held in contact with the paper. — —Make sure contact printer is tight enough or piece of glass is held securely in place atop negative and paper.

Unsharp image: Grain unsharp all over

Enlarger not properly focused. — —Refocus and print again.

Unsharp image: Sharp grain

Subject was out of focus (camera focused incorrectly). — —No remedy. No sharp print can be made from an unsharp negative.

Grain sharp on one side of print

Enlarger is out of alignment or paper is not flat on the easel. — —Check that enlarger lens, negative stage, and baseboard are flat and parallel to each other; make sure paper is not buckled in easel.

Image and grain sharp in middle, fuzzy in corners

The negative has expanded slightly (buckled) in the heat from the lamp-housing. — —Leave enlarger on for a minute or two to warm the entire negative equally, refocus, then turn light off while you insert a new piece of paper on easel, and expose. If the problem persists, you may need to use a glass negative carrier.

Print gray and murky all over

The paper is fogged or outdated. — —Check your safelight: Move it further away or change to a smaller bulb; review safelight test (Chapter 3). If problem is due to outdated paper, the addition of potassium bromide or liquid orthazite to the developer may help (follow manufacturer's instructions).

Gray print with black edge or streaks

Print is fogged, that is the paper has been partly exposed to white light. — —In future, make sure that paper boxes are not torn and completely closed; make sure all white light is off during exposure and processing; put all unexposed paper away before turning on room lights.

Print streaked, mottled

Development time was too short. — —Make a new print, developing for the recommended time; or dilute developer to give longer developing time.

White spots on print

These indicate dust marks. — —Remove negative and clean it. Make sure the enlarger is grounded to minimize static electricity which attracts dust.

Brown or pinkish-gray stains

Developer is exhausted or contaminated. — — Replace with fresh developer and reprint.

Print dull, lifeless

The print is too "flat". — —Reprint, using a higher contrast grade of paper.

Print very harsh

The print is too contrasty. — —Reprint, using a lower contrast grade of paper.

SPOTTING AND ETCHING

Spotting. Dust is a constant problem for the darkroom worker. No matter how meticulous you may be, or how carefully you blow dust away from your enlarger and negative before printing, you will eventually find that some prints have little white flecks or spots on them, caused by dust on your negative during exposure.

The best way to remove these spots is to use a retouching dye that penetrates to the paperbase. Retouching pencils and water activated paints sit on the surface of the print and can wear off. *SpoTone* is the best known of these dyes and the easiest to use. It can be bought at most art-supply and camera stores and comes in six different tints. Three for use on untoned prints; the other three are made for prints that have been toned. The user mixes the tints together and dilutes the mixture with water to match the tone of the print in need of "spotting".

It take a little practice to retouch dust marks properly, but once learned it is easy to do. You will need the following supplies:

- One small bottle each of SpoTone #0 (olive); #1 (blue-black) and #3 (neutral black).

- A small white ceramic, plastic or enamelled dish, or a piece of glass on which to mix the SpoTone tints together.

- A small container of water, with a minute quantity of wetting agent on the side.

- A very-fine pointed (#000) sable brush, or a good sable water color brush trimmed to a point of 2 or 3 hairs only, to apply dye to the print.

- A clean working area with good, even light.

- A fixed and dried piece of the same paper as the print on which to test the tint mixture—the white border of a test print will do.

- Useful but not absolutely necessary are a magnifier, and an eye dropper—to transfer the dye from bottle to palette.

Set everything out within easy reach, making sure that prints are not in danger of having SpoTone spilled on them accidently. The dyes are permanent, and will permanently stain almost anything they are spilled on.

Look up the mixing directions recommended for your paper type on the SpoTone chart (supplied in the kits of three tints). Dip your brush into the bottle of the first tint and transfer one drop to your palette (or use the eye dropper). If the mixture calls for more than one drop, transfer as many as needed before going on to the next bottle of dye. Rinse the brush and dry it on a tissue or paper towel. Now add the second tint as recommended, mixing it with the first on your palette. When the mixture is complete, allow it to dry. It can be used wet, but you will find that the tints are more easily controlled when used after they have dried on the palette.

Once the mixture is dry, dampen the brush slightly with water and ease it into the dye on the palette. A drop or 2 of wetting agent added to the water will help the dye penetrate the water-resistant surface of the print. Many photographers use saliva instead of water and wetting agent. Since the brush should not be too wet, saliva gives a little more control. Stroke the brush on the test paper a few times, until the dye color is diluted to match the area you going to spot. SpoTone tends to "dry down" a little, be sure to use a tone slightly lighter than the area you will be working on. When the tones are as close as you can get them, touch the tip of the brush to the white spot. Do *not* use stroking motions. Light stippling will work best. You want to imitate the grain, not make solid patches of color.

As soon as the spot seems to disappear, stop and go on to another one. If the spot is too large for one touch, or if it is a line caused by a scratch, use a series of spots, rather than strokes, to fill it in. Start with darker areas and go on to the lighter ones as the brush dries.

Keep the brush just barely damp. Never apply undiluted dye to the print—the result will always be darker than needed.

Place everything within easy reach

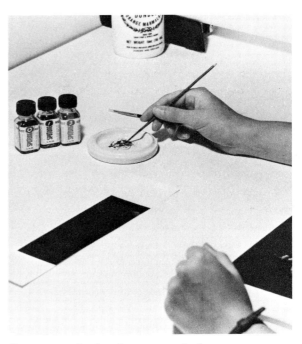

Dampen your brush and ease it into the dye

Stroke the brush on paper until the dye color matches the area that needs spotting

Use a light stippling motion to fill in the spot

Etching. Black spots and scratches on a print are more difficult to remove than white ones. If possible the defect should be corrected on the negative. To remove these defects from a print use an X-Acto knife (or similar tool). Be sure the knife is sharp and has no rough edges.

Hold the knife perpendicular to the print surface and use gentle scraping strokes. Use short strokes and a light hand. Patience is a great attribute when etching a print as it may take quite a few strokes to remove even the smallest spot or hairline. Avoid digging *into* the print surface. No matter how well done etching will always be visible especially if the print is held at an angle to the light. However, if the print surface is broken by digs into the emulsion the etching will be obvious even at a normal viewing angle. The abrasions left by stroking motions can often be softened by rubbing the spot with a clean *silk* handkerchief.

For both techniques, etching and spotting, it is best to do your first experiments on reject prints. Bear in mind that patience and a light touch are the most important requisites—so work slowly and carefully. The result will be worth the effort.

Fine Tuning the Negative

The exposure and development methods outlined in Chapter 2 and 3, together with a thoughtful and methodical working routine, have enabled you to approximate real-life tonal relationships in your pictures. That is, your photographs have the same general light-dark relationships that existed in your subject.

You may have found, though, that the lighting conditions you meet most often do not translate into photographs as well as you would like to, or that you are more interested in making your images tonally different from "real life."

The following chapters describe methods and materials that will help you get results nearer to the kind of image you want to produce.

Photographers can be divided *loosely* into two categories: Those who are interested in recording the world as they find it; and those for whom reality is raw material; to be interpreted or even changed by their imagination. In both cases, control of the photographic tools and understanding of their capabilities and their limitations is essential if high-quality photographs are to result.

The importance of training yourself to see in your mind's eye what the final print will look like, even before you make the exposure, cannot be overemphasized. Without this ability you cannot make full use of your medium. There is no way of arriving at an end result properly if you do not know what that end result is supposed to be.

The "mind's eye" includes *imagination* and *previsualization;* both are important steps toward taking control of the photographic process. By *imagination* we mean the ability to sense, as you look at your subject, what the final print of that subject *ought* to look like. *Previsualization* is a term used to describe a method by which a photographer can know what the tones of his subject *will* look like in the finished print.

Imagining what your final print should look like is not really difficult—in fact, all photographers do it in one way or another. Once we learn to manipulate the materials we can predict the tonal distribution in any print, and then *modify* exposure and development to turn *imagined* prints into real ones.

PREVISUALIZATION

There are two basic requirements for successful previsualization of print tonalities, or range of tones from the darkest to the lightest, in any picture. The first is to understand the relationship that exists among eye, subject, exposure meter, film, camera controls, film developer, and photographic paper. The second requirement is to work out the method that will put this understanding to successful creative use.

The human eye can recognize details in objects under a broad span of illumination; for instance, on a sunny, cloudless day the most intensely lighted object may look 1,000 times "brighter" than the object receiving the least light. Another way to phrase this is that the eye can perceive a *subject brightness* range of a thousand to one (1000:1).

Black-and-white film that has been exposed and developed normally can record a light intensity range of only about 256 to 1 (256:1). Any objects falling outside of this ratio will not register on

the film. That is, any sections of the scene that reflects more than 256 times as much light as the darkest recorded object in that scene will fall outside the emulsion's ability to build up density (totally opaque on the negative). Parts of the subject that are more than 256 times darker than the most intense (brightest) object recorded will fail to make the film respond at all and will register as clear (unexposed) areas on the negatives.

Photographic paper is even less able to handle a wide range of "subject brightness": It can record light intensities only within a range of about 50 to 1 (100:1 if pure white and maximum black are included).

All this may make you wonder how to make accurate photographic translations of subject tone at all. The answer is that it is not possible, at least not with a full-range subject. If you have a photograph that you think looks "exactly like" the original, take it back to the scene and compare the two. You will immediately see that there is little true resemblance — yet the photograph may really "seem" or "feel" like its subject. This is due to two factors. First, the tonal relationships of your photograph are probably proportional to the scene; and second, your subjective, unconscious appraisal of the photographic image, coupled with an equally subjective sense of the various "brightnesses" of objects in the picture, strongly remind you of the subject. The mental associations caused by an image are what make photography (or any other visual medium, for that matter) work.

By knowing how to translate subject brightness values into different negative densities, and then into blacks, whites, and various grays of a print, you can recreate the tones of virtually any subject you saw in front of your camera. You can also use this knowledge to modify the tonal distribution of your negative and your print somewhat, so that the final product becomes a true representation of what you saw in your mind's eye, even if this differs from "real" life. In other words, here *imagination* and *previsualization* come together.

BRIGHTNESS AND LUMINANCE

Brightness is a quality that is perceived by the human eye but is not measurable. Because of various psychological associations one has with the things that are seen, and because objects appear lighter or darker depending on their surroundings (see illustration), an objective measurement of brightness is impossible. However, there is a way to measure the specific degrees of light falling on and reflected by an object. Light *falling* on an object is termed *incident light*. Light *reflected back* from the surface of an object is called *luminance*.

Exposure meters that measure the light given off by an object are called *reflection-light* or *luminance* meters. Most hand-held and all in-camera meters are of this type. Meters that measure incident light are also available. These *incident-light* meters are most effective when used in controlled lighting situations, such as in cinematography, or in studio photography.

All luminance exposure meters are designed to indicate camera settings that will produce a medium gray (18% gray) rendition of the subject being measured — as long as film and paper are processed in the normal fashion. It does not matter how light or dark the subject is — a white door, a red brick wall, or a black dress will all appear middle gray in the print *if* they are exposed at the indicated setting, then developed and printed normally. To prove this yourself — try the experiment that follows.

Hang a white towel over a door or a chair, or anywhere that the light is even. Make a close-up reading of the white cloth, taking care not to cast a shadow on the area you are metering. Mount your camera on a tripod and position it as close to the cloth as your lens allows you to without going out of focus, and without casting a shadow. Fill the frame with your subject (white towel). Check focus, then expose at the setting indicated by your meter.

Next, substitute a large piece of black construction paper or cloth for the white towel, take a new reading, adjust camera setting, make exposure.

Repeat once more, substituting a 18% (middle) gray card for the black paper. Use the remainder of the film to make pictures as you would normally. Develop the film as you usually do, then make a contact test strip and proof sheet.

When the proof sheet is dry, examine the "white," "black," and the "gray" exposures. You will find that all three appear to be almost exactly the same gray tone. Whatever variations do exist can be attributed to slight variations in your shutter or meter, or to the contrast effect from any background that may show in each picture.

Bearing the result of this experiment in mind, it becomes obvious that following your meter readings without interpreting them is unreliable at best, and at worst can lead to serious errors under some lighting conditions.

It is sometime possible to arrive at an acceptable negative by *bracketing* exposures, that is, by making a number of shots of the same subject starting with the exposure the meter indicated and then changing that by increments of 1/3, 1/2 or full stops up to two or more stops in both directions (overexposure and underexposure). This procedure is common among photographers using color, who have to take into account, not only the luminance of their subjects, but also their color value; in black-and-white photography it is less necessary because the negatives have a greater margin of error (latitude) and because more darkroom controls are available.

More accurate methods of tone control are available to the photographer willing to set aside a few hours for learning a basic, systematic approach to photography. The most comprehensive and reliable of these methods is the widely used *Zone System*. Its name is taken from the premise that negative densities and their related print tones can be divided into ten separate steps or "zones" of tone value. Zone 0 is represented by clear sections of the negative (which will be maximum black in the print); Zone V is the tonal value that prints as middle gray (same as a 18% neutral test card); and Zone IX is represented by maximum density in the negative (the pure white of the paper base of the print). The other zones represent the remaining shades of gray that can be produced in a print.

The lower the roman numeral of a zone, the darker its corresponding print tonality.

Scale

| 0 | I | II | III | IV | V | VI | VII | VIII | IX |

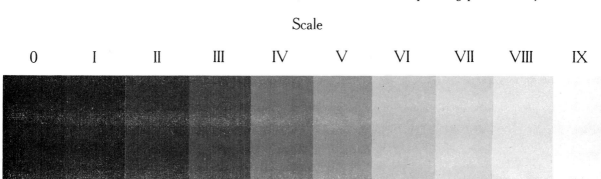

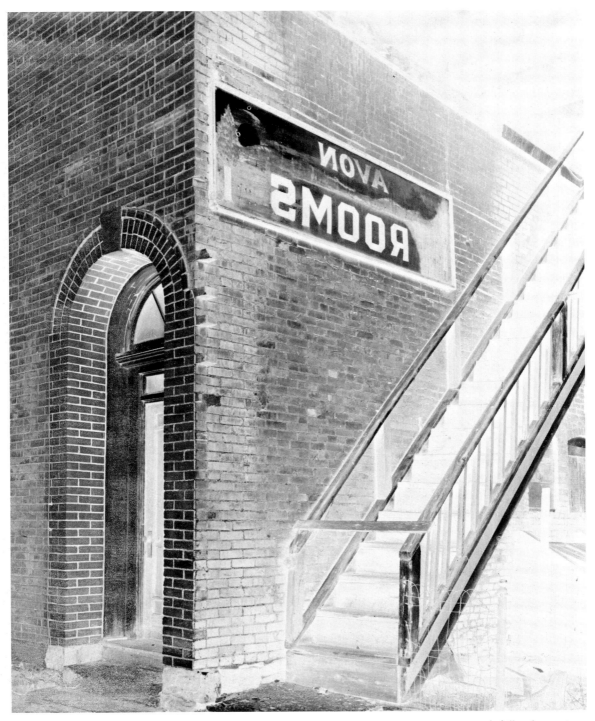

A full-scale negative

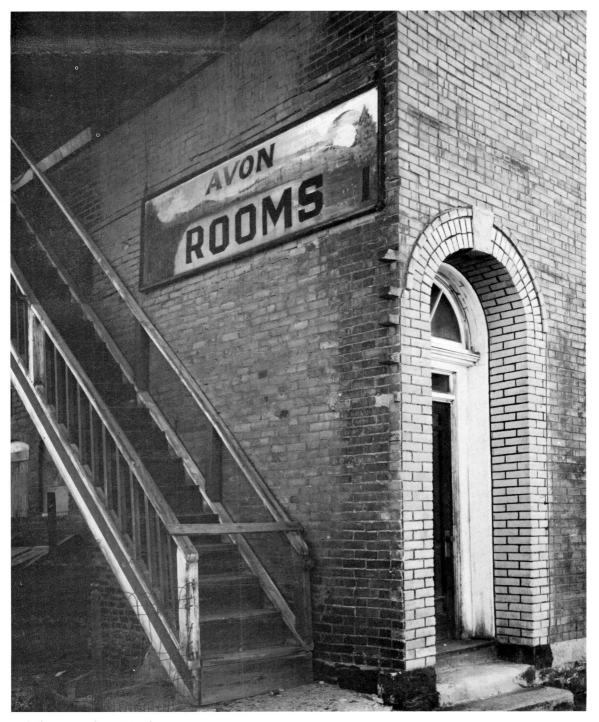

and it's corresponding print values

Using the zone system, the photographer can decide to place certain parts of his subject into predetermined zones, then expose so that the darkest important section of the subject will register detail on the negative. In zone system terminology this is described as *exposing for the shadows*. Having done this, the negative is developed long enough (or development is reduced) so that highlight sections register at the predetermined zone while printing, known as *developing for the highlights*. A well-made, full-scale negative, exposed and developed according to the zone system, will print on a normal-contrast paper with none or a minimum of manipulation needed.

Used properly, and with a thorough understanding of the techniques involved, the zone system can free you from having to guess at an exposure most of the time. It can also save you some irritation in the darkroom. The beauty of the system lies in its ability to produce full-scale negatives that allow you to burn in and to dodge for expressive purposes, rather than for correction of exposure mistakes.

There are some drawbacks to using the zone system, though, especially for the user of 35mm cameras or roll film cameras without interchangeable backs. First, all the negatives on a given roll of film have to be exposed for scenes of the same tonal range; second, the advantages of a small camera (speed of use and inconspicuousness) are negated by the need to make a number of light measurements of the scene. The zone system is primarily designed to be used with large-format cameras or with cameras with interchangable backs.

A full description of the zone system can be found in Ansel Adams' *Basic Photo Series* (N.Y. Graphic Society). For the less mathematically inclined, there is an excellent discussion of the system in the *New Zone System Manual* by White, Zakia, and Lorenz (Morgan & Morgan). Anything beyond a basic outline of the system is beyond the scope of this book, yet some of its techniques and methods are basic and have broad applications.

If we restate the old adage about "exposing for the shadows and developing for the highlights" in zone system terms, we can say that the most satisfactory exposure of a negative is one that calls for a Zone I value to be the lowest printable density on the negative. Anything lower in value than this will not register on the film in any meaningful way. Since the Zone I value is so close to being absolutely clear on the negative, it is extremely difficult to judge it by eye alone. An instrument known as a *densitometer* must be used for accurate readings of density, especially of this low level. The densitometer is an electronic device that reads the amount of light which can be passed through an exposed and developed piece of film. The readings are expressed in *density numbers*.

Since the control of photographic materials, whether you use the zone system or not, depends upon correct exposure of your film, you should try to locate someone in your area with a densitometer. Most graphic arts labs and many commerical labs have such an instrument.

You could purchase a densitometer, however, for occasional use, the expense hardly justifies this. Macbeth manufactures a highly sophisticated line of opaque and transmission densitometers, they sell for about $2,000.00 and up. The *Kodak* Transmission Densitometer while considerably less expensive is also less sophisticated.

PRECISE EXPOSURE INDEX

To find the right exposure index for your combination of film, camera, and developer, first determine which A.N.S.I. speed rating (ASA) will allow Zone I readings to record as a densitometer number of .10 above film base and fog (.10 above the clear film, along with any minute densities that will have built up because of developer action). This is easily done by following the procedure outlined below:

1. Set your camera's or exposure meter ASA dial to the rating recommended by the manufacturer of the film you are using.

2. Set up your equipment as you did while doing the basic film-speed adjustment test in Chapter 2: Camera on tripod, *even* lighting 18% Neutral Test Card, and so on. Attach the gray card to something so that it is *parallel to the film plane.* Check for even light on the card by measuring its center and four corners.

3. Move your camera in close enough to photograph the card and nothing else. Don't worry about going out of focus; tonal value is the only important thing in this test.

4. Take a reading of the card, then adjust your camera setting to *4 stops lower* than the indicated reading (4 stops less exposure). This is because the gray card represents a Zone V value, but you want to make a Zone I exposure, which is 4 stops lower than Zone V.

5. Expose.

6. Make a note of the ASA rating, the frame number, the meter reading, and the actual exposure you gave to achieve Zone 1.

7. Repeat Steps 4 through 6 but change the ASA setting on your meter to one half of the film recommended speed. If you are using Plus-X, change from ASA 125 to 64; if using Tri-X, change from 400 to 200; if Ilford Pan F, change from 50 to 25.

8. Repeat Steps 4 through 6 again halving the ASA rating: This will give 1/4 of the recommended speed for the film—Plus-X becomes ASA 32; Tri-X becomes ASA 100; Ilford Pan F becomes ASA 12.

9. Repeat again, this time tripling the ASA rating used in Step 8, so that you are setting the meter to the setting nearest 3/4 the manufacturers' rating—Plus-X at 80, Tri-X at 320; Ilford Pan F at 32.

10. Double the last meter settings, so your meter now gives 1-1/2 times the manufacturers' rating: Plus-X at 180; Tri-X at 650; Pan F at 64, and repeat, again, Steps 4 through 6.

11. Repeat for the last time, simply doubling the manufacturers' rating: Expose Plus-X at ASA 250; Tri-X at ASA 800; Pan F at ASA 100.

12. Put your lens cap over the lens and expose to give you a blank frame. It will be used with the densitometer to compare against the exposures you have just made. Whichever one is closest to being .10 above it is your Zone I exposure.

Process the film as recommended by the manufacturer, or the way you normally do if different. In either case, development time you now use may not be the one you should continue with once your Zone I results are known. Changes in development time may become necessary later on, after you have made negatives at your true film speed rating.

Have someone make the densitometer readings for you, or—if you are allowed to make the readings yourself see next page for how to make readings with a *Kodak* Transmission Densitometer.

When you have found out what your true film speed rating is, set your meter to that rating and assemble your test equipment again. You are now

USING THE *KODAK* TRANSMISSION DENSITOMETER

To read densities of the film sample, raise the densitometer head and place the sample, emulsion side up, on the opal-glass disk in the base; then, lower the head until the nose-piece touches the sample. Be sure the appropriate aperture of the filter holder is in the viewing beam. When you change from one spot to another on the sample, raise the head so you don't scratch the surface of the sample.

When you raise the densitometer head, you'll notice two things: First, the light dims when the head is up and brightens when the head is lowered. This saves the lamps and makes centering the sample easier on the eyes. Second, there are four position lines on the opal disk in the base. Use them to center the area to be read. Your densitometer actually "sees" an area 1-1/4 mm in diameter.

With your sample in place and the densitometer head lowered, look into the eyeshield. Does the central spot look uniform in density? If not, move the sample around very slightly until it does. When the center density is uniform, make your reading. Turn the density scale until the center spot matches the surrounding field as closely as possible. The spot should practically disappear. Now read the density value on the scale under the index line.

The scale is graduated in equally spaced steps of 0.05, with each 0.10 step designated. If your reading doesn't fall exactly on one of the calibration marks, use the nearest mark (or estimate the intermediate density value). For example, if the scale indicates the sample you're measuring has a density a little more than halfway between 1.60 and 1.65, call it 1.65 (or 1.63). If it is a little less than halfway, call it 1.60 (or 1.62).

only one more step away from precise negative control—the establishment of an adjusted normal developing time.

Normal Development Test: Four rolls of film are needed for this test. If you use 35mm film, make sure your test rolls are the same length you use normally (20 or 36 frames) although only 12 test exposures will be made on each roll.

When your testing equipment is set up the same way as in the previous test, take a reading of the gray card. *Make certain your meter is set at your newly discovered exposure index* or the test will be useless.

Make the following series of exposures, keeping notes on each.

Frame #	Exposure
1	Stop down 4 stops from the meter reading
2	Stop down 3 stops from the meter reading
3	Stop down 2 stops from the meter reading
4	Stop down 1 stop from the meter reading
5	Exposure at the meter reading
6	Open up 1 stop from the meter reading
7	Open up 2 stops from the meter reading
8	Open up 3 stops from the meter reading
9	Open up 4 stops from the meter reading
10	Open up 5 stops from the meter reading
11	Open up 6 stops from the meter reading
12	Make a blank exposure (lens covered with lens cap)

Repeat the above series with the remaining 3 rolls of film. When all 4 have been exposed, develop one roll as you normally would, wash and dry and mark roll with a grease pencil Roll #1.

Develop another of the rolls of film for 20% less than you did Roll #1. Mark this roll Roll #2.

Give Roll #3 10% less developing time than Roll #1.

Develop Roll #4 15% *more* time than Roll #1.

Make contact test strips of each roll (mark the sheets of paper Roll 1, 2, 3, and 4) give each proof sheet the same exposure and development. Wash and dry.

Take the proof prints and examine them in good light. Each proof print will consist of a series of varying densities, from the maximum black of the blank frame (Frame #12) to gradually lighter tones in Frames #1 to 11. Frame #11 should be as light as the paper base in all four proof prints.

Examine Frame #8 in all four prints. Frame #8 represents Zone VIII. Look for a tone that is just noticeably less white than the paper base. When you find it, examine Frames #9, 10, and 11. These should all be as white as the paper base if you have picked the right proof print.

Your correct normal developing time is the one that gives you the first indications of tonality at Frame #8, the first truly recognizable shade of light gray in Frame #7, and pure white in Frames #9 to 11. This will be your "normal development" time for that film/developer combination.

METERING WITH THE PRINT IN MIND

In order to put all the testing you have just gone through to creative use, you will want to develop a sound working knowledge in important parts of your subjects. The following page give some generally encountered subjects, along with their corresponding gray scale tones:

A contact print of your "normal development time" negatives will give you the raw material for making a gray scale. First, cut the contact sheet as shown. Position Frame #10 *in front of* Frame #1, and mount or glue all the frames onto a strip of cardboard. Having done this, you will notice that the frame numbers represent the sequence of zones from 0 to IX—Frame #1 is Zone 1, Frame #2 is Zone II, Frame #3 is Zone 3, and so on.

If you carry this strip around with you as you photograph, you will be able to help yourself develop the ability to "see" in terms of black, white, and gray.

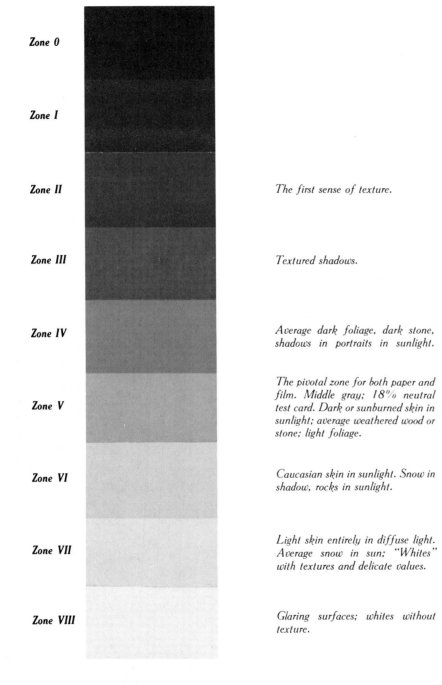

Zone 0

Zone I

Zone II

The first sense of texture.

Zone III

Textured shadows.

Zone IV

Average dark foliage, dark stone, shadows in portraits in sunlight.

Zone V

The pivotal zone for both paper and film. Middle gray; 18% neutral test card. Dark or sunburned skin in sunlight; average weathered wood or stone; light foliage.

Zone VI

Caucasian skin in sunlight. Snow in shadow, rocks in sunlight.

Zone VII

Light skin entirely in diffuse light. Average snow in sun; "Whites" with textures and delicate values.

Zone VIII

Glaring surfaces; whites without texture.

Zone IX

Hold the strip up to a part of your subject and, with the help of your personal gray scale, decide which tone you want that part of your subject to have in the print. Take a exposure-meter reading and adjust the lens setting so that you get the correct exposure for the tone you are after. For example: If you point your meter at a light gray stone statue, and you want the statue to have the tonality shown on your scale at Zone VII, you have to open up two stops from the meter reading (one stop equals one zone). Remember that the meter only reads for middle gray (Zone V), and that the reading must be interpreted to be of any use.

Let us say that you decide to find out what zone the base of the statue will fall on if you expose for Zone VII placement of the statue itself. Your reading indicates that the base is four stops darker than the rest of the statue. Since the statue will print as Zone VII, the base will appear as Zone III in the print. As you look at your gray scale, you are now able to "see" two important parts of your subject in tones of gray. With a little practice, you will find it easy to measure all of the important areas of your subject, then to mentally translate them into gray tones. Walking around for a short time and comparing measured parts of various subjects with your tone scale will be of immense value; you will soon notice that you are able to predict where parts of the scene will fall *before* you measure them.

COMPACTION AND EXPANSION

As you go about photographing, you will discover that the contrast range of many subjects is greater or less than that which your film and paper can fully reproduce when exposed and processed normally. To find out if normal exposure and development will give you a full-scale print, meter your subject as follows:

1. Make a reading of the *darkest* area of your subject where readable detail is desired (Zone III). Since the meter will indicate a Zone V exposure, *stop down* 2 stops from the indicated setting to arrive at Zone III. Make a note of this setting.

2. Make a reading of the *lightest* area of the scene where detail is to show in the print. Again, the meter will indicate a Zone V exposure. You will need to *open up* 2 stops to arrive a Zone VII. Make a note of this setting.

3. Now compare the settings for light and dark areas of your subject. If the difference between them is 4 stops, you can expose and develop normally, as you have been doing up to now.

Compaction: If the difference is 5 stops, you have the choice of dropping your low value reading one stop to Zone II which would mean a considerable loss of printable detail in the dark areas, or you can lower the high value reading through less development (compaction). A 5 stop difference would call for a normal-minus-one (N-1) development—a 6 stop difference would require N-2 development. There is no exact formula for how much less time to develop. For N-1 one-third less than your normal developing time is a good start; for N-2 it would be one-half your normal development time.

Be aware, though, as you make changes in your development time, that less than five minutes development time may result in mottling and uneven development. If a development adjustment in a time shorter than five minutes, you will need to use a higher developer dilution or use it at a temperature lower than 20°C (68°F), but not lower than 18.3°C (65°F) or the developing agent may not respond.

Expansion: Still using the sample readings above, if the high and low meter readings are less than 4 stops apart, more than normal development is indicated to arrive at full scale negative/print. With a 3 stop difference and if you leave your low reading on Zone III, the high reading will "fall" on Zone VI—but you want it on Zone VII so a Normal-plus-one development (N+1) should be given. A 2 stop difference would require a N+2 development. N+1 can be arrived at by starting with 1-1/3 you normal development time, N+2 by about 1-1/2 your normal development time.

The following three contact sheets show what happens when negatives are developed normal, normal-minus, and normal-plus—and the effect on over-and-underexposed negatives. HC-110 developer was used, dilution B. Normal development was 7-1/2 minutes, minus-development was 4-1/2 minutes and plus-development, 9 minutes.

The contact prints were exposed for the minimum time required to obtain a solid black in a blank frame, on a normal-contrast paper.

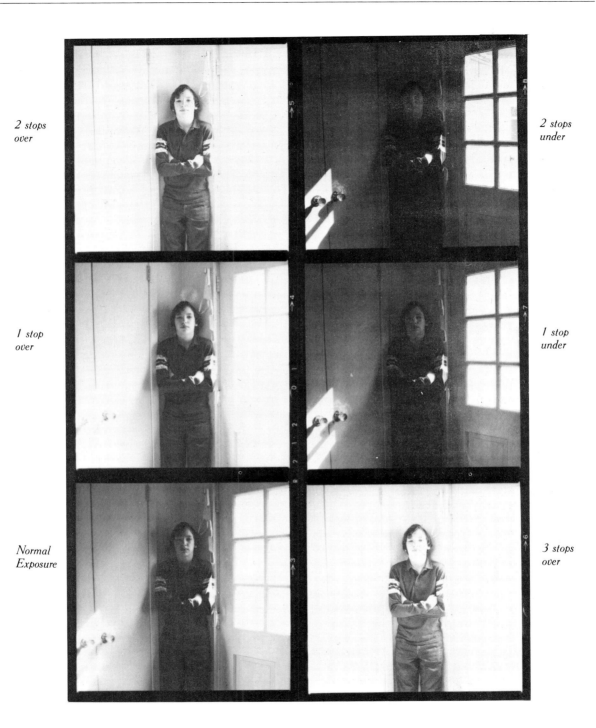

2 stops
over

2 stops
under

1 stop
over

1 stop
under

Normal
Exposure

3 stops
over

Normal Development

*2 stops
over*

*2 stops
under*

*1 stop
over*

*1 stop
under*

*Normal
Exposure*

*3 stops
over*

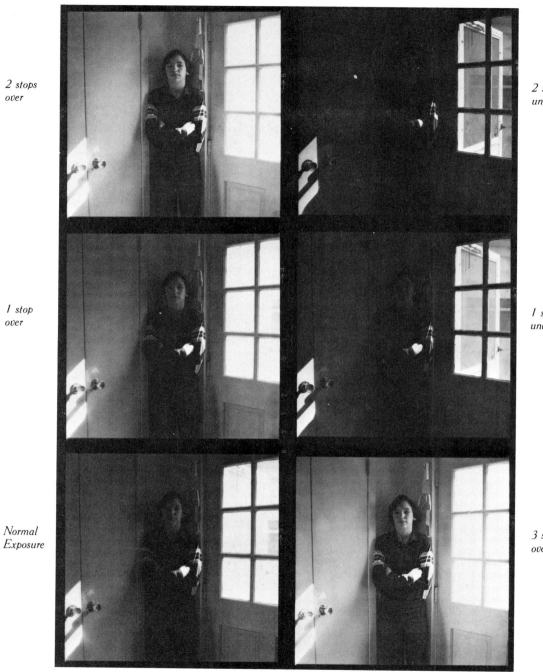

Normal-Minus Development

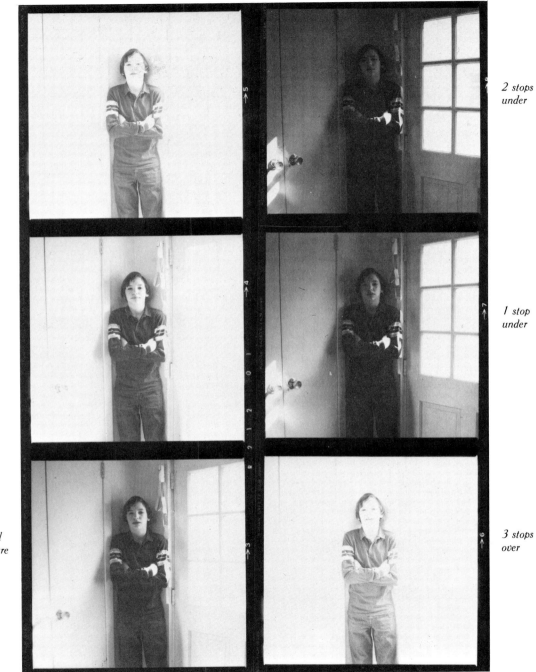

2 stops
over

2 stops
under

1 stop
over

1 stop
under

Normal
Exposure

3 stops
over

Normal-Plus Development

DEVELOPING SHEET FILM

Tray Development. Set up four trays. 20×25cm (8×10 in.) trays are recommended for 10×12cm (4×5 in.) film. Tray #1 contains plain water, #2 developer, #3 stop bath, and #4 fixer; all solutions should be at 20°C (69°F). The tray of water is used to presoak the negatives. (This step can be deleted if you develop only two or three sheets of film at one time but should be used when developing a complete filmpack.) The presoaking is helpful in separating sheets that sometimes stick together when slid into the water and in softening the emulsion for a more even absorption of the developer. Additionally, while it is possible to "feather" all 16 sheets of a filmpack in your hand at one time, it is best to break it up in 2 batches of eight.

The first batch is placed, emulsion side up, in the water, given 1 complete round of agitation, then the second batch is added (be sure to dry your hands before picking up the second batch of negatives). The 16 sheets are then given one more round of agitation, lifted out of the water in one stack and placed in the developer. (Add 30 seconds to the developing time to allow for replacement of absorbed water by developer.) While the negatives are in the developer, stopbath, and fixer they need to be *constantly* agitated to allow each negative to come in contact with fresh solution. Agitation is accomplished by sliding your fingers underneath the bottom sheet and bringing it to the top where it is dropped flat rather than at an angle, to avoid gouging the top sheet. Give the negative a slight push to be sure it is covered with solution and repeat with the next sheet. Negatives are transferred from one tray to the next, all together, in one stack: Move all negatives to a corner of the tray, tap them lightly so they line up; lift the stack, hold it at a slight angle for a few seonds of drainage, and place in the next tray.

Lastly, before you take a filmpack apart, or unload film holders, have a shallow box handy (the lid of a paper box, for example) to place your film in. Place the negatives emulsion side up — the side facing the paper backing in filmpacks — in a corner of the box; this way you can easily locate the negatives and avoid brushing them off your work surface when feeling around in the dark.

Remove film

Place sheets in tray one-by-one

Pull cap from film pack ⟶

Open pack ⟶

Remove paper backing sheets ⟶

Place sheets of film in your hand like a set of cards ⟶

To agitate, lift sheet of film from bottom

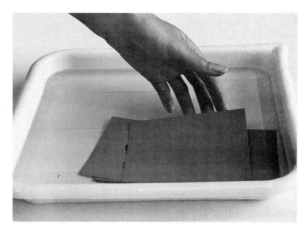

and place on top — repeat

TANK DEVELOPMENT

This method works better with the stiffer sheet film than with the thinner sheets of filmpack. The most difficult part is sliding the film into the holder, and care should be taken not to nick adjacent negatives when placing the holders back in the solution while agitating. As with tray development, agitation has to be constant. Holders are transferred from one solution to the next one-by-one in the same order as they were placed in the developer.

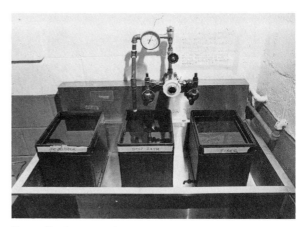

Bring all solutions to the proper temperature ⟶

Slide film into holder and close clip ⟶

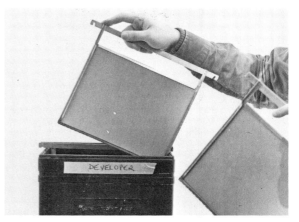

Place holders in the developer ⟶

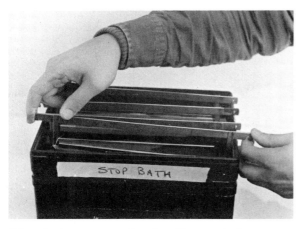

When development is complete place film in stopbath

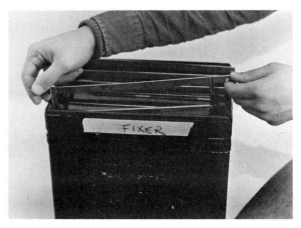

and fixer, transfer holders one-by-one ⟶

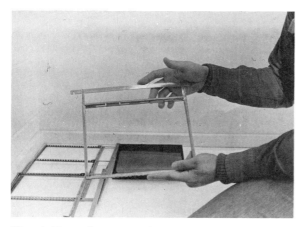

Place holders within easy reach ⟶

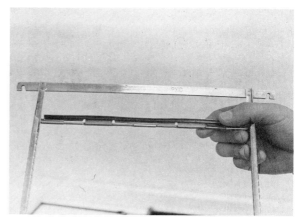

Press clip to open holder ⟶

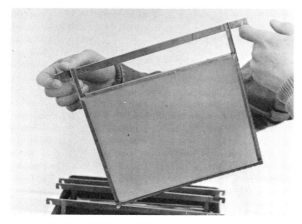

Agitate by lifting holder and tilting it

tilt in the other direction on the next round ⟶

Wash negatives thoroughly ⟶

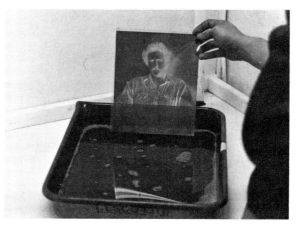

Treat with a wetting agent and hand to dry

SENSITOMETRY

Most photographers have little or no knowledge of *sensitometry* — the science of measuring the speed and contrast characteristics of photographic sensitive materials. In average photographic practice it is not necessary to have this knowledge but because all manufacturers' recommendations such as film speeds, paper characteristics and response, and optimum developing times are based on the application of sensitometry, it is helpful to have some idea what it is all about.

To measure and analyze the behavior of photographic emulsions, negative or positive, it is necessary to expose the material to be tested under *standardized, controlled conditions.*

The instrument used for this purpose is called a *sensitometer*. This device gives a series of exposures which are precise and repeatable. When developed, the resultant *step tablet* can be read on a *densitometer,* an instrument which allows the densities of each exposure to be noted as a numerical value.

After exposure, it is essential that the material be developed under accurately controlled conditions, indicating that time, temperature, agitation, and the developer meet rigid consistent specifications.

The numerical values given by the densitometer are written in ascending order (the emulsion under test having been exposed to gradual equally increasing quantities of light), and later, are plotted on graph paper to show the relationship between them, and the degree of exposure given to arrive at each density.

The graph is literally the portrait of a developed piece of developed film. The line that has been plotted is known as the *Characteristic Curve (H&D curve).* (The H&D curve is named after Hurter & Driffield, the originators of photographic sensitometry.)

The vertical part of the graph represents the degree of density, the horizontal part indicates the amount of exposure required to yield each density.

The amount of exposure is given in logarithmic terms because by so doing, the graph can be compressed to convenient dimensions. Sensitometers are frequently set up to produce half-stop, third-stop, or full-stop increments, depending upon the particular applications that are required. If, for the purposes of this discussion, we assume that we are dealing with a step wedge in which each exposure is twice that of the preceding one (one-stop increments), it means that the second stop is twice that of the first; the third is four times the first; the fourth is eight times that of the first, and so on.

Since there are over thirteen or fourteen exposures or more, to plot these values on a graph would require a piece of paper many yards long, and would result in a totally impractical graph. As an example, the fourteenth exposure would be 8,192 times the first exposure!

Using logarithms, however, 0 would represent 1; 1 would represent 10; 2 would represent 100; 3, 1,000; 4, 10,000 and so on, bringing the proportions of the graph down so that it may be easily interpreted without any danger of inaccuracy.

The characteristic curve tells a lot about the way a photographic emulsion behaves. If the emulsion being plotted shows a marked degree of density in those areas that have not been exposed (like the "clear" edges of film, for example), it means that the emulsion/developer combination under test produces a high level of chemical fog. This can be seen at the far left part of the graph, just before the beginning of the "toe" portion. If this section, on the other hand, is close to 0 on the graph, the fog level is low.

The section of the curve directly above the fog level is generally referred to as the "threshold". This is where photographic tones begin recording.

Emulsion speed can be determined by examining this threshold point. The closer the threshold point is to the beginning of the log exposure (horizontal) part of the graph, the more responsive to low light levels the emulsion is, and therefore the "faster" it is.

The straight line portion shows the level of contrast that can be expected from the emulsion: The steeper the rise of the straight line portion, the more contrasty the emulsion; and the degree of exposure latitude the emulsion will give (the longer the straight line portion extends across the horizontal part of the graph, the more latitude the emulsion has).

Differences in developing time, dilution and/or temperature will produce differently shaped graphs for the same emulsion; therefore the plotting of these graphs can be done to predict the response of any film or paper to changes in processing or exposure.

As mentioned earlier it is not necessary for a photographer to know, or to apply, sensitometry in order to use photographic materials effectively. However, if you want to pursue this subject further we refer you to *Photographic Sensitometry* by Todd and Zakia (Morgan & Morgan) or you can go back to the source of it all and refer to *The Photographic Researches of Ferdinand Hurter & Vero C. Driffield* published in a facsimile edition by Morgan & Morgan.

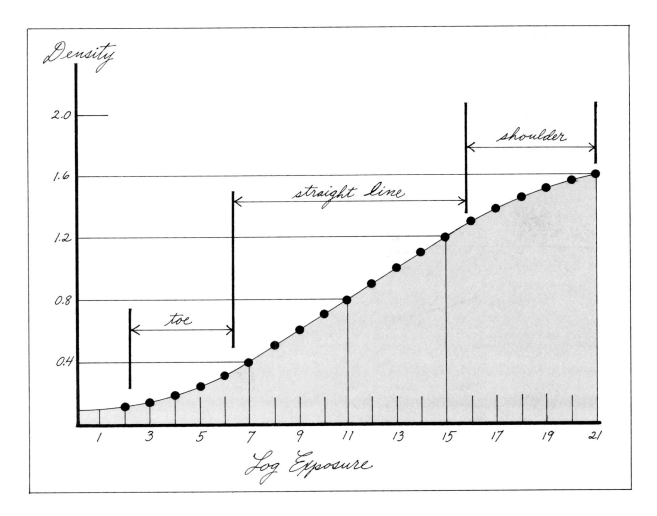

INTENSIFIERS AND REDUCERS

No matter how carefully you expose and process your negatives and prints, there will probably come a time when, through some mistake or oversight, you produce negatives that are too thin, or too dense, to print. This occurrence is always traumatic, but not always disastrous—sometimes, you can recover your images by using *intensifiers* to add density to thin negatives, and *reducers* to remove some of the developed silver from negatives that have been massively overexposed or over-developed.

Intensifiers. There are a number of different intensifiers, but they all have one thing in common—they can only increase density in a negative where some density (detail) exists already. No chemical can put detail into a blank area on a developed negative, so intensifiers should not be thought of as a magic elixir for salvaging impossibly thin negatives. All intensifiers will increase graininess and contrast as well.

Kodak Chromium Intensifier—this substance, prepackaged and sold in powder form, will intensify negatives without increasing their overall contrast as much as will some of the other intensifiers available. It works by leaving chromium deposits on the silver of the negative, thus making it more opaque. It is a process of bleaching and redevelopment. Part A of the package contains the bleach; Part B is used to clear the image.

Following the manufacturers' instructions, prepare the two solutions in separate containers and pour them into two clean, white trays (use white so that you can see what goes on).

Presoak your negative in *clean* water for about 10 minutes, then bleach them in solution A until the film turns yellowish tan in color.

Rinse the bleached film in water, then place into solution B; the negatives will turn from yellow to a milky white color. Agitate the negatives while they are in solution B. After about 2 minutes, remove the negatives, rinse, and redevelop the film using

Dektol (yes, Dektol) for about 10 minutes. Other developers, such as *Kodak* D-72 can be used, but Dektol is readily available and works as well as any developer. *Do not* use standard *film* developers such as D-76—they will destroy the image.

By varying the redevelopment time, you can exert some control over the amount of intensification —but not by much.

Caution: The chemical agents in *Kodak* Chromium Intensifier are poisonous—mix the solution away from all foodstuffs and cooking utensils; and wear gloves, or use tongs, while bleaching and clearing.

Formulas for other types of intensifiers can be found in Chapter 11.

Reducers. There are 3 main types of reducers: All work by removing silver from the image.

Subtractive reducers are designed to remove silver from negatives that are either overexposed or have a very high fog level. Grain is increased, but the overall contrast level of the negative remains the same, since reduction takes place at the same rate in highlight and shadow areas. The best known of this type of reducer is *Farmer's Reducer*. It consists of a mixture of potassium ferricyanide and fixer (sodium thiosulfate), and can be bought in prepackaged form.

After you have mixed the solutions and presoaked your film, pour the reducer into a clean white tray, immerse the negative to be reduced, and agitate continuously. Examine the negative often, and rinse it in running water *just before* you get the degree of reduction that you are after.

Remember that once you have removed density by reduction, there's very little you can do about getting it back—so be cautious.

Caution: Potassium ferricyanide is poisonous. Be careful.

Proportional Reducers will remove more silver from highlight areas than from shadow areas of a negative: This makes them ideal for use on *normally exposed but overdeveloped* negatives that are too dense and too contrasty. Proportional reduction

will lower the overall contrast of a negative somewhat.

One rather easy to make proportional reducer is prepared by mixing fresh rapid fixer, hardener included, with about 15 ml (1/2 oz) lemon juice (if you use reconstituted lemon juice to do this, use one without preservatives). Reduction by this method takes a long time—at least one-half hour—but the chemicals are safe if used with normal caution, and the ingredients are readily available. In effect, what you are doing by using this method is to indulge in a little "controlled over-fixing". The results will provide you with a more easily printable image, but you do run the risk of ending up with an impermanent negative.

KODAK R 5 PROPORTIONAL ACID PERMANGANATE PERSULFATE REDUCER

Solution A:

Water	1.0 liter
Potassium Permanganate	0.3 gram
Sulfuric Acid 10% sol.	16.0 ml

(A 10% solution of Sulfuric acid is made by *slowly* adding 1 part concentrated acid *into* 9 parts water, stirring gently. *Be very careful. Sulfuric acid is dangerous.)*

Solution B:

Water	3.0 liters
Potassium Persulfate	90.0 grams

To use this preparation, add 1 part A to 3 parts B. Make sure that your negative has been well washed and pre-hardened (see formula for hardener below). Immerse the negative in the reducer, and agitate gently until you get the desired result. Take your negative out and place it in a clearing bath, made by preparing a 1% sodium bisulfite solution. When the negative has cleared, wash thoroughly and gently wipe it down before hanging to dry.

HARDENER FORMULA KODAK SH-I

Water	500.0 ml
Formaldehyde 37% sol.*	10.0 ml
Sodium carbonate (monohydrated)	6.0 grams
Water to make	1.0 liter

*37 parts formaldehyde to 63 parts water

Mix in the order given. Harden negatives for about 3 minutes, then rinse in water, fix in fresh acid fixer for 5 minutes, and wash thoroughly.

Superproportional Reducers will remove silver from dense areas of a negative, while leaving shadow areas relatively untouched. Therefore, this type of reducer works best on *underexposed and overdeveloped* negatives. Contrast is lowered to a greater degree than it is with a proportional reducer, and shadow areas will retain more easily printable densities. One of the easiest superproportional reducers to mix and use is DuPont 3-R, the formula for which is:

Water	1.0 liter
Ammonium persulfate	60.0 grams
Sulfuric acid	3.0 ml

This will provide you with a stock solution which has to be diluted 1:2 with water for use. Reduce the image until you *almost* have the effect that you want—then put the film immediately into a fresh acid fixing bath for about 3 minutes, and wash thoroughly.

Caution: When using acids, be extremely cautious not to spill or drip any on yourself. If this happens, rinse with free flowing water and call a doctor. NEVER add concentrated acids to water by pouring them in fast—do it slowly—and *under no circumstances* should you add water to acid. Always put the acid *into* water.

FILM DEVELOPERS CHART

Agfa Rodinal

Agfa Rodinal liquid concentrate to be diluted for
one-time use. It is based on the developing agent
Paraminophenol. It produces brilliant negatives
with extremely high acutance and good enlargeabil-
ity of slow emulsions. Rodinal can be used with
fast films such as Tri-X or HP5 as well, although
some might find the resulting grain pattern to be a
bit coarse. The pattern is so well-defined and crisp
that it more often than not improves the apparent
sharpness of the image — and only becomes obstru-
sive when the negative is enlarged to $20 \times$ or
more.

Rodinal has been around for many years and has
long been a favorite of photographers who prefer
"sharpness" to "fine grain" in their images.

The working dilutions of Rodinal can be varied
to change the degree of contrast you want in your
negatives. See the following table for some basic
guidelines.

Dilute Rodinal concentrate with water at working temperature as indicated below:

Exposure Index	Subject Contrast	Dilution	Time in minutes		
			18C (65F)	20C (68F)	22C (72F)
25-50	Normal	1:100	19-24	16-20	13-16
	Low	1:75	18-22	15-18	12-14
	High	1:100	12-14	10-12	8-10
100-125	Normal	1:75	17-19	14-16	11-13
	Low	1:50	19-22	16-18	13-14
	High	1:75	14-17	12-14	10-11
200-250	Normal	1:50	14-17	12-14	10-11
	Normal	1:20	9-12	8-10	6-8

Here are some more specific recommendations for two of today's most commonly used film types: *Kodak* Plus-X and Ilford FP4. Dilute Rodinal concentrate with water at working temperature, as indicated below.

Exposure Index	Light Intensity	Subject Contrast	Dilution	Time in minutes		
				18C (65F)	20C (68F)	22C (72F)
80	Bright	Highest	1:100	12.5	10.5	8.5
125	Bright	High	1:100	13.75	11.5	9.25
160	Bright	Moderate	1:75	13.75	11.5	9.25
400	Bright	Low	1:50	14.5	12	9.5
400	Dim	High	1:75	15	12.5	10
400	Dim	Moderate	1:50	15.5	13	10.5
600	Dim	Low	1:50	16.75	14	11.25
800	Very Dim	High	1:75	18	15	12
800	Very Dim	Low	1:50	19.75	16.5	13.25
200	Normal	Moderate	1:85	— 12 minutes at 24°C (75°F)—		

Kodak Tri-X film development in Rodinal (also applies to Ilford HP4 and HP5)

Exposure Index	Light Intensity	Subject Contrast	Dilution	Time in minutes			
				18C (65F)	20C (68F)	21C (70F)	22C (72F)
250	Bright	High	1:85	16.75	14		11.25
400	Bright	Moderate	1:75	17.5	14.5	13	11.5
400	Bright	Low	1:50	17.5	14.5		11.5
600	Dim	High	1:75	18.5	15.5		12.5
800	Dim	Moderate	1:50	19	16.5		13.25
1200	Very Dim	High	1:65	21	17.5		14
1600	Very Dim	Low	1:50	22.5	18.5		14.5
3200	Very Dim	High	1:65	24	20		16
6400	Very Dim	Low	1:50	25	22.5		20
800	Available Light	Moderate	1:100	—17.5 minutes at 24°C (75°F)—			

Acufine

High acutance, fine grain developer, available in powder form. (Can be replenished.) The manufacturer claims that an increase in effective film speed is possible with this developer. For best results Acufine should be mixed in distilled water. Agitation should be very gentle (about 5 sec. every minute—one or two inversions of the tank). If you use a cold-light enlarger head, you should increase the recommended developing times by 20-25%. Full mixing instructions and developing times for various films are included with each package. The most common times, temperatures and films are listed below.

Film	Exposure Index	Subject Contrast	Time in minutes		
			20C (68F)	21C (70F)	24C (75F)
Kodak Panatomic-X	100	Average	3.75	3.5	2.75
Ilford Pan F	64	Average	2.25	2	1.75
Kodak Plus-X	250	Average	4.5	4	3.25
Ilford FP4	250	Average	4.5	4	3.25
Kodak Tri-X	1000	Average	5.25	5	4
Ilford HP4 or 5	800	Average	6.5	6	4.75

Acu—1

Similar to Acufine—gives even higher exposure indices. Supplied in powder form, and intended for one-time use. As with Acufine, care must be taken in agitating, and in using mineral-free or distilled water for mixing the solution. Here are the times and temperatures for Acu—1:

Film	Exposure Index	Dilution	Time in minutes				
			20C (68F)	21C (70F)	24C (75F)	27C (80F)	30C (85F)
Kodak Tri-X	1200	1:5	11	10	8	6.5	5
Kodak Plus-X	225	1:10	10	9	7	5.5	4.5
Kodak Panatomic-X	100	1:100	6.25	5.25	5	5	3.25
Ilford HP4	1000	1:5	13.5	12.5	10	8	6.5
Ilford FP4	250	1:10	10	9	7	5.5	4.5
Ilford Pan F	125	1:10	6.25	5.5	5	4	3.25

Autofine

A replenishable fine-grain developer with low-fogging properties, to be used with film exposed at film manufacturers recommended speeds. Distilled water should be used for mixing the stock solution. Read manufacturer's instruction for replenishment. Autofine produces negatives with quality, if used carefully.

Film	ASA Rating		Time in minutes			
			18C (65F)	21C (70F)	24C (75F)	27C (80F)
Kodak Tri-X	400	}	11	8.75	7	5.75
Ilford HP4	400					
Kodak Panatomic-X	32	}	9.5	7.5	6	4.75
Kodak Plus-X	125					
Ilford FP4	125					
Ilford Pan F	50		6.5	5	4	3.25

Beseler UltraFin FD1

Liquid concentrate to be diluted for one-time use. FD1 is designed to produce a 1 stop film speed increase with slow and medium speed films. The formula acts like a compensating developer, allowing shadow areas to develop properly while stopping highlight areas from "blocking up". Do not use this developer with high speed films — use UltraFin FD2 instead (see below).

Film	Exposure Index	Time in minutes*		
		20C (68F)	22C (72F)	24C (75F)
Ilford Pan F	100	10	9	7.5
Kodak Panatomic-X	64	12	10.25	9
Ilford FP4	250	15	13.5	11.25
Kodak Plus-X	250	15	13.5	11.25

*Times indicated apply to development of two rolls of 35mm film (or 1 roll of 120) in a 2 reel tank, or 1 roll in a single reel tank. If you are developing 1 roll in a 2 reel tank (and therefore in twice as much solution), decrease development times by about 20%.

Beseler UltraFin FD2

Beseler's developer for a film speed increase with high speed films. Similar to FD1 in that it is a surface-acting, compensating type developer.

The times given below apply to 2 rolls of 35mm film of 1 120 roll processed in a 2 reel tank; decrease times by 20% for development of 1 35mm reel in a 2 reel tank.

Film	Exposure Index	Time in minutes			
		18C (64F)	20C (68F)	22C (72F)	24C (75F)
Ilford FP4	250	10	9	8	6.25
Ilford HP4	800	24.5	22	19.75	16.25
Kodak Plus-X	250	11	10	9.5	7.5
Kodak Tri-X	800	16.5	15	13.5	11.25

Beseler UltraFin FD5

This developer is a liquid concentrate, giving excellent acutance and as long a tonal scale as anyone could hope for. The developer is designed for processing films exposed at the normal recommended speed. Results obtained with this solution are sparkling and sharp, and produce negatives from which truly fine prints can be made.

Film	Exposure Index	Dilution	Time in minutes			
			18C (64F)	20C (68F)	22C (72F)	24C (75F)
Ilford Pan F	50	1:20	7.75	7	6.25	5.25
Ilford FP4	125	1:20	10.75	9.75	8.75	7.25
Ilford HP4	400	1:20	15.5	14	12.5	10.5
Kodak Panatomic-X	32	1:20	10.75	9.75	8.75	7.25
Kodak Plus-X	125	1:20	15.5	14	12.5	10.5
Kodak Tri-X	400	1:20	24.5	22.5	20	16.75
Kodak H.S. IR	Test	1:20	9.5	8.5	7.5	6.25
Ilford Pan F	50	1:30	13.25	12	10.75	9
Ilford FP4	125	1:30	19.75	18	16.75	13.5
Ilford HP4	400	1:30	28	25.5	23	19
Kodak Panatomic-X	32	1:30	18.25	16.5	14	12.25
Kodak Plus-X	125	1:30	29.75	27	24.25	20.25
Kodak H.S. IR	Test	1:30	16.5	15	13.5	11.25
Kodak Tri-X			— — — Not recommended — — —			

Ethol T.E.C.

A compensating developer, available in both powder and concentrated liquid form. T.E.C. is primarily designed for use with slow and medium speed films, though decent results can be gotten with this formula on high speed films as well. The manufacturer claims at least a one or one and a half stop increase in film speed, and recommends that Tri-X be exposed at an E.I. of 1000 in daylight, 800 under tungsten (Photoflood) light.

The liquid concentrate is used by diluting it 1:15 in water. Diluted developer must be stored in the refrigerator, in a tightly stoppered bottle. Throw it out if and when it turns brownish. T.E.C. cannot be replenished.

The powder version of T.E.C. comes in two parts. Part A should be dissolved in a half gallon of pure or distilled water; Part B is dissolved in a separate half gallon of equally pure water. To develop film, take 1 part each of A and B, and add to 14 parts of water. Use one time and discard.

The following table gives development times and temperatures for some of the more commonly used films. Tables for other films are supplied with the developer.

				Time in minutes		
Film	Exposure Index Day	Exposure Index Tungsten	Dilution	18C (65F)	21C (70F)	24C (75F)
Kodak Pan-X	80	64	1:15	6.25	5.5	4.25
Ilford Pan F	64	50	1:15	7.5	6.5	5.5
Kodak Plus-X	400	320	1:15	15	12	9.75
Ilford FP4	320	250	1:15	11.25	10	8.75
Kodak Tri-X	1000	800	1:15	16	12	9.5
Ilford HP4	1000	800	1:15	16.5	15	13.75
H&W VTE Pan	80	64	1:30	NR	10	NR
H&W VTE Ultra	25	20	1:45	23.5	20	27

Ethol Blue

Ethol Blue is a liquid concentrate that has long been a favorite of those who like the look of news photographs — grainy, without too much shadow quality (although a reasonable amount of information can be gotten in shadow areas, it is difficult to arrive at properly printable separation of closely related tones). Certain images take on an added dimension of immediacy when processed in a developer like this one; though if full tonal scale and unobtrusive grain pattern is what you are after, you will probably do better with a general purpose developer like *Kodak's* D-76. Ethol Blue is of most use if you photograph in extremely dim light situations, or at theatrical and dance events. Ethol's recommendation for Tri-X is E.I. 400 to 2400, depending on developer dilution and processing time. Obviously, the higher you rate your film, the less image quality you will get out of it. Here is a developing time/temperature table for some of the more commonly used films:

Ethol Blue (see description previous page)

Film	Exposure Index Day	Exposure Index Tungsten	Dilution	Time in minutes		
				18C (65F)	21C (70F)	24C (75F)
Kodak Panatomic-X*	64	50	1:60	4.5	3.75	3
Kodak Panatomic-X	80	64	1:120	8	7	6
Kodak Panatomic-X	125	100	1:60	7	5.5	4.75
Ilford Pan F	80	64	1:60	5.25	4.5	3.75
H&W VTE Pan	32	25	1:90	6.25	5.5	4.75
Kodak Plus-X*	400	320	1:30	3.75	3	2.5
Kodak Plus-X	400	320	1:60	6	5	4.25
Ilford FP4	320	250	1:30	3.75	3	2.5
Ilford FP4	320	250	1:60	7	6	5
Kodak Tri-X	400	400	1:60	6	5.5	5
Kodak Tri-X	1600	1280	1:30	7.5	5.25	3.75
Kodak Tri-X*	2000	1600	1:30	7.75	6	4.75
Kodak Tri-X	2400	2000	1:30	8.25	6.75	5.5
Ilford HP4	1200	1000	1:30	8.25	6.5	5
Ilford HP5						

*Indicates manufacturer's suggested combination of optimum results

H&W Control 4.5

4.5 is a liquid concentrate made especially for use with very thin emulsion, high resolution films like H&W VTE and VTE Ultra. These films, carefully exposed and processed in 4.5 developer, will provide you with 35mm negatives from which grain free, phenomenally well detailed, mural sized enlargements can be made.

4.5 should be diluted in pure water, but there is no real need for distilled water. Dilute one capful of concentrate into 8 oz. of water for each roll of film. The resultant mixture may appear slightly yellowish which is normal.

Do not store the developer concentrate in the refrigerator. Keep the concentrate away from air by emptying partially full containers into smaller ones. Keep all containers tightly stoppered, and away from areas colder than 40°F, or warmer than 70°F. If you notice thin crystals in the concentrate, redissolve them by immersing the container into hot water for a few moments.

Dilute the concentrate just before using, and use it once only.

The following table applies equally to VTE pan and VTE Ultra:

ROLL SIZE	Time in minutes		
	18C (64F)	20C (68F)	23C (73F)
36 exp	5.5	4.5	3.5
20 exp	5.25	4.25	3.20

Note: development times are critical. There is no margin for error. Agitate gently for the first 10 seconds of development, then for 6 seconds every half minute. Empty your tank quickly when development time is completed. Rinse briefly in water *at the same temperature* as the developer, then fix in a non-rapid fixer. VTE films fix rather quickly (about 45 seconds in fresh fix), and should not be allowed to remain in fixer for longer than 2 minutes. Wash normally. Pay close attention to the instructions packed with the film *and* the developer.

Ilford ID-11 and *Kodak* D-76

ID-11 is essentially the same formula as *Kodak* D-76. Either of the two will produce equally excellent results with almost any black and white film. This developer formula is the one used as a standard against which other developers are measured. ID-11 and D-76 produce full emulsion speed, excellent shadow detail, fine, crisp grain and very low fog levels, even with extended development. The quality of properly exposed negatives developed in either of these solutions is exceptional.

Both ID-11 and D-76 are supplied in powder form. The stock solution can be used straight, or diluted with one part water. (1:1 dilution can only be used once; straight solution can be replenished.)

Film	Exposure Index	Dilution	Time in minutes				
			18C (65F)	20C (68F)	21C (70F)	22C (72F)	24C (74F)
Kodak Panatomic-X	32	straight	6	5	4.5	4.25	3.75
Kodak Panatomic-X	32	1:1	8	7	6.5	6	5
Ilford Pan F	32	straight	6.25	5.5	5	4.75	4.25
Ilford Pan F	32	1:1	8	7	6.75	6	5.5
Kodak Plus-X	125	straight	6.5	5.5	5	4.25	3.75
Kodak Plus-X	125	1:1	8	7	6.5	6	5
Ilford FP4	125	straight	7	6	5.5	5	4.75
Ilford FP4	125	1:1	8.75	7.5	7	6.25	5.75
Kodak Tri-X	400	straight	9	8	7.5	6.5	5.5
Kodak Tri-X	400	1:1	11	10	9.5	9	8
Ilford HP4,5	400	straight	8	7	6.74	6	5.5
Ilford HP4,5	400	1:1	14	12	11	10	8.75

Ilford Microphen

Microphen is Ilford's fine grain developer. Films to be processed in Microphen should be rated somewhat higher than the manufacturer's recommended speed. Ilford suggests an increase of one half stop. Microphen is lower in alkalinity than most general purpose developers, and therefore does not promote grain clumping; grain size is consequently smaller. Microphen is supplied in powder form, and can be diluted 1:1 or 1:3 from the stock solution. Development times can be increased over the indicated times to provide negatives with more contrast. Best results are obtained at 20°C (68°F). This developer gives good acutance and excellent rendition of subjects with a long tonal range, especially when it is used in one of the working dilutions. In its straight form, Microphen can be reused. 20 oz. of developer will properly develop up to six 36 exposure rolls of 35mm film in succession, provided that you increase processing time by 10% for each additional roll. A replenisher is also available.

Ilford Michrophen (see description previous page)

Film	Exposure Index	Time in minutes at 20°C (68°F)		
		Straight	1:1	1:3
Pan F	80	3	4	7
FP4	200	5.5	7	8.5
HP4,5	650	5	9	18

These times are recommendations only, and may have to be adjusted. Run your own tests. Use these times as starting points for establishing development times for Kodak films as well; Rate Tri-X at 650, Plus-X at 200, and Panatomic-X at 50. Then use Pan F development times for Panatomic-X; FP4 times for Plus-X; and HP4 times for Tri-X.

Ilford Perceptol

Perceptol is a powder type developer especially designed for high acutance and very fine grain. Results gotten on Tri-X and HP4 with this developer will be noticeably less "grainy" than those gotten on the same films with standard developers. In order to get the best results using this product, you will need to give your film one half to one stop more exposure. Use the following table as a guideline:

Film	Exposure Index	Time in minutes at 20°C (68°F)		
		Straight	1:1	1:3
Pan F	25	8.5	NR	NR
Pan F	32	NR	10.5	13.5
FP4	64	8	NR	NR
FP4	100	NR	9	13
HP4	200	8.5	NR	NR
HP4	320	NR	12	NR

Kodak D-76 See Ilford ID-11.

Film	Dilution	Time in minutes				
		18C (65F)	20C (68F)	21C (70F)	22C (72F)	24C (75F)
Panatomic-X	straight	8	7	6.5	6	5
Panatomic-X	1:3	NR	NR	11	10	8.5
Plus-X	straight	8	7	6.5	6	5.5
Plus-X	1:3	NR	NR	11	10	9.5
Tri-X	straight	11	10	9.5	9	8
Tri-X	1:3	NR	NR	15	14	13

Kodak HC-110

HC-110 is a highly concentrated liquid developer, capable of producing brilliant negatives with extremely good tonal rendition and sharpness. In its concentrated state, it will keep for years. Though its "thickness" may make it difficult to measure out in small amounts at first, you will soon get the hang of it, especially if you enlist the aid of a graduated eye dropper or pipette. HC-110 produces a grain structure that is noticeable, but extremely well defined, leading to a great degree of apparent sharpness in your images (not unlike Rodinal). Zone System afficionados like this developer very much, and with good reason. HC-110 is generally used in one of two dilutions: Dilution A is 1 part concentrate to 15 parts water; Dilution B is 1 part concentrate to 31 parts water.

Film	Dilution	Time in minutes				
		18C (65F)	20C (68F)	21C (70F)	22C (72F)	24C (75F)
Tri-X	Dilution A	4.25	3.75	3.25	3	2.5
Panatomic-X	Dilution B	4.75	4.25	4	3.75	3.25
Plus-X	Dilution B	6	5	4.5	4	3.5
Tri-X	Dilution B	8.5	7.5	6.5	6	5

Many more developers are on the market than those we have listed here. We have tried to present you with a choice, listing the most notable examples of each developer type that we feel may be of interest to you. Careful use of any of the items listed above will provide you with eminently printable negatives. The ultimate decision is yours — try a few of them, learn their idiosyncracies, and then settle on the one that provides you with negatives *you* find easiest to produce expressive prints from.

Replenishers. Replenishers are developer-like solutions used to extend the working life of certain film developers and contain much the same ingredients that their respective developers do, but in greater concentrations. They are readily available for many of the more popular film developers such as *Kodak* D-76, Microdol, HC-110 and Ilford Microphen. Replenishers offer some advantages — but at the cost of a certain degree of consistency and predictability.

One time use of full strength developer is expensive and reusing it requires a 10% or so increase in development time for each additional roll. This means that from the second roll on, you are subjecting your film to a developing solution that is becoming progressively slower acting and less contrasty — bromides build up in the solution due to development, and begin to act as restraining agents; the developer becomes more oxidized with each additional use.

Replenishment allows the full-strength developer user to maintain a standard development time; for each roll of processed film, a small amount of replenisher is added to the developer. Theoretically, this brings the developing solution back up to full strength, and prolongs its useful life indefinitely. Unfortunately, practice is somewhat different from theory. Since replenishers do little to control oxidation of the developer itself, replenished solutions become gradually softer-working and less "contrasty" as they are used more and more. The changes are subtle — you may not notice much of a difference from one roll to the next, but as time goes on there will be a definite decrease in the contrast of your negatives. If you are after high quality, repeatable results, you should use your developing solutions one time only.

Another problem that can arise from the use of replenisher, or re-use of stock solution developers, is that of contamination. Unless you are extremely meticulous in your cleaning, and unless you use distilled water to mix the replenisher solution, you may end up contaminating and ruining not only the solutions, but your developing film as well.

Replenishers are useful in large volume, commercial applications, and for those times when consistency of result is not a must. In most other cases, you would be better off diluting your developer and using fresh solutions for each batch of film you process.

Fine Tuning the Print

A first step to learning how to produce a high-quality photographic print is to look at as many *exhibition* prints as you can find. Magazine or even most book reproductions will not tell you enough. There is a world of difference between a fine original print on photographic emulsion and a reproduction of it in inks, no matter how well done the reproduction may be.

Go to all the outlets for photographic art in your area—art galleries, museums, libraries and so on—and carefully study the prints you see. Get in touch with other photographers living nearby and look at their work. Only by doing this can you come to know the power and beauty photography is capable of, and only by seeing what is possible in printmaking can you begin to do full justice to your negatives.

CHEMICAL MANIPULATION

The physical appearance and quality of a photograph can be altered and sometimes improved by chemical, as well as physical, means. Alterations in the dilution of print developers can change the way tones appear on the paper; changes in developer temperature or time can cause changes in contrast and tonal distribution of a print; and certain metallic toners can be used to change the basic image tone of papers.

Developer Dilution. Changing the recommended dilution of developers can cause a slight increase or decrease in the contrast range of graded photographic paper. For instance, if a photograph calls for a little more contrast than can be obtained on Grade 2 paper with normal processing, but not as much as Grade 3 would normally give, a more dilute developing solution used with the Grade 3 might give the effect that was wanted. If the image comprises mostly dark tones, a print on Grade 2 paper, using a slightly more concentrated developing solution, might be the best answer.

Photographic subjects, photographers' styles and tastes, and the characteristics of different negatives and different papers are so varied that no hard-and fast rules should be given for specific changes in solutions, exposure compensation, and so on. Methodical, interpretive experimentation will allow you to find the right adjustments for *your* photographic circumstances and tastes.

There is one instance, however, where a specific recommendation can be given about adjusting developer dilution. Those who use warm-toned chlorobromide enlarging papers (such as Agfa Portriga Rapid) may have found certain emulsion batches to have a rather unpleasant-looking greenish cast. Often paper can be restored to its original brown-black image tone by giving a slight overexposure and developing in a 1:1 dilution of Dektol for 1-1/2 minutes instead of the recommended 2 minutes.

Occasionally a stubborn highlight can be persuaded to show some detail: Carefully apply straight, *undiluted* developer to the area with a cotton wad or a warm finger. But this should be a last-resort rescue for an area that should have been burned in more during printing.

Developer Temperature. Developing agents, like most photographic chemicals, need to reach a certain level of temperature to be effective. Hydro-

quinone, found in most contemporary print developers, will not function in any useful way below about 15.5°C (60°F) and will react with exposed silver halides very poorly at temperatures below 18.3°C (65°F). In view of this, 20°C (68°F) to 21.1°C (70°F) should be used for optimum results.

Some photographers extoll the virtues of hot developer to "bring in" highlight "hot spots" areas in a print. While this might occasionally work, usually however, only gray, distressed-looking areas appear where highlights ought to be. The same is true of rubbing with the hands, or of rinsing or dipping stubborn highlights in hot water to make them more "receptive". These emergency procedures may be useful to newpaper lab workers to whom time is a constant enemy and the image, not the print itself, is vital; but they are best kept to a minimum by anyone interested in a fine print. *Slight* increase in developer temperature—say, 2° to 5°F—can be attempted to alter the warmth or coolness of shadow tones in a print, especially with neutral and warm-toned papers. Contrast is also affected to some degree.

Cold-tone and Warm-tone Developers.

Developers such as Dektol, Ektaflo Type 1, Bromophen, and Versatol are primarily designed for use with neutral and "cold" papers. Other developers, Selectol Soft and Ektaflo Type 2, for instance, are formulated to give softer, warmer results, especially with warm-toned papers like Portriga Rapid and Ektalure.

Using Dektol ("cold") with Portriga Rapid ("warm"), or Ektaflo Type 2 ("warm") with Kodabromide ("cold") makes it possible to modify the base and image tones of prints to some degree: Portriga becomes a little cooler in appearance when developed in a solution such as Dektol, while Kodabromide and Ilfobrom both take on a more "pearly" appearance, especially in the middle tones, when developed in warm-tone developers.

Two-Solution Developers:

Two-solution formulas offer the printer subtle control over the contrast of the photographic print. By altering the amount of either the "soft" (metol) or "hard" (hydroquinone) portion of the formula, gradations of one-quarter step within a single paper grade can be obtained.

The best known of this type of developer is the Beers Solution. Although there are slight variations in published formulas, the following is a representative version.

SOLUTION A

Water 52°C (125°F)	750 cc
Metol	8 grams
Sodium Sulfite	23 grams
Sodium Carbonate	20 grams
Potassium Bromide (10% sol.)	11 cc
Water to make	1000 cc

SOLUTION B

Water 52° C (125°F)	750 cc
Hydroquinone	8 grams
Sodium Sulfite	23 grams
Sodium Carbonate	27 grams
Potassium Bromide (10% sol.)	11 cc
Water to make	1000 cc

Mix chemicals in the order given, then mix the two solutions with water, in the proportions given below for the contrast range desired.

CONTRAST	LOW		MIDDLE			HIGH	
Sol. A	8	7	6	5	4	3	2
Sol. B	0	1	2	3	4	5	14
Water	8	8	8	8	8	8	0

If you do not want to mix the chemicals yourself, similar results can be obtained by combining a prepackaged "soft" developer such as *Kodak* Selectol-Soft with a "hard" developer such as *Kodak* Dektol. Make the stock solutions, label them A & B respectively, and use them as you would the Beers.

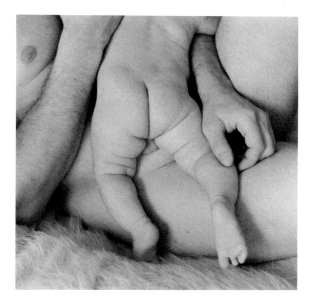

The straight print (left) is enhanced by considerable burning-in of the four edges of the print and some dodging of the baby's figure.

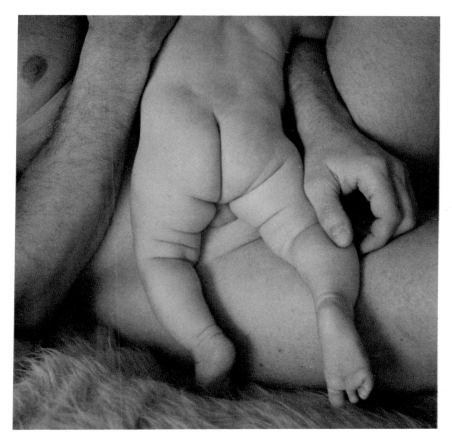

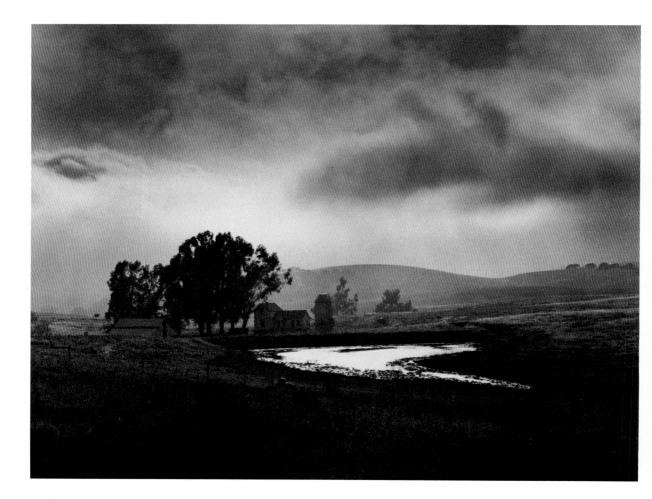

It is easy to overdramatize in printing, especially in landscape photography. The sky (and foreground, somewhat) in the print above is burned-in too much, resulting in an exaggerated and heavy effect.

In the print opposite, the burning-in has been reduced—the result is more natural and approximates the beautifully soft, fog-filtered light of the original scene.

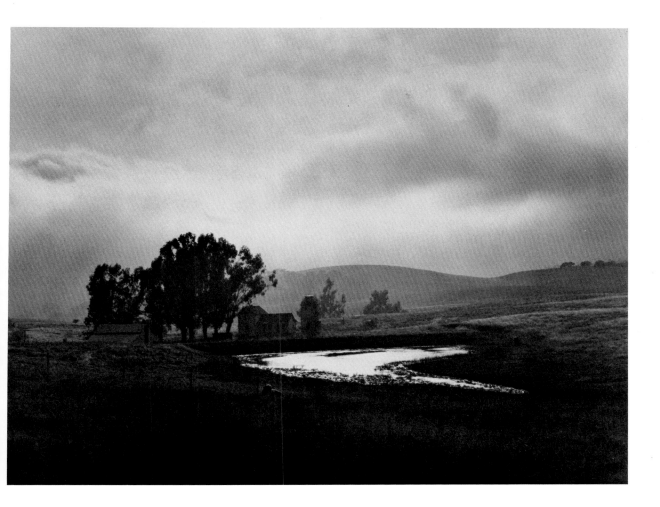

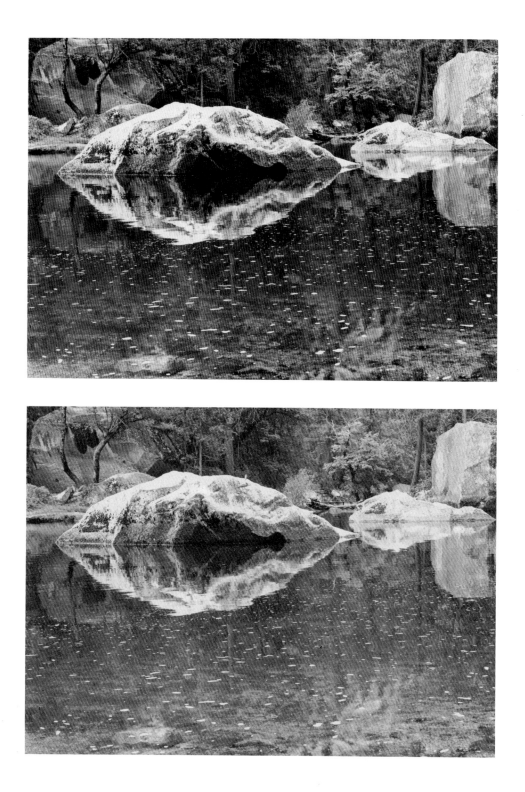

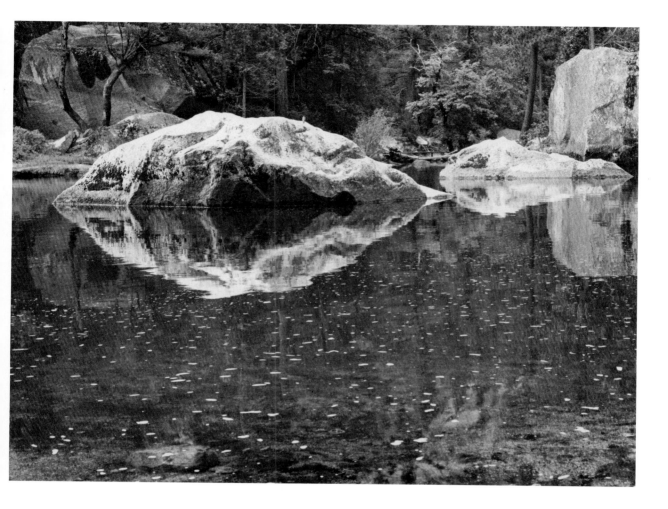

An example of two-solution development. The print opposite (top) was developed in Dektol 1:2. The print on the bottom in Selectol-Soft 1:1. The print above was developed in Selectol-Soft for 1 minute and 15 seconds and then in Dektol for 1 minute. (Exposure for the three prints was identical.) The effect is subtle and more noticeable in a larger print. However, in the print above shadows hold a little more detail and highlights are softer as compared to the print developed in Dektol only.

Above is an example of an image that just did not work: It was an attempt to use the spotted sunlight in a forest to make a portrait. However, there was "something" there that made it difficult to give up on the negative.

Extensive cropping, and a slight tilting of the enlarging easel during exposure (place a box or other solid object under one edge of the easel and adjust your focusing), resulted in the expressive portrait opposite.

Overleaf: Careful and controlled use of a dodging tool (bottom) can put light in an image where there was none (top).

Another method for using two-solution developers is to set up a tray with Sol. A mixed for low contrast, Sol. B mixed for high contrast. (However, if you use Selectol-Soft, dilute the stock solution 1-1, Dektol 1-3.)

Place your print in Sol. A first and develop until the high and middle values approach the tone and detail you want, then transfer the print to Sol. B to "snap up the blacks". If the print is left too long in the second tray, the whole print may become too contrasty; if left too long in the first tray, Sol. B just may not have much effect. There are no set guidelines to using this technique but it is worth experimenting with.

Chapter 11, Fine Tuning the Chemistry, gives more details on the effects of the various elements in the developer and how more, or less, of one of these elements affects the final print. It also gives a number of formulas to try for those who want to experiment further.

Pulling a print out of the developer before development is completed (often, as in the example above, because of excessive exposure in the enlarger) results in mottled grayish prints. Cut down on the exposure and develop fully.

Toning for Print Color. The basic image tone of any photographic paper can be altered with the use of various chemical toning agents. Some of these, such as gold or selenium toners, supplant the metallic silver in photographic emulsions with their own metals or cause their metals to become adsorbed onto the silver. This makes the photographic emulsion more stable; it may also change the hue or the image tones of the prints to some degree. Gold toner works best with cold-tone papers, enriching the shadows and lending a steely, blue-black tint to them. Selenium toner gives a very slight overall purplish hue to the print, especially when used on warm tone papers. If selenium toning is carried out for an extended period, the image can become a rather garish red, so care must be taken not to overtone. And different papers react to it entirely differently.

Toning procedures are given in Chapter 7, Processing for Permanence—and additional toner formulas can be found in Chapter 11, Fine Tuning the Chemistry.

Filter #1

Filter #2

PRINTING WITH VARIABLE CONTRAST PAPERS

The printing techniques described at some length earlier in this book apply equally well, for the most part, to graded and variable-contrast papers alike: Chemicals, exposure tests, agitation methods, and so forth are the same for both sorts of paper. There are some differences in procedure, however.

Safelights and Filters. First, most variable-contrast papers require the use of a dark amber (OC) safelight. The red safelight recommended for use with some graded papers will fog variable-contrast papers. If you want to use both kinds of paper, it is probably wiser to choose the amber filter because in most cases it will not cause any problems when used with graded black-and-white emulsions.

Variable-contrast paper differs from graded paper in that it has two emulsion layers, each sensitized to a different wavelength. One layer has extremely high contrast; the other, very low. The response of these two layers to the negative image is controlled to greater or lesser degrees by the colors (wavelength filtration) of the contrast control (CC) filters. To change the degree of contrast in a print being made on variable-contrast paper, you change the filter. Filter hues range from pale yellow to deep magenta. The yellowish ones produce low contrast, while the magenta ones cause the high-contrast emulsion layer to react more strongly. A number of manufacturers offer these filters; the most readily available are *Eastman Kodak* Polycontrast filters. They are sold individually (gels) or in complete kits (plastic). In either case, they come in half-grade contrast steps from #1 to #4 — seven in all.

Filter #3

Filter #4

The gels are designed to be used above the lens of your enlarger, between condensers or on top of the heat absorbing glass, if there is one. The plastic filters are meant to be used directly below the enlarging lens, in a special mounting bracket. While they are sturdier and a little simpler to handle than the above-the-lens type, they can degrade picture quality if they get scratched or dusty, since they are in the path of the projected image.

You can use *Kodak* Polycontrast filters with Ilford's or Agfa's variable contrast materials. Similarly, contast control (CC) filters made by concerns other than Eastman Kodak can be used with Kodak variable-contrast papers. Note, however, that there is no standardization of contrast numbers among the manufacturers of these materials; so a #2 filter made by Beseler or duPont, say, will give slightly different degrees of contrast from *Kodak*

#2 Polycontrast filter, and vice-versa. The filters are not linear in response, either. That is, you cannot combine a #2 and a #3 filter to produce #5 contrast.

Variable-contrast printing offers some advantages over graded paper printing:

- One box of paper can take the place of three boxes of graded paper.

- It is a little easier to exert creative control over burning and dodging.

- If you are making a print that needs a normal contrast range overall, but could be improved by a little more contrast in one part, you can dodge that area slightly during the initial exposure, then burn in detail using a higher numbered filter.

- The opposite is also possible: Local areas can

be made less contrasty: Hold them back (dodge) for overall exposure, then insert a lower numbered filter and burn in only that area. This is useful in such cases as highlights on metal, which would otherwise fall outside the tonal range of the paper but can be made to look bright and luminous, yet just slightly less white than the paper base. Also when a highlight falls near the white border around the image. Snow scenes can be printed more easily using the same technique.

As with everything else, creative use of variable-contrast can only be assured if you start by reading the manufacturers' instructions carefully, practice, and then experiment with them. Get to know the "personality" of the paper you are using. You will find, for example, that it usually takes longer to burn in a dense part of a negative when printing with a high-numbered filter than it would if you were doing the same on an equivalent-contrast graded paper. Yet variable-contrast papers are generally more sensitive to light than graded papers are and will fog more easily; pay strict attention not only to the type of safelight filter to use but also to the correct lamp wattage and distance.

The extra effort in learning to use variable-contrast emulsions properly can repay you many times over, not only in the quality of the prints you will eventually be able to make but also because the increased care you take will become second nature to you, thereby improving your working routine overall.

Bleaching. If you ever had the good fortune to see an original photograph printed by W. Eugene Smith, you may have marveled at the uncanny ability he seemed to have to produce bright, sparkling, almost unreal highlight areas in an otherwise rich, dark print. In many cases these minute, all-important highlights were achieved with the help of the chemical *potassium ferricyanide,* strengthening the effect of the light on his subjects.

Potassium ferricyanide, commonly referred to as *bleach,* is used to lighten areas of a print that are too dark, yet are too small to be dodged. It can also be used to reduce overall density of a print or a negative. (Review reduction and intensification in Chapter 5.)

A dilute solution of bleach is made by mixing potassium ferricyanide crystals with plain fixer until a very pale yellow solution results. Fixer activates the ferricyanide. This solution is then applied, in very small amounts, to the overly dark print area with a cotton swab or fine brush. (First, swab away excess moisture from the area to be bleached.) Depending on the strength of the solution, lightening can be seen immediately, and is stopped by washing the bleached area with more fixer.

The bleach works by literally eating away at layers of silver on the print surface. Its effect is irreversible—if the solution is too strong, or if you have overdone it you will have to begin again with another print. Use as weak a solution as you can and wash the area often with fresh fixer.

Bleaching is most easily done on prints that have just been fixed in fixer without hardener. Start with fixing your print for three-quarters of the minimum time, bleach, then return the print to the fixer for the remaining time, wash and dry as usual.

For a bleached print to be visually effective, the bleaching must be done with subtlety and restraint. Do not try to cover up mistakes in film development or print exposure by "bleaching in some added contrast"; it will not work. Bleaching a print should be used only as a last resort, or with a well-thought out effect in mind.

Caution: Potassium ferricyanide is a poison. If, for example, you are in the habit of moistening a brush with your mouth (as you might do when spotting a print) make extra sure not to do this when bleaching a print. Even small amounts of ferricyanide, swallowed, can have very serious consequences.

DODGING AND BURNING IN

Burning in and *dodging* are manipulations that can be even more effective when used expressively than they are when used to correct tonal imbalance. Secondary elements in an image can be subdued by slight burning in, for example, letting the main part of the image stand out a little more. Slight dodging of light areas in a print can give them more prominence than they possessed in a straight print. Middle tones can be separated by a combination of burning in and dodging, and so add depth to an otherwise "flat" image. Careful, selective work on areas showing metallic objects can give a real sense of *"metal-ness"* to those areas. With judicious use of these two techniques the aesthetic substance of an image can be enhanced.

Practice Steps. Make a portrait of someone wearing *dark* clothing. Place your sitter against a *middle-toned* background and give him or her a *light-colored* object to hold.

Pay *close* attention to the way the light falls on your subject and how it affects different areas of the scene.

Expose for the skin tone, then *develop normally.*

Make a contact proof sheet, pick the image you feel is the strongest, and make a straight print.

Examine the print. How would the photograph change if the sitter's clothing were a little darker? lighter? What happens when you put your finger over the light object in the sitter's hands? Would the overall effect become stronger if this object were to be burned in a little? Would the feeling of texture in the sitter's clothing benefit from dodging in some areas and burning in in others? What other similar considerations can you think of?

Go back into the darkroom to make a series of adjusted prints *from the same negative,* changing only one thing at a time. You will be able to watch the image evolve gradually into a more expressive version than the straight print you made originally.

Keep in mind that it is very easy to overdo manipulation of the print. Subtle changes are more powerful than heavy-handed adjustments. If you need to make major changes, it is probably because you did not examine your subject carefully enough before exposure. The changes we are concerned with at this moment are small ones, details for the sake of refinement of the image and creative interpretation.

Look over your file of photographs and pull out a few you feel are your strongest. Go through the above procedure with these, *keeping notes as you go along.* After a while you will automatically begin to make adjustments as soon as you see the straight print, and you may even find that your ideas of how to print some of your negatives has changed since the last time you worked with them. This is due not only to your growth as a printer but also to your mood and to the thoughts you are having about the image while you are printing. If you at last begin to suspect that there is no correct way to make a print of a good image, take heart: You have discovered the truism that printing is an interpretive endeavor, and as such is open to change.

Edge Burning. There is one subtle technique that often greatly enhances the visual and psychological effect of a print on the viewer. It is very simple: Once you have gotten the best print possible from your negative, burn in all four edges of the print briefly. This can be done by moving a cardboard from the center to the edge (with a smooth constant movement) and repeating it on the other three sides. Another method consists of using a large dodging tool; hold the dodging tool directly underneath the lens, then lower it with a smooth horizontal motion to a point above the print that allows exposure to the edges of the print, raise the tool again to the lens and repeat if necessary. The time required for edge burning varies and depends on the overall exposure of your print, and the contrast grade used. When done properly, the effect is not so much seen as felt. The viewer's eye is drawn to the image more strongly because of this reinforcement of the containing edge—frame—to the image.

Basic exposure was the same for both prints but edge burning (below) adds depth to the image

LIVING WITH YOUR PHOTOGRAPHS

It is common practice among advanced photographers to put up on their walls recently completed work, or work still in progress, so that they can assess it at arm's length and appraise it more objectively than they can do in the darkroom.

The idea has a lot of merit and will help you decide not only whether the image is successful, but also whether the print you have made of it is all that you want it to be. It is easy to become so wrapped up in solving exposure and development problems while printing that the making of the print becomes simply an intellectual exercise. Sometimes a photograph can be printed "too well": The printer has become overly concerned with eking the last dram of tonality from certain areas, and so runs the risk of producing an image without unity or wholeness.

By putting your recently printed images on the wall and absorbing them for a while you come to recognize any excesses you may have been tempted to indulge in, and you will find yourself more able to see what is needed to make your photographs truly evocative. Other alternatives you will become aware of have to do with the size and shape of your prints.

Print Size. Too often the size of a photographic enlargement is decided by the technical quality of the negative. The temptation is to make prints as large as possible—as large as the sharpness of the image and grain will allow; all this without consideration of composition, subject matter, texture, or the manner in which the print is to be displayed. Print size has not only a visual effect but a psychological one, as well. This is true in landscapes, architectural work, abstract details as well as portraiture.

The size of a photographic print, when decided upon with due consideration to the image itself, can have a powerful influence on the aesthetic effect of the photograph. To prove this to yourself, make a series of prints from what you consider to be your best negative. Start with a contact print, then make five or six enlargements, gradually increasing the size. Print the entire negative "full frame" so there will be no variation caused by slight differences in cropping. Try to give all the prints the same tonality (this is probably going to be a bit more difficult than it sounds, especially when you try to make an expressive contact print; but the experience you gain in printing will be well worth the effort.

When all the prints are dry, look at them together from a comfortable viewing distance. You will notice that the picture will change in character as its image size changes. One of the prints will convey the content of the image better than the others. If you repeat the experiment with a number of negatives, of different subjects, you may find that certain types of images work best for you when printed to a certain size.

To extend the size experiment a little further select three of the prints you made, the smallest, medium size, and largest one. Display the smallest print where you can see it easily and as often as possible. Live with the print for a week or so, then replace it with the medium size print. Let this second print become part of your environment for the same length of time as you did the first. Finally, replace this print with the largest one, and let it make its effect on you.

A week is recommended for each image because time is needed for acceptance of the photograph as part of your surroundings—and it is precisely this acceptance that will allow you to decide which print size best conveys what you want to express in your photograph.

There is no rule regarding the "correctness" of print size: It is strictly a subjective matter, but one every photographer owes himself or herself to examine.

CROPPING

Cropping is done by some photographers sometimes, and by others all the time. Some photographers feel that the image should be composed in the cameras view finder at the time the photograph is made: Cropping, if done at all, to be limited to cleaning up the edges of the print. This approach certainly should not be disregarded; it is something to strive for.

However, more often than not, in average situations, you will find yourself without the right lens to close in on your subject (or, by the time you have changed lenses the situation has changed) or,

you just cannot maneuver yourself into a different position and etc. Make the photograph anyway and crop when making the print.

Some photographers can visualize the image they want and crop directly on the enlarger easel. However, a handy aid is to cut yourself two L shapes out of paper, or cardboard, in size a litte larger than your average print size. Move the L shapes (one upright, the other upside down 🔲) over your uncropped image; it will help you to isolate that part of your photograph the best conveys want you wanted it to express when you took the photograph.

Cropping (from the full frame opposite) and some burning-in, emphasizes a fleeting moment.

PRINTING FOR REPRODUCTION

One of the more disturbing experiences a photographer can undergo is to see a poor reproduction in a newspaper or magazine of a print that you labored over diligently in the darkroom. Yet as often as not, the fault will be as much yours as the engraver's or pressman's. For example, if you were in a position to ask the engraver what kind of print was needed to make the best possible reproduction, you may have been told to make it "snappy" or "a little on the contrasty side". If you then went in your darkroom and produced a print that you (as a photographer) thought was contrastier than the original image and delivered it for reproduction, the engraved and inked result most likely bore no resemblance to your subtly toned original.

It is not that the engraver is telling you untruths. He did say "contrasty". But printers, pressmen, and engravers speak a different language than that of a photographer. Because most reproduction processes cannot handle subtle differences in tone when those tones are close together, the printer needed a print with little or no *juxtaposition of similar tones,* that is, more contrast between side-by-side areas. You, as the photographer, understood "contrasty" to mean smaller tonal differences than usual, that is, little detail in shadows or in highlights, with tonal subtlety only in the middle tones. Therefore your contrasty print, when reproduced, ended up with highlights resembling chalk, shadow areas taking on the appearance of soot, and very little in between but middle gray. Bearing this in mind, it becomes obvious that what is needed is a print that has highlights just a *little* less brilliant than in an exhibition print and shadows that are just *slightly* less deep, so that the highlights will "pick up" a little when reproduced, approaching the way they look in the original, while the shadows will "drop" a bit, becoming more like those of the original print. In short, the print for *reproduction* is best made a little lighter and *less* contrasty (in photographic terms) that its *exhibition* version.

This is true for a number of reproduction processes, but not for all. Using the sheet-fed gravure process (where only one print is made at a time) with fine inks and high quality papers, for instance, the engraver can make quite reliable copies on an original exhibition print. There have even been occasions, when some hand finishing is done, where the copies surpass the original in tonal quality. However, sheet-fed gravure is an expensive process and you are unlikely to encounter it in the average situation.

Among other points to keep in mind when printing for reproduction are the following:

- While glossy prints (glossies) are preferred by some printers they are not an absolute necessity; a semi-gloss paper such as Kodabromide F, for example, will do as well.

- Avoid off-white photographic paper. The film used to make the halftone is partially color blind; light reflected from a cream colored paper, for example, affects the halftone film less than light reflected from pure white stock. For the same reason avoid heavily toned prints, *i.e.,* such as a sepia-toned print.

- Avoid textured photographic paper. The more textured and therefore the duller the surface, the less detail and brilliance will result when the engraver shoots the halftone.

- It is best to make your print about one-half again as large as it will appear when reproduced. By reducing your original print any imperfections will be reduced also—the reverse is true: If the engraver has to enlarge your original, imperfection will enlarge also; in addition, loss of detail and contrast is likely to result.

- While, depending on the process used, manipulation by the engraver can increase the contrast of your original print no amount of manipulation can put detail where there was none to begin with. So, if you want to see it in the reproduction it has to be *there*—in the original.

Lastly, keep in mind that while there are printers who specialize in high-quality reproduction of photographic prints—*this* is a long, exacting, and expensive process. In the average situation you will have to accept the fact that, except in very *rare* situations, a reproduction of *of your original print* just will not look as you envisioned it.

Letterpress. Each reproduction method has its own tonal limitations. Newspaper presses can seldom render more than five tones in an image, including black and white. Although photo offset is becoming more usual, many newspapers still use *letterpress* printing and *photoengravings.*

Photoengraving does not allow for much subtlety in reproduction; areas of the image are either inked or not inked. Shadow tones are achieved with the use of *screens.* As light passes through the holes in the screen a black dot is recorded on the plate. After the plate has been etched with acid, the thousands of dots making up the image remain raised above the background areas. The dots take ink and transfer it onto paper to form the pictures, along with the type, in your morning paper. Look at the pictures with a magnifying glass and you will see large black dots surrounded by white in the areas of the image corresponding to the shadow portions of the original, and very small black dots with large white surrounds in the highlight areas. At a normal viewing distance, these areas pass for black-and-white. Middle tones in the original are reproduced as medium-sized black dots with mid-sized white surrounds, giving the impression of neutral gray when viewed at a normal distance ("normal distance" here being reading distance).

The quality of reproduction possible by this method is limited by the degree of spreading of the inks used, their degree of absorption, the reflectance of the paper used, and the fineness of the screen grid. Most newspapers use very porous paper, spreadable ink, and coarse screens, which is why reproduction of finely detailed photographs in newspapers is virtually impossible.

Two other types of reproduction process in general use are *photolithography* and *photogravure.*

Photolithography. The original material to be reproduced is photographed on litho film. A fine-dotted screen is used over the film. The resulting negatives are the contact-printed onto a thin, flexible aluminum plate that has a sensitized colloid surface. Since colloid hardens where it is exposed to light but not otherwise, the unhardened (unexposed) areas can be washed away and the remaining—hardened—parts become water-repellant but will accept greasy ink. The thin litho plate is then wrapped around a cylinder. This plate never comes into contact with the paper itself; printing is accomplished by transfer of the inked image from one cylinder to another, and finally onto the paper. This indirect method gave the name *offset* to the process.

The main advantage of photo-offset over the letterpress methods is that more subtly toned rendtions are possible, especially in shadow areas.

Photogravure. This third method is generally used for magazine reproduction, where a large number of copies must be reproduced quickly, yet with good image quality. It can handle subtly toned originals more faithfully than either of the other processes.

All of this is to say that different printing processes will be capable of reproducing different kinds of prints, suited to the end result. You will rarely be in a position to dictate the reproduction process to be used, or to supervise the printing of your photographs. But, if you keep in mind that none of the processes is generally capable of the subtle variations in tonality one can achieve photographically, and that the easiest way to compensate for this lack of subtlety is by finding out what the engraver really wants when he asks for a "contrasty" or "snappy" print, you will be less disappointed by the end result.

ILFORD

Ilfobrom

Safelight: OA; OC
Surface: Glossy; Matte; Semi-Matte; Velvet; Stipple; Rayon Luster.

Fast, cold tone, neutral black enlarging paper; brilliant whites, Available in Grades 0-5, with Grades 1-4 having the same speed. (This allows you to change contrast without having to adjust exposure time when working from the same negative.) Single and double weights; all contrast grades available in glossy finish. Grades 2-4 available in all surface textures and finishes except Rayon Luster, which is made in grades 1-3 only. Fiber based.

Ilfospeed

Safelight: OA; OC
Surface: Glossy; Semi-Matte; Silk.

A resin coated version of Ilfobrom, available in medium weight only (between single and double weight). Extremely fast development, fixing, washing and drying times. Grades 0-5 are made in glossy finish; Grades 1-4 in either semi-matte or silk. Can be dried in 30 seconds using any RC print dryer, or in 15-30 minutes by air, depending on humidity.

Ilfospeed Multigrade

Safelight: OC
Surface: Glossy; Semi-Matte; Silk; Pearl.

Variable contrast version of Ilfospeed. Uses contrast control filters to change tonal range of the paper. Medium weight only. The Pearl surface bears a passing resemblance to fiber based glossy paper that has been dried without ferrotyping.

Ilford Galerie

Safelight: OA; OC
Surface: Glossy

Neutral black enlarging paper. Fiber based. High silver content. Capable of extremely subtle tonal gradation. New product, introduced in the US in 1979. Available as of now in Grades 1-3 only, double weight, glossy. A bit more expensive than most, but the beautiful results make it a bargain for serious printers.

AGFA

Agfa code their papers as follows: 1 = Single Weight Glossy; 111 = Double Weight Glossy; 118 = Double Weight Semi-Matte; 119 = Double Weight High Luster, fine surface grain; EW = Extra Warm (very low contrast); W = Warm (low contrast, soft); S = Special (between soft and normal contrast); N = Normal (medium contrast); K = Brilliant (between normal and high contrast); H = Hard (high contrast); EH = Extremely Hard (very high contrast)

Brovira

Safelight: OA; OC
Surface: 1; 111; 119

Cold tone, neutral black enlarging; high speed; bromide; clean, brilliant whites. Fiber based. Grades 0-5. Available in single and double weights.

Portriga Rapid

Safelight: OA; OC
Surface: 111; 118

Warm tone, olive/brown black enlarging; high speed; chlorobromide; warm, creamy whites. Fiber based. Grades 1-3. Available in double weight only.

Brovira Speed

Safelight: OA, OC
Surface: Glossy; Semi-Matte

Extremely fast, resin coated version of Brovira. Short washing and drying times. Middle weight.

All Agfa papers can be successfully processed in any general purpose print developers, stop baths, and fixers. Portriga Rapid is much more prone to staining than the others, and should never be processed in the same batch with any other paper. Portriga will also produce variously toned prints, depending on the temperature and duration of development. Long development times will generally produce colder, olive/black tones, while higher than normal temperatures and shorter development times will give warmer, brownish/ black tones from the same paper batch.

Each paper has an emulsion batch number on its box or package. If you use Portriga, make a note of this number—Portriga varies in base tint from batch to batch, so that if you come upon an emulsion run that you find especially pleasing, you can guarantee yourself more of the same by ordering from the same batch when you replenish your paper supply.

KODAK

KODAK PAPER CODES: A = Smooth Luster; **F** = Smooth Glossy; **J** = Smooth High Luster; **N** = Semi-Matte, smooth; **E,G** = Fine grained luster, pebbled surface; **M** = Matte—no sheen; **K** = Fine grained luster—more shiny than E and G; **R** = Tweedy, rough surface; **Y** = Silk finish, high luster.

All Kodak RC papers available in Medium Weight only.

Azo

Safelight: OC
Surface: F; E; N

Contact printing paper, warm black/neutral black image tone. Fiber based, available in Grades 0-5 SW glossy, 1-3 DW glossy; 1-4 DW matte; 2, 3 DW fine grained luster; and 1-4 fine grained luster. Developers like Dektol, D-72, Versatol and Ektaflo Type 1 will produce neutral/cold tones, while Selectol, Ektonol, Ektaflo Type 2 and D-52 will give somewhat warmer tones. Azo can be used as an enlarging paper but is extremely slow by modern, projection printing standards.

Ektalure

Safelight: OC
Surface: E; R; G; Y; K; X

Enlarging paper, warm/brown black image tone. Available in one grade only (somewhere between Grades 2 and 3), but in an absolute plethora of surfaces. The E surface is of most use to many photographers. Users of Portriga will sometimes use this paper as a substitute when Portriga is in short supply. Results are similar, but somewhat warmer and less brilliant than those obtained on Portriga. Surface tints available=Wh (white); WWh (warm white) and Cr (cream/white—almost ivory).

Kodabromide

Safelight: OC
Surface: F; N; A; E; G

Enlarging paper with a neutral/cold black image tone. Fiber based, in Grades 1-5. Available in single, light and double weights, in a variety of surfaces. Used by many exhibition printers who like its assertive, cold blacks. Tones well, and produces crisp, brilliant highlights. Grades 1-5 available in DW F and G surfaces; SW F and E. LW in surface A only. Grades 2-4 can also be gotten in DW N and E; and SW N.

Kodabrome II RC

Safelight: OC
Surface: F; N

Essentially a resin coated version of Kodabromide, with a brightener added to the emulsion for more brilliant whites. Very fast processing and drying times. Medium weight in 5 contrast grades, from "soft" to "ultra hard". F and N surfaces only.

Ektamatic SC

Safelight: OC
Surface: F; N; A

Enlarging paper with warm/black image tones, primarily designed for use in stabilization processing machines. Can be tray processed. Tray processing produces more neutral, colder results than does stabilization. Used with Polycontrast filters, or their equivalents. Available in single, double and light weights. Light weight in A surface only. Fiber based.

Medalist

Safelight: OC
Surface: F; J; E; Y

Fiber based enlarging paper with a warm/black image tone. A fine general purpose paper, capable of beautiful results. Used by many exhibition printers who consider Portriga or Ektalure a bit too warm in tone. F (glossy) surface available in DW Grades 2 and 3 only. SW F surface can be had in Grades 1-4. Five different surfaces are available in all.

Panalure, Panalure Portrait

Safelight: 10, 13
Surface: F; E

These papers are primarily designed for printing black and white images from color negatives, so a #10 or #13 safelight is necessary to avoid fogging the paper. Both papers will produce neutral blacks, though Panalure Portrait will give browner results than its "non portrait" counterpart. Single contrast grade—Panalure comes in SW, Panalure Portrait in DW.

Polycontrast

Safelight: OC
Surface: F; N; A

Enlarging paper, contrast is changeable by using contrast control filters. Fiber based, neutral/warm black image tone; somewhat warmer in tone than its faster counterpart, Polycontrast Rapid (see below). Available in F, N and A surfaces, in SW, DW and LW. The A surface is obtainable only in LW.

Polycontrast Rapid, Polycontrast Rapid RC, Polycontrast Rapid Type II RC

Safelight: OC
Surface: F; N (Poly Rapid also comes in A, SW)

Polycontrast Rapid is a faster, somewhat colder toned version of Polycontrast, and has the same choices of finish and weight. Poly Rapid RC is (or was) Kodak's initial resin coated paper offering. Among its advantages were extremely fast processing and drying times. It suffered from a lack of clarity in shadow areas, and a general "filminess" if dried without a heat drier. Poly Rapid Type II is Kodak's answer to the critics of the original RC, and it is an assertive answer indeed—the tones are all one could ask for from a paper of this type; the filminess is gone; there is hardly any of the curl one normally associates with resin coated products; and because the paper has a developing agent *in it*, the image comes up almost immediately in the developer. The tonalities of this RC paper are richer and better defined than most other RC papers.

Processing for Permanence

One of the main difficulties encountered by people involved in photography during its relatively short history has been in keeping photographic images from discoloring or fading away entirely. Untreated silver-based images can be not only internally unstable but also susceptible to damage and change when brought into contact with air, changes in humidity, and so on. This has caused a search by individuals and large concerns for methods to make photographs as stable and permanent as possible.

This does not mean that the photographs you make in the usual way will fade and disappear overnight. A photographic print fixed in fresh hypo for the correct length of time, then treated in hypo-clearing agent and washed properly, will last unchanged for 20 years or more, depending on processing and storage conditions. In many cases, photographs are not needed that long. (Imagine how much room would be required to store every print you would make in 20 years.) There are some instances, though, when a photograph should be made to last as long as current technology will allow. If you are making a print for an archive, a collection, someone who has purchased one of your photographs, or of your best work to frame and hang on the wall for yourself, there are certain procedures you can follow to make certain the photographs you have made will outlive you—and then some.

FIXING PRINTS TO LAST

Two-Bath Fix. Improper fixing is the single major cause of eventual destruction of photographic negatives and prints by fading, discoloration, or splotch-iness. Fixing solution should be checked often for effective strength, kept at recommended temperatures during use, and used for the correct length of time with proper agitation.

Fixing for too long is as bad as not fixing long enough. Overfixing lets the emulsion take up too much fixer, making thorough washing impossible; it will also cause the developed metallic silver to be attacked and somewhat broken down, bleaching the image in the process. With too little fixing, not all of the unexposed silver halides will have been removed; later these will change when exposed to light and the image will eventually be destroyed to some extent.

To avoid these problems with *negatives,* make sure the fixer you are using is not exhausted (see below), fix for the recommended time, and wash the negatives thoroughly, having treated them with a washing-aid first.

For *prints,* use the two-bath fixing method. This is done by setting up *two* trays of fixer: Fix the print for half the recommended time in the first tray, then drain the print and immerse it in the second tray for the remaining minutes. When the fixer in the first tray shows signs of exhaustion (see below), throw it out, move the second tray into the first position, and prepare a fresh second tray.

Test For Fixer Exhaustion. During normal fixing action silver salts being dissolved from the photographic emulsion combine with chemicals in the fixer solution to form chemical compounds known as *argentothiosulfates.* The more emulsion the fixer comes in contact with, the more of these compounds is produced. This, coupled with

natural exhaustion of the fixing agent itself and contamination by solutions carried over from the developer tray, will make the fixer ineffectual after a certain amount of use. The manufacturer's label on the fixer states the useful capacity — how many prints, or rolls of film, the working solution will treat before becoming exhausted. The fixing bath should be replaced often, preferably *before* it has reached that point. There are various commercial preparations, such as Edwal Hypo-Chek to test the argentothiosulfates in fixer. Or make your own as follows.

1. Dilute 5 parts potassium iodide with 95 parts water to make a 5% solution of potassium iodide.

2. Take 25 ml of the fixer you are testing and add 1 ml of the 5% solution to it.

3. If the result is a cloudy mixture that does not clear when shaken, it means that enough silver has accumulated in the fixer from the prints already treated to form an insoluble silver salt called silver iodide, rendering the fixer exhausted.

Hypo Eliminator. The following formula produces a substance that removes fixer from photographic emulsions. Care must taken when using this solution: The ammonia in it is not only unpleasant to smell but also harmful if inhaled. Do mix the chemicals together *carefully* in a *well-ventilated* area. *Do not store this substance in a stoppered bottle:* The bottle will shatter when gas given off by the substance expands.

NOTE: Do not confuse Hypo Clearing Agent with Hypo Eliminator. The clearing agent will remove *some* residual chemicals and thereby reduce washing time but it does not do as thorough a job as Hypo Eliminator.

KODAK HYPO ELIMINATOR HE-1

Water . 500 ml
Hydrogen peroxide (3%) 125 ml
Ammonia solution* 100 ml
Water to make 1 liter

1 part concentrated ammonia (28%) to 9 parts water

Mix the chemicals immediately before use and keep in an *open* container.

1. After treating prints or film in hypo-clearing agent, wash them for five minutes in running water.

2. Soak prints in HE-1 for 6 minutes at 20°C (68°F).

3. Wash for 10 minutes at 20°C (68°F), then dry as usual.

Each quart of HE-1 will treat the equivalent of a dozen 20 × 25 cm (8 × 10 in.) photographic prints, 12 or 13 rolls of 120 roll film or 35mm 36-exposure film.

If you find this chemical solution too volatile or inconvenient to prepare, you can still give your prints and negatives a large degree of permanence by treating them instead in working solutions of one of the commercial washing aids such as Perma Wash. As we mentioned before, washing time should be at least double that recommended by the manufacturer.

WASHING PRINTS

Improper washing is a major cause of image deterioration and contamination. Wash water should run rapidly, bringing fresh water to the surface of your emulsions as often as possible, but do not let the prints circulate so violently that they scratch each other with the corners. Make sure prints do not stick together during the washing procedure.

Printwashers. Washing prints can be done by transferring prints, from one tray to another, by hand — with a constant flow of fresh water, and discarding of hypo-laden water; a long, tiring, and

tedious process. Or, you can purchase one of the many models of mechanical washers on the market and have them do the work for you—with some precautions to keep in mind.

Fixer is easily removed from the surface of a print. But the chemicals that have penetrated the paper fibers are not easily removed. The use of a chemical washing aid (see above) is recommended, regardless of the type of washer you decide upon. While, with most photographic products, it is wise to follow the manufacturer's recommendation as to the time needed for effective performance of their product, with washers it is equally wise to disregard them. Run your own test. In most cases, you may find that at least double the recommended washing times are needed for acceptable hypo-free prints.

Always include a "test print" with the batch you are washing. The test print can be a proof you are discarding, or an unexposed sheet of paper—but one that has gone through the same chemical steps as your prints. Prints seem to wash clean,

A simple tray washer for small loads

faster, at the edges, so any test run on the edges of a print only may give you a false reading; by including an unwanted print you can test the center as well.

Suggestions for effective washing water temperatures range from 20°C (68°F) to 26°C (80°F). Anything much below 20°C will lessen *any* washer's effectiveness. Temperatures above 26°C may, with prolonged washing times, result in blistering and peeling of the emulsion.

The choice of washer that will work best for you depends on the average number and size of prints you wash at one time, your available space, and your budget.

If, on the average, you only wash about 6 20 × 25 cm (8 × 11 in.) prints at one time, an inexpensive *Kodak* Automatic Tray Siphon may be all you need. If, on the other hand, you regularly produce a number of 40 × 50cm (16 × 20 in.) prints, you may want to investigate the Zone VI

The Arkay Rotary Washer

The Zone VI washer

Washer: Their largest model will hold 15 40 × 50cm prints (or 30 27 × 35cm [11 × 14 in.] prints) and sells for about $400.00. (Smaller models are available also. For additional information write to Zone VI Studios, Newfane, Vermont 05345.)

TESTING WASH EFFECTIVENESS

A simple test of the thoroughness of your washer can be made as follows:

Residual Fixer Test.

1. Prepare a solution of
 0.1% potassium permanganate with
 0.2% sodium hydroxide.

2. Dilute the above solution with water until it has a light pink color. Pour this into two separate graduates or beakers. (Transparent ones will be more convenient—see Step 5.)

3. Lift a print or negative from the wash water and let it drip into the first beaker.

4. Drip a few drops of ordinary tap water into the second beaker.

5. If color disappears from the first beaker faster than it does from the second, fixer is still present in either the emulsion or the wash water. Further washing is required.

Another test consists of the following:

Silver Test Solution ST-1.

1. Make a stock solution by adding 2 gr sodium sulfide (anhydrous) to 125 ml water.

2. To test for any residual hypo, dilute 1 part of this stock solution with 9 parts of water. (Note: Working solution will not keep longer than one week.)

3. Place 1 drop of ST-1 working solution on the edge of a washed and squeegeed print (or film.)

4. After 3 minutes, dab the spot with a clean white blotter or paper towel. Look at it in good light. If there is any distinct discoloration where the ST-1 was applied, too much fixer remains and additional washing is required.

PROTECTIVE SOLUTIONS

Gold and selenium toners help make photographic prints much more resistant to the detrimental effects of air, light, and humidity than they are in their untreated state. They also tend to enhance the looks of a print by enriching the tone.

A solution of gold chloride prevents fading by combining with the developed silver in the print to make it less susceptible to change. Gold is far more stable than silver under a variety of atmospheric conditions.

KODAK GOLD PROTECTIVE SOLUTION GP-1

Water (20°C)* 1 liter
Gold chloride (1% stock sol.)** 10 ml
Sodium thiocyanate (liquid) 15.2 ml

*Distilled water is recommended.
**Dissolve 1 gram gold chloride in 100 ml of water.

1. Add gold chloride 1% stock solution to 750 ml of the water and set aside.

2. Dissolve the sodium thiocyanate in 125 ml of the water.

3. Add the sodium thiocyanate solution *slowly* to the gold chloride solution, *stirring rapidly.*

4. Add water to make 1 liter and mix well. Pour into a tray. If working solution is not at 20°C (68°F), place tray in a water jacket—a larger tray of water at the right temperature.

5. Put in one print. Leave it for 10 minutes, or until the image starts to look slightly blue-black. Treat one print at a time.

6. Wash for 10 minutes and dry as usual.

One quart of GP-1 will treat eight 20 × 25cm (8 × 10 in.) prints. Best results are obtained with prints that have first been treated in HE-1. (see p. 112.)

Selenium Toner. This toner, although designed as a coloring agent (it gives a reddish-brown hue to neutral and warm-tone papers, while cold-tone papers turn faintly blue in deep shadows), is a useful aid to print permanence.

Selenium toner has certain advantages over gold toner: It is far less expensive; it is sold in liquid form and is simple to prepare and use; and it stores easily, lasting a long time on the shelf. Careful use of selenium toner makes the shadow areas of prints separate slightly and become a bit darker, and so gives them an added sense of depth and liveliness.

The recommended dilution and toning time indicated on the *Kodak* selenium toner bottle applies to its use as a *coloring* agent. More dilution makes for more subtle tonal changes, yet even with great dilution there will be enough selenium in the bath to *protect* the silver of the print.

Note: Even when diluted, selenium is a hazardous substance and should be use with care. *Read the directions.* WEAR GLOVES. *Never* use it straight out of the bottle.

Following are two ways to go about selenium-toning a print. The first is used with a print that is fully fixed, but not washed.

Selenium Toning METHOD #1

1. Prepare toning bath by mixing 1 part *Kodak* Rapid Selenium Toner with 9 or 12 parts working solution of hypo-clearing agent. Toning solution temperature is not critical, but for the sake of consistency and convenience it is best kept at about 20°C (68°F).

2. Lift print from the second fixing tray, drain slightly and place in the toning bath. Do not rinse first, or yellowish blotches will appear on the print in those areas where some fixer remains, whereas if the print is completely saturated with fixer the stains have no "gaps" in which to develop.

3. Agitate the print constantly, so that there is a continuing resupply of fresh toner on the print surface. This is extremely important in toning, because if you are not careful the print might tone unevenly.

4. There is no set time for toning—much depends on the sort of paper you are using

and the degree of tonal change you want. The solution will respond faster as more prints are put through it. Since changes in tone are caused by the selenium's coating the silver in your print, you will be safe in assuming that a satisfactory degree of print longevity has been reached by the time *any* change in tone is noticeable. Most people find 2 to 6 minutes enough.

5. After the desired degree of toning is obtained, transfer prints to a tray of working solution of hypo-clearing agent. Agitate for 5 minutes, then proceed with wash as usual.

Selenium Toning METHOD #2

This method differs from the first in that the toner is diluted with distilled water instead of with hypo-clearing agent and is used on *finished prints:* Prints that have been fully fixed, cleared, treated with hypo-eliminator, and fully washed. This method is useful when you decide to tone prints that are dry and finished but need that extra bit of "life" selenium toner can provide. It also works best with warm (chloride) papers.

1. Keep in mind that the print must be *completely free* of fixer residue. Test for residual hypo (see page 114); otherwise you might end up with a rather ugly mess.

2. Dilute the toner is essentially the same way as in the first method, but substitute distilled water for the hypo-clearing agent. The more dilute the solution, the slower the process and the more subtle the result.

3. Since you are not using a fixer-laden print you do not need to keep the print moving constantly while it tones, but intermittent agitation is useful in bringing fresh toner to the print surface.

4. Keep an untoned duplicate print nearby, so that you can compare the two to keep track of changes in the one being toned. These

changes can be extremely difficult to see. Selenium toner acts on the print very slowly at first, then with increasing speed and intensity as the minutes wear on. Bearing this in mind, keep checking against the untoned "control" print and pull the other from the bath *just before* it reaches the degree of toning you want; this will compensate for the chemical inertia of the toning process. Transfer the prints to a tray of working solution of hypo-clearing agent. Agitate for 5 minutes and wash.

Kodak Rapid Selenium Toner contains a certain amount of fixer; so all prints toned with it must be cleared and washed the same as any newly fixed print.

Keep a separate tray for selenium toning and make sure you clean it after every use.

Wipe down all counter surfaces thoroughly after toning and check the floor for possible drips. Selenium toner is clear when wet, but it dries to an unpleasant shade of pinkish red. It will stain many surfaces permanently if allowed to dry on them.

DRYING PRINTS

The air drying of photographic prints on racks or in blotter books has two major advantages over heat drying. Racks are easily kept clean (by washing before *and* after each use), and blotters can be replaced often (relatively cheaply) to avoid contamination of prints by residual chemicals on the drying surface. The aprons on heat dryers are difficult to keep clean and expensive to replace. Heat drying also tends to exaggerate "drying down", making judgement of final print tones more difficult. *Cleanliness is of utmost importance, whichever method is used.*

If heat drying is used, extreme care must be taken to see that the apron is clean. It should be taken off and washed thoroughly at the first sign of discoloration and should be replaced periodically

with a new one. Heat must not be set too high, in order to avoid scorching the apron and marring the prints as a result.

Not many people can afford the luxury of a large rotary heat dryer, but they are often found in rental darkrooms and schools. *Never* put a fine print on one of these if you do not know what other prints have gone through the machine: Someone may have put hypo-laden, semi-washed, or poorly toned prints on the very same surface where your carefully treated one must go. If you have to print in facilities which are not under your control, bring blotter books or rolls with you, take your photographs home, and dry them there.

Photographers whose darkroom space is limited, or who prefer not to subject their prints to the heat of machine dryers, have two options: Prints can be dried between photographic blotters; or they can be air dried on "trays" made of plastic or fiberglass screens.

Photographic Blotters. Blotters are available in individual sheets, books, or rolls; only those especially manufactured for photographic purposes should be used — ordinary blotting paper contains chemicals that can attack the print surface.

The easiest form of blotters to use, especially with prints larger than 20×25cm (8×10 in.) are loose sheets. They should be a size larger than the prints to be dried — this will ensure that the print is completely covered. Place your fully washed and squeegeed print on a sheet of blotter and place another sheet on top of the print. Smooth the "sandwich" down. Blotter-print-blotter combinations can be stacked one atop the other with an extra blotter between each sandwich for extra absorption. The stack can be weighted down with books or a weight. However this will prolong the drying time and too much pressure may cause small pieces of the blotter to become imbedded on the print surface. All you really need to keep the prints reasonably flat is a couple of magazines on top of the pile, just to keep everything together. Drying time can be speeded up by replacing damp blotters with dry

ones. Let the damp blotters dry completely before re-using.

Blotter books are readily available in sizes to fit 20×25cm (8×10 in.) or 27×35cm (11×14 in.) prints. They are essentially the same as loose sheets but come in a spiral-bound book.

Blotter rolls usually come in 25cm (10 in.) widths and are wound around a core of corrugated cardboard. For use you must unroll the entire roll and place prints into it from the center outwards, then roll it back up for drying. The roll takes up little space, but is a bit less convenient to use than blotter sheets or books.

Place prints face down on the blotter

Blotters should be replaced often as they soak up residual chemicals from prints and pick up dust particles from the air. These residues and particles get transferred onto the next wet print, so be prudent and discard the blotters after about 4 or 5 uses, even if your prints are "perfectly" washed.

Print Drying Racks. Air-drying of prints is the preferred method for many photographers. Screens can be easily washed off thereby greatly lessening the danger of chemical contamination. Drying racks and screens can be constructed to fit any space available and can be as simple or as elaborate as the need (or fancy) dictates. (See illustrations for two

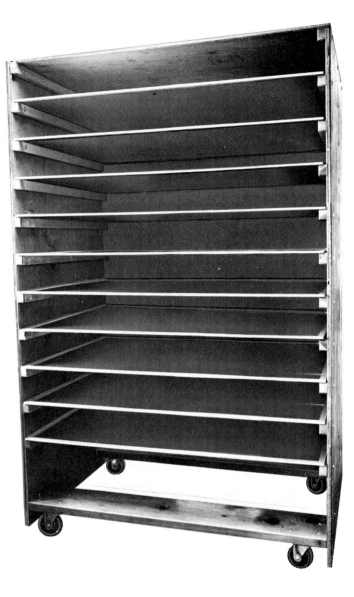

The frame of this drying rack is constructed with 3/4" plywood, an opening is left in the back to allow for cross-ventilation. The screens rest on 1 × 2's which are fastened to the box with stove bolts and T-nuts which allow for secure and flush fastening. Casters are bolted to 2 × 6's making the rack moveable. The frame is given several coats of polyurethane for protection. The drying screens were made at a glass shop to fit, each screen can hold 18-8 × 10 in. prints.

A simple rack constructed from 1 × 2's and 2 × 2's cut to size and planed at a lumberyard. The frame is assembled with glue and finishing nails. The screen frames are rabbeted, plastic screening stapled in and strips of wood tacked as shown, to hold the screen material securely. Each screen can hold 4-8 × 10 in. prints. Additional units can be constructed and stacked one on top another.

examples). No matter what the size or shape of the rack, never use metal screens—they will rust quickly and ruin your prints. Only plastic, nylon, or fiberglas screen material should be used.

If space is at an absolute premium you might find this idea useful: By taking an old but working windowshade and replacing its material with fiberglas screening, you will be able to stretch the screen out for use and roll it up, out of the way, when your prints are dry. By attaching a thin strip of wood to the free end of your screen, and with some

string and eye hooks (see illustration) you will be able to keep it taut when it is extended. The only tools you will need to make this item are a pair of scissors to cut the mesh, and an industrial size staple gun to attach the mesh to the windowshade rod and the strip of wood.

Finally, to air-dry your prints simply place your washed and squeegeed print on the screen, face down for fiberbased papers and face up for RC papers. Drying time can take from a few hours to overnight depending on temperature and humidity.

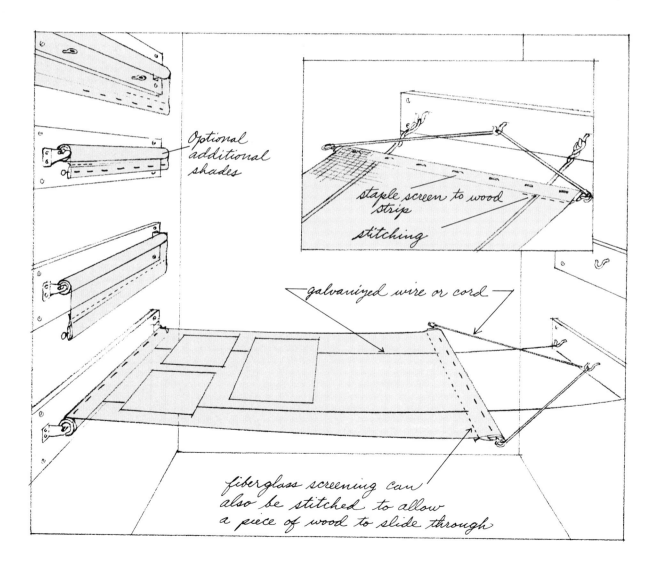

Optional additional shades

staple screen to wood strip
stitching

galvanized wire or cord

fiberglass screening can also be stitched to allow a piece of wood to slide through

Mounting Prints

For both presentation and protection, mounting your finished print on a supporting material is an essential step in the photographic process.

There are several ways of attaching prints to the support material. However, one method you should NOT use is to attach the photograph to its backing by means of glue. This is a sure way to guarantee eventual destruction of the photographic image by the chemicals in the adhesive.

Other mounting methods include, among many, the use of archival paste, "repositionable" intermediate sheets, and spray-on cements. None, with the exception of the paste, has so far been proven harmless to prints over a long period of time but research is going on constantly.

The safest and most generally used method of mounting is dry mounting. This is accomplished by means of a piece of a specially prepared tissue — mounting tissue — which is sandwiched between the photograph and the mounting board, then heated to melting point while under pressure — in a mounting press. The hot press makes the tissue adhere to the back of the prints and the front of the mounting board; when it cools, it fuses board and print together.

Care should be taken to follow the temperature and time recommendations given by the mounting tissue manufactureres. If the mounting press is too cool the tissue will stick to the print only — and not to the mount. If too hot the opposite will happen — the tissue will stick to the mount and not to the print.

A Tempilstik® is useful to measure the actual temperature of the platen of your mounting press.

Tempilstiks® come in various temperature ratings and are available at welding-supply shops.

MOUNTING SUPPLIES

- *Mounting board* (available from most art-supply or graphic-art stores — many photo dealers carry it as well). If you are going to mount prints you have processed archivally be sure to use acid-free 100% rag mount board — otherwise the sulphur or acid content of the board will eventually migrate to your photographs, and undo all your careful work.

 An alternative mount is fully fixed and washed unexposed photographic paper of the same type and size as the print you are going to mount.

- *A mat knife* or single-edge graphic-art grade razor blade to trim the print and cut the board. Make sure you have plenty of extra blades. (Note: X-Acto knives will do for lightweight boards.)

- *A paper cutter* — you can do without this but it greatly simplifies the trimming process, especially if you mount more than a few prints at a time.

- *Dry-mounting tissue.*

- *A tacking iron* — a small-faced instrument similar to a soldering iron used to tack mounting tissue to the photograph, so that it won't slip out of position when being attached to the board (the very tip of a regular clothes iron will work too, with control set for wool).

- *A dry-mounting press,* used to fuse print, tissue, and board.

- *A large T-square,* or architect/engineer's right triangle, to square up the print on the board. If it is of steel, it can be used to guide the cutting-blade; otherwise add a steel straightedge (a sharp knife or blade will cut into aluminum and spoil your cut). If you find a T-square with inches and/or centimeters markings, with fractions, so much the better — you won't need the next item.

- *A ruler,* to measure out the areas to be cut.

- *A sharp, medium-hard pencil* — technical drawing pencils are good because they have very thin leads.

- *A kneaded eraser,* artgum, pounce (chalk-filled pillow), to remove pencil marks from the mounting board and clean away any finger marks.

- *A drawing board* and smooth cardboard to use as a base to cut on, to prevent damage to your work surface (avoid wood with heavy grain or corrugated board because the knife will follow the crevices).

Additional useful items include a pure bristle brush (2-1/2") to brush off mounts and prints, and an architect's "bean bag" to hold down the print when positioning it on the mounting board. A roll of masking tape.

MOUNTING STEP-BY-STEP

1. Clean off your work area and make sure it is well and evenly lit; shadows might cause you to make mistakes.

2. Measure the board you plan to mount the print on. Use your T-square and ruler to measure off and mark the dimension — both the outside edge and the area the picture will occupy, if it is not to be flush mounted. Keep pencil marks to nearly invisible dots.

3. Place several layers of smooth cardboard underneath the board you are about to cut. Tape them to the drawing board or other cutting surface so that they won't slip.

4. Using the T-square, ruler, or straightedge, cut *carefully* through the board along the points you made earlier. Do not attempt to get through the board all at once. Several smooth strokes with a really sharp blade are more effective and safer than one strong slice. Press down firmly on the T-square, letting the blade of your knife go smoothly along its edge. Be careful not to turn the blade into or away from the edge of your T-square. Make certain you know where your fingers are at all times! Change blades *as soon* as you feel any resistance while cutting. Sharp blades will do most of the work for you and are safer to use.

5. When your board is the right size, take a sheet of mounting tissue and trim it so that it is just *very slightly* smaller all around than your print 3mm (1/16 in.). You can also tack the mounting tissue to the print (Step 8) and trim them together.

6. Turn on the mounting press and set it to the correct temperature. (Follow the manufacturer's recommended temperatures; there are variations between temperatures for fiber-based and resin-coated papers.) Also plug in your tacking iron and set it low for RC papers, medium for fiber papers. Clear off your working space leaving only print, board, and tissue. Get rid of any slivers of board or tissue that may have been left over from cutting; if any get caught between your print and mounting board they will show up as bumps after mounting.

7. When the press has reached the correct temperature "bake" the board and the print by placing each one by itself in the press for a few second. This will remove any inherent moisture that could otherwise cause uneven mounting or warping. First, though, make sure you have a sheet of clean, smooth paper in the press to prevent the print and board from coming into direct contact with the

Measure and mark the dimensions on the mount, both the outside edge and the area the photograph will occupy.

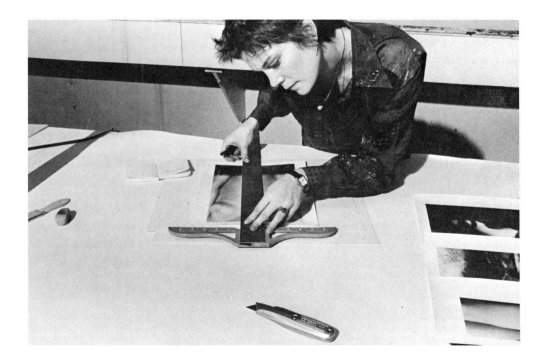

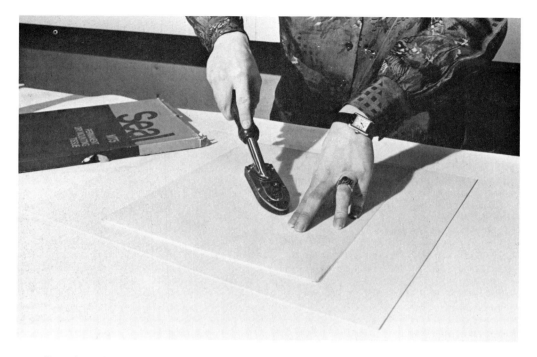

Press the tacking iron onto the tissue near the center of the print. To attach the print to the mount, lift one edge of the print and tack the tissue to the board.

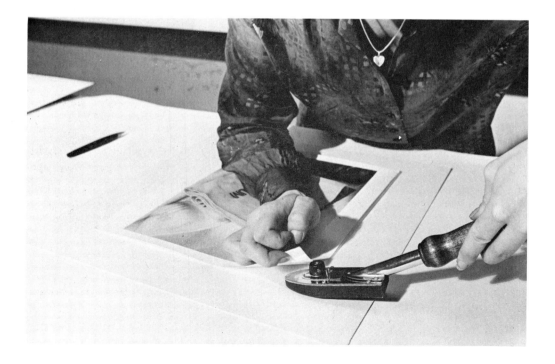

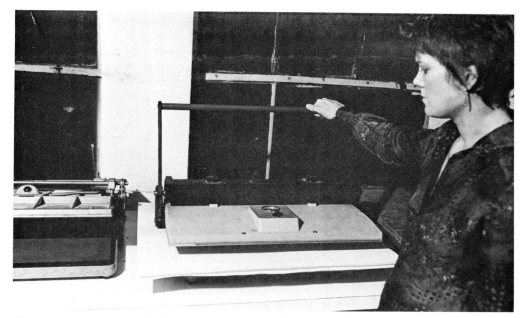

Place mount, with print attached, into the press and leave for recommended time.

heating surface (platen). Check that the felt-covered lower platen is clean and no threads or grit are on it.

8. Place the "baked" print face down on a clean piece of paper on your work surface. Lay the trimmed-to-size-sheet of mounting tissue over the back of the print. Press the surface of the tacking iron onto the tissue, near the center of the print. Do not leave the iron in place for more than about a count of 3; just long enough to make the tissue adhere to the print.

9. Put the mounting board on the work surface. Place the print-tissue combination face up on the board and square up the print and board. If you are mounting with a border be sure the print is within the marks you made for it in step 2. Using a piece of clean, lintless cloth to hold the print in place at its center with your elbow or forearm, lift one edge of the print and tack the tissue to the board. Do the same on one other side to make sure the tissue is flat and there are no crimps in it.

10. You now have the print adhering to the tissue at the center and the board adhering to it by the edges. Carefully lay the sandwich in the press. Close the press, having made sure that print and board are properly aligned (if flush-mounting) and that the protective sheet of paper is in place, between the platen and the print.

11. Leave the press closed for about 1 minute (or the manufacturer's recommended time), then remove the mounted print. Immediately place the print under a cool weight so it won't warp. A pair of large, heavy books will do, provided they completely cover the mounted print. (Place the print face down on an inter-leaving sheet before placing the weight on top).

12. After a few minutes, take the print out and examine it. Flex it gently to make sure the mounting has taken hold properly. If you notice any separation, put the print back in the press for another minute, then remove and let cool once again.

Mounting Considerations. How you position your print on the mounting board or which surface or color of board you use is often a personal choice.

Mounting board is available in white, off-white, cream, black, and a variety of tones and colors in between. Surfaces can be shiny, matte, "pebbled" or even have a "tweed-like" look.

Fancy surfaces and colors are often preferred by "salon" exhibitors, especially with color photographs. They are also used by photographers who want to display a favorite photograph in their home and want the presentation to match the surroundings. Generally speaking, with a straightforward black-and-white print, it is best to keep the mounting simple. Use a white, matte, board for a cold-tone print and an off-white or cream, matte, board for a warm-tone or heavily toned print.

Mounting board is also available in various thicknesses, or weights. A two-ply board is about as lightweight as one should use and that for prints smaller than 20×25 cm (8×10 in.). Anything larger than that should go on a heavier 4-ply board.

(Also if you have processed your prints archivally do not negate all your efforts: Use only acid-free, neutral pH mounting boards.)

Traditionally, a print is centered on the board, with a little more space allowed on the bottom than on the top. Relationship of print size to mount size can vary but some workable proportions are: A 28×36 cm (11×14 in.) board for prints up to 20×25 cm (8×10 in.) and 36×45 cm (14×18 in.) or 38×47 cm (15×19 in.) boards for prints up to 36×45 cm.

Always place a clean, smooth interleaving sheet over your mounted print to prevent scratches and abrasions on the print surface.

Although overmatting your mounted prints is not necessary many photographers feel it gives a more finished look and provides additional protection.

Lastly, keep in mind that mounted prints require more storage space and care in handling. You'll save on time, energy, and space by only mounting selected prints.

RECORD KEEPING

The one aspect of photographic work that most photographers pay the least attention to is the establishment of an effective filing system for their negatives and prints. There may be little need for a system at first, but as time goes on, and the body of work increases, it gets harder to keep track of one's negatives and prints.

A good method is one that will let you find specific negatives or prints in the least amount of time and with the least bother. There is no universal system, but the following hints may help you work out your own.

The simplest way to begin a filing system is by making contact proof sheets of each roll of negatives, tape the contact sheet (thoroughly washed) to the sleeves containing the negatives, and note its content on an index card, a separate piece of paper in a master file, or in a record book set aside for that purpose. Space should be left for descriptive entries of each frame, so that these can later be cross-indexed by subject. Further notes can be made on the back of the contact sheet. Give each roll a number, and write it clearly on the negative sleeves, contact sheet, and record pages or cards. Then if, for convenience of storage as your material grows, negatives are to be kept separate from their contact sheets, the roll number on the back of the contact sheet will lead you quickly to the negatives. On the negatives, roll numbers can be easily

marked on the shiny side at the clear edge of each strip (see illustration). India ink, while permanent on paper, can wash off the film base; instead get an opaque waterproof acetate (or "celluloid") ink from an art-supply store. It will not affect the negative emulsion, but be careful to avoid getting ink on the image itself.

This kind of basic system is of immense help to the photographer whose negatives are beginning to accumulate. The only difficulty is to schedule yourself to number and note each roll of film when you develop it. That way, your record-keeping will stay up to date and never overwhelm you.

A comprehensive and detailed analysis of filing and classification can be found in the *Leica Manual,* 15th Edition, pp. 475-84 (Morgan & Morgan).

STORAGE

Safe storage of negatives and prints is much easier today than it used to be. Makers of commercial negative sleeves and print storage boxes have responded quite well to the ever growing need for chemically inert storage materials. Glassine and plastic negative storage sleeves made by such concerns as Paterson and ROWI are for the most part suitable for long-term storage of photographic negatives. There are two things to be wary of when purchasing these items, however; color and odor. *Color:* Do not buy glassine sleeves that appear to have a yellowish cast. This hue is usually caused by the presence of sulfuric acid in the material. Sulfuric acid will, given time, do horrible things to photographic emulsions. *Odor:* Avoid plastic negative sleeves that "smell of plastic". What you are actually smelling is petroleum-based vapor, given off by some plastics, which is detrimental to the stability of photographic emulsions.

For *temporary* storage of prints, there is nothing as good, as inexpensive, and as convenient as the box the paper arrived in, together with its original black paper. Photographic paper manufacturers are

more aware than anyone else of the delicacy of their product, so they take appropriate care when selecting materials for packaging. If you use such boxes for storage be *sure to label them* "Prints", to avoid any possibility of accidental exposure of unused paper in case boxes get mixed up.

Longer-term or permanent storage of prints is best done in boxes specially designed for that purpose. These come in various size and depths from various makers. See Listing of Suppliers—for names and addresses of firms dealing in Archival Storage supplies. Interleaving paper is extremely useful in keeping print surfaces clean and free from scratches. Make sure *any paper that comes into contact with your prints* is totally *acid-free* and preferably made from 100% *rag stock*. Rag paper is relatively expensive, but is worth the price because it is chemically inert: Not only will it not harm your prints; it will also act as a barrier to sulfur from other sources—wood, mounting boards of less than museum purity, and so forth. Fine rag paper is available at art-supply stores.

Photographs should be stored in a cool, dry place. Silica gel packets, placed in or near the boxes holding your prints, will help to keep the humidity at an acceptably low level. Dryness is more important than temperature—damp heat is the worst condition for storage. Silica gel turns pinkish as it absorbs moisture; it has to be replaced from time to time, even in dry climates.

Special Techniques

Photography is not solely confined to the production of silver based images on mass produced photographic paper. The medium makes use of any method that creates images by the chemical action of light on a sensitive surface. This means that photographs can be made on cloth, china, wood, metal or any other surface to which a light-sensitive emulsion has been applied; and that a wide range of chemicals can be used to obtain a photographic image.

This chapter describes various methods of altering the "straight" photograph. The methods and techniques discussed may or may not make whatever photograph you use them on better — just remember that the best image results from knowing when a particular process suits and enhances not only the physical appearance, but the *intent* of the image as well. This is to say that anyone using these processes in an attempt to give a bad or weak photograph a new lease on life will probably be in for a disappointment — although an occasional pleasant surprise might occur.

Be careful to follow all manufacturers' instructions when you use the various substances described here. Some of them can be quite dangerous if used wrongly, so be meticulous in your measurements, in ventilation if necessary, and in following all indicated safety precautions. Double check every move you make with chemicals you're not familiar with, and you will be assured of a safe and pleasurable expansion of your photographic horizons.

SOLARIZATION AND THE SABATTIER EFFECT

In 1862, a Frenchman by the name of Sabattier discovered that re-exposing a photographic emulsion to light during development caused a rather unusual and pleasing effect, provided that the re-exposure was not too intense or too long to make the emulsion turn completely black. Since that time, many photographers have taken advantage of this effect to produce visually striking, sometimes surreal images.

The *Sabattier Effect* is caused by a partial reversal of tones, especially around the outlines of sharply defined objects, or lines. Essentially what happens is this: The photographic image develops and becomes visible because the emulsion's silver salts undergo a chemical breakdown, causing metallic silver to build up in the exposed, developing areas. The deposits are most dense where the exposure has been greatest, and where development has taken the most effect. Now, the silver deposits on a partially developed emulsion act as a kind of barrier, or mask, that blocks some of the light the film is hit with during re-exposure. The second exposure therefore becomes a "ghost image", superimposed on the first. This causes a mirror effect, or reversal, in those parts of the image that have sharply defined edges.

The more technically minded might prefer the following explanation: Bromide ions in the emulsion will retard development at the borders be-

tween fully and partially developed areas of an image that undergoes re-exposure. This causes an effect known as a Mackie Line (a sharp, black outline around the sharply defined areas mentioned earlier). This line is far more noticeable on negatives than on prints.

Controlled re-exposure of *photographic paper* is generally referred to as *solarization*. The principal is much the same, and many people mistakenly refer to any re-exposure during the development process as solarization.

Both of these processes will produce a negative and positive image at the same time. The Sabattier Effect on film offers you the advantage of repeatability—the effect is permanent, so that many prints can be made from the treated negative. Solarizing prints is somewhat harder to control; it is difficult to produce exactly the same effect twice. However, the advantage of solarizing a print is that since the negative is a normal one, conventional prints can be made from it as well.

Almost any kind of film can be used to produce Sabattier negatives; but sheet film is more convenient to use since it can be processed one piece at a time. Roll film and 35mm users will have to "Sabattier" all the negatives on a roll, since it all has to be processed at one time.

The most convenient and controllable method of producing a Sabattier photograph is to take a conventional negative and print it onto a piece of sheet film. This will give you a positive image which you can use as is, or you can contact print it onto another piece of sheet film to produce a negative image. In either case, the Sabattier Effect is done on the sheet of film, so you can make your camera exposures as you normally do, leaving all of the special manipulations to be done in the printing darkroom.

Kodak Commercial Film 6127 works very well for the Sabattier Effect. A full image appears on this film after about 40 seconds of development. The image will turn almost completely black during re-exposure, as described in the procedure

below. DO NOT BE TEMPTED TO PULL IT FROM THE DEVELOPER before the full development time has elapsed—it will lighten and clear during fixation.

Here are the steps to follow for *Kodak* Commercial Film 6127:

1. Use a RED safelight—the film is orthochromatic, and can be developed by inspection.

2. Use a sheet of film to make an exposure test-strip.

3. Develop in *Kodak* DK-50 developer, full strength, for 2 minutes with constant agitation.

4. When you have determined the proper exposure for your image, expose a sheet of film at that exposure. Set your timer for 2 minutes, and begin developing, remembering to agitate constantly.

5. Make sure that the film is placed in your developing tray EMULSION SIDE UP. Develop for 30 seconds, constantly agitating, then allow the film to settle to the bottom of the tray for 10 seconds with NO AGITATION.

6. Re-expose the film to white light while it is still in the developer. A safelight with the filter removed, or an enlarger light will do well.

7. Turn off the white light, and agitate again. Keep the film constantly moving as you develop it for the remainder of the 2 minutes.

8. When the 2 minutes are up, rinse the film in stop bath, then fix, wash, and dry the film as you would any other.

If you want to do this with HP5, Agfapan, Tri-X or any other panchromatic film, you will have to carry out the steps in total darkness.

Kodak Plus-X sheet film will give good results if processed as outlined below:

1. Tray process the film in *Kodak* HC-110 developer at a dilution of 1:16 at 20°C (68°F).
2. Set your timer for a total development time of 3 minutes.
4. Make sure the film is completely submerged, then re-expose it to white light.
5. Turn off the white light, and continue developing for the remainder of the 3 minutes.
6. Rinse in the stop bath, fix, wash, and dry as usual.

No mattter which type of film you use, the length of time you have to re-expose can only be determined by experimentation. Too much will wipe out the image; too little may not give you the effect you are after.

Kodalith Ortho Film 6556, Type 3, will give interesting results with this process. This film's very high contrast will make the Mackie Line very noticeable. Use Kodalith Super Developer, prepared just before use. Kodalith film can be safely used under a red safelight; agitate the film constantly before re-exposure, BUT NOT AFTERWARDS, or you will end up with streaks and blurs.

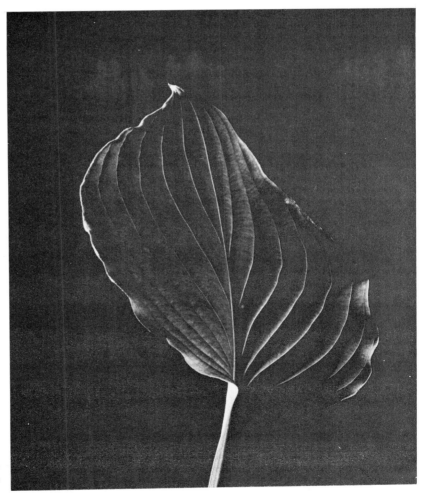

Funkia Leaf© by Barbara Morgan.
An example of the Sabattier Effect,
with a well-defined reversal.

SOLARIZING PRINTS

High contrast papers are best for solarization, since they tend to fog less than low contrast ones. Here is the procedure:

1. Set your developing time for 1-1/2 minutes.
2. Put a negative in your enlarger, focus, insert paper, and expose.
3. Develop the print for about 20 seconds with constant agitation, then turn it face down and allow it to settle for 10 seconds with no agitation.
4. Turn the paper face up, and re-expose using a 7-1/2 watt bulb mounted about 5 feet away — or use the light from your enlarger. (NOTE: If you use your enlarger, you will have to wipe all of the developer from the surface, or you will get blotches).
5. Turn off the white light, and continue developing for the remaining of the 1-1/2 minutes.
6. Stop, fix, and wash the print as usual.

You might want to vary the length of development, or the distance of the white light source. Attaching a dimmer switch to the light source, will give you much more control over re-exposure.

As you begin to solarize images, you will find that the exposure used for a conventional print will be somewhat too long for an effective solarized image. Control of the final result is never predictable, but you will have far more control if you start with about half of the exposure needed normally. Longer re-exposure times will produce a more negative image, so you can fine-tune your results by juggling your exposure/re-exposure times until you get the effect you are after. Further control can be obtained by changing your developer dilution; try Dektol at 1:10, for example — but remember that you'll have to increase exposure time. In a while, you'll be able to judge the difference in exposure time needed for a solarized print and a conventional print of the same negative.

A Test Print. As has been made clear, solarizing a print is not the most predictable of photographic processes: Often the effect will be more as if the print was fogged rather than solarized. Making a test print will give you some idea as to what happens in different combinations of basic exposure and re-exposure. To make the test proceed as follows:

1. Mount a 7-1/2 watt bulb five feet above the bottom of the developer tray.
2. Mix the developer (and stopbath and fixer). To start try Dektol 1:10. (With a more concentrated dilution reduce the developing times given.)
3. Insert your negative in the enlarger and make a test strip print; move a cardboard, *vertically*, across the paper in a five-second intervals for a total 25 seconds.
4. Develop the print for 1 minute with agitation.
5. After 1 minute turn the print face down and let it settle for about 10 seconds without agitation. (Another method involves transferring the print to a tray of plain water where the print is allowed to settle, face down, for 1 minute.)
6. After the settling time is up turn the print face-up and re-expose; move a cardboard, *horizontally*, across the print at five-second intervals for a total of 25 seconds.
7. Continue development, with agitation, for an additional 2 minutes.
8. Stop, fix, and wash the print as usual.

The result of all this will be a print with a "checkerboard" pattern giving you 25 possible combinations — the basic exposure in the vertical strips and the re-exposure time in the horizontal strips.

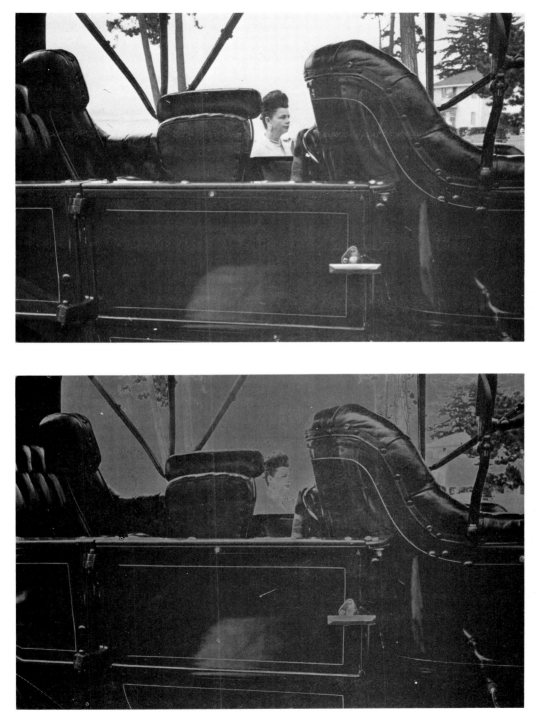

A straight print and its solarized version.

PHOTOGRAMS

Photograms are the simplest, and in a sense the purest, of all photographic forms. They are made by placing opaque or translucent objects directly onto a piece of photographic paper or film, then exposing the combination to white light. Processing is done in conventional photochemicals.

In the history of photography, they have been a number of well known figures who made photograms. The earliest of these was William Henry Fox Talbot, who, in 1839, exhibited a series of images made by pressing ferns, flowers and lace against sensitized paper. This produced white silhouettes against a dark ground. Fox Talbot called his photograms "Photogenic Drawings".

More recently Man Ray and Christian Schad,

two artists much involved in the Dadaist movement of the first quarter of the century, produced many photograms. Schad, who called his results "Schadographs", used opaque paper cutouts. Man Ray used all sorts of objects including bottles, chicken wire, and even salt and pepper and entitled his photograms "Rayographs".

To make your own photograms, stop down your enlarging lens 2 stops and place a sheet of photographic paper in the easel. Now look around your darkroom — there are all kinds of things at hand — your focusing aid, magnifying loupe, a pair of scissors, a film reel, whatever. Place these directly on the paper, and move them around until the arrangement suits you. Expose the paper for 10 seconds or so, remove the objects, and process the paper normally.

Light will have been blocked where the objects rested on the paper; if some of them were translucent, light will have been retarded, causing varying shades of gray to register. Multiple-image effects can be obtained by moving the objects between several short exposures.

You might also want to combine the projection of a negative with objects placed on the paper. The possibilities are boundless, the basic procedure painless; and the results can be quite rewarding.

COMBINATION PRINTING

Combination printing is, as its name implies, the making of one photograph from a combination of negatives. The procedure was first used out of necessity: In the 1850's photographers were rather limited by materials available to them. Film emulsions were very slow and incapable of recording a wide range of tones. It was impossible, for example, to record land and clouds in the sky on the same negative — so photographers of the time (most notable among them Gustave Le Gray) would make the "land exposure"; then a "cloud exposure" on another plate. These were then masked and printed together, giving a more or less realistic depiction of an outdoor scene.

Modern emulsions, with their broad color sensitivity and wide latitude, obviate the need for this kind of multiple printing; but the technique can be put to good use by anyone with a need or desire to print parts of two or more images together.

The most critical thing in multiple printing is registration. The positioning of the negatives must be precise, and this can be difficult, especially if the images are complex, or if your negative carrier is of the glassless type.

To make combination printing easier, try to use negatives that have large blank space which you will fill in with other negatives. If the blank space in the negative is clear, and if you have another negative of the same size, you may be able to put

them into the negative carrier together. If the two images cannot be combined this way, as a sandwich, follow this procedure:

Put one negative in the carrier and focus the image. Place a sheet of plain white paper in the easel and sketch the outline of the empty area. Mark the position of the enlarger. Remove the sketch, then make a test strip for the negative.

Now insert the second negative in the enlarger and put the sketch back in place. Adjust the negative until it lies as you want it to in the final print. Remove the sketch, mark the position of the enlarger, and make a test strip for this negative.

Develop and examine both test strips. Make a note of the exposures that work best.

Print the second negative on a fresh sheet of paper, and dodge out any areas that may overlap with the first negative. Do not develop this sheet but put it in a light-tight box. Be sure to mark the paper so you can put it back in the right position when you return it later on. Remove the negative.

Now put the first negative back in the enlarger at the height you had noted. Use the sketch to help you place and focus it properly. Put the exposed paper back in the easel, checking the positioning mark you put on it before, and print. Dodge where necessary to prevent clear areas from printing as black.

Finally, process the paper in the normal way. If you use negatives of very different contrast you may experience some problems. To look right, the grain and the contrast of the negatives must be similar, and it is wise to use negatives made on the same type of film.

Sophisticated print-making and negative combinations have been around since the mid-19th century. Oscar Rejlander and Henry Peach Robinson were technical marvels in this respect. Rejlander combined up to 36 negatives in some of his pictures, painstakingly printing each image onto one huge piece of sensitized paper. Robinson sketched out the details of his large prints before he made them, planning the image as if they were paintings.

Fossil in Formation © *by Barbara Morgan. The print above is the result of combining the two images opposite. The view of the city is printed lighter than it would be as a straight print, so the city appears ghostly when combined with the fossil.*

This fascinating "map projection" of a human body is the work of Tetsu Okuhara.

Although not strictly a darkroom technique, the method used to arrive at an image such as this is not particularly complicated, requires little in the way of special materials, and can be immensely rewarding if done with care and a keen sense of aesthetics.

Mr. Okuhara makes his images by photographing his subject from a multitude of meticulously worked out angles, then by making tiny (contact or near contact size) prints of each negative he plans to use in the final product. Each of the tiny prints you see so carefully registered on the opposite page is from a different negative. The registration has to be exact, the spacing worked out to the millimeter. Planning the final print is a time consuming and painstaking procedure. The end result is much like an exploded view of the subject, giving you a glance at a number of perspectives all at once—a true, working two-dimensional representation of a three-dimensional object.

MONTAGE

A montage is a construction of images that overlap, join or merge with one another. This technique allows you to create shapes and patterns, alter scale, or combine images that one would not normally see together.

To make a photomontage, find prints that match one another in contrast and tone, preferably on single weight paper (it's easier to cut). Using a pair of very sharp scissors, cut out the needed parts of each print and feather the edges with fine sandpaper on the back of the print. Now apply a layer of thinned rubber cement and attach it in a marked position. The edges may have to be retouched with SpoTone.

Cutouts can be made of different photographs. Mounting them on wood blocks or cardboard will give you images more of a three dimensional quality.

Some photographers completely cut apart and rearrange the elements in a print, making a new pattern of forms. A photograph can be cut in slices, squares or discs, and then recomposed. Sometimes an interesting montage can be created by using one image repeatedly. The image can be flipped by turning the negative upside down, or left to right, then combined with the normal image. Patchwork montage can give your photographs a surreal quality. Juxtapose unexpected objects to evoke fantasy, absurdity, or humor.

Montage is an effective way to produce panoramic views of a landscape or interior. Start by shooting the sequence on a tripod so that the horizon line will blend exactly when you splice the images together. (Overlap the image slightly to allow for later registration on the paper.) All exposures should be at the same F stop and printed identically to create the illusion of one final print. Use single weight printing paper, and dry mount the images in the proper sequence.

GRAPHIC ARTS FILM

Graphic arts films are used commercially in lithographic, letterpress, gravure and silkscreen printing.

In conventional photography you expose the film, develop it and then make paper prints from the film negative. In graphic arts, film is exposed and developed, but then is used to prepare a printing plate with which the final image is produced.

Unlike conventional film, which is capable of recording a wide and subtle range of grays from black to white, graphic arts film is extremely limited, producing a high contrast image that is almost exclusively comprised of blacks and whites. Middle tones are arrived at by projecting the developed film through a special screen that breaks up the high contrast image into a multitude of tiny dots. When printed, the resulting dot pattern visually fuses with the white of the paper, giving the illusion of gray shades. The image produced is called a *halftone.*

Autoscreen film is a special type of graphic arts film, containing a built-in dot pattern. This enables it to transform a continuous tone original into a halftone image directly.

Most commonly used graphic arts films are orthochromatic, or blind to red light. They can therefore be safely handled under a red safelight.

One of the most commonly used graphic arts films is *Kodalith*, although several other companies also make similar lithographic film.

A good film to start with is Kodalith Ortho Film Type 3. Begin with ordinary photographic chemicals, except for the developer. Use Kodalith developer, which comes in two parts. Keep Part A and Part B mixed in separate brown bottles, combining them only as you begin to work. This developer will be exhausted three hours after the two parts are combined, but can be stored in separate form for several months.

Next, put red safelight filters in your darkroom. A red, low wattage light bulb (7 to 15 watts) will also work. Be sure to keep all safelights at least 4 ft from the film and chemicals.

Put a negative or slide in the enlarger and focus. Kodalith should be placed in your enlarging easel with the lighter, emulsion side upwards. Make an exposure test strip, and process the film in the developer. Be very careful not to scratch the film, and keep it free of dust to prevent pinholes. Stop, fix, and wash as you would a paper print, and then hang the negative up to dry.

Once you have determined the proper exposure, you can make a final Kodalith film positive (provided, of course, that you started with a negative in the enlarger). If you began with a slide, you will end up with a negative image which can then be contact printed onto another sheet of Kodalith for the final positive image.

Some photographers take the positive final Kodalith and place colored paper behind parts of the image, or tint the film with dyes, such as those used by cartoon animators (cel vinyl colors). They tape the final result to a mounting board, mat it, and display.

Others make a contact print of the positive so that paper prints can be made from the resulting large negative. However, better results can usually be obtained if you use a direct positive *duplicating film* for the production of large negatives.

To use duplicating film, set up your darkroom as usual. Put a normal negative in your enlarger and project it to make a test strip on a piece of high speed duplicating film. The film should be developed for 2-1/4 minutes in Dektol to get a continuous-tone negative. If you use DK-50, development will take a full 7 minutes. Remember that this is a direct-positive film—dodging and burning are reversed. The longer you expose the film, the lighter it gets. If your image is too dark it needs *more* exposure, not less.

This film can be used to contact print negatives, glass plates, or any translucent image source. The result can be enlarged or contact printed onto normal photographic paper.

*Window #3 by Amy Stromsten. This image is from a series of
window with Kodalith images placed on the glass*

CYANOTYPE

The Cyanotype process, also called blueprint, is used by engineers and architects as a convenient method of reproducing technical drawings. The process was discovered in 1840 by Sir John Herschel: Therefore this is one of the earliest forms of photography, and the only one of these early forms still in widespread use.

The Cyanotype produces blue images on a white ground, using two readily available and relatively inexpensive chemicals. These are Ferric Ammonium Citrate and Potassium Ferricyanide. These substances are usually on hand at any chemical suppliers. When mixed together with distilled water, they form a sensitive emulsion that can be applied to natural fibers such as cotton, canvas and silk, and to sturdy papers such as those used for watercolor. If you decide to use paper, make sure that it is pre-sized when you buy it; or size it yourself by spraying with household fabric starch.

Follow the steps below to make the emulsion:

Part A:
Ferric Ammonium Citrate 50 grams (1.76 oz)
 to
Distilled water 237 ml (8 oz)

Part B:
Potassium Ferricyanide 35 grams (1.23 oz)
 to
Distilled water 237 ml (8 oz)

Parts A and B must be kept in separate, tightly stoppered containers made of dark glass or plastic. They will keep for several months.

To sensitize a surface, combine equal parts of A and B, and use immediately.

Caution: When mixing the chemicals, do so in a well ventilated area and WEAR RUBBER GLOVES. Avoid inhaling the powders, and keep the solutions away from skin and clothing. Blueprint emulsion is quite toxic and stains the skin.

Coating the Surface. Under very dim light, apply the solution (equal mixture of A and B) to your material evenly with a brush, or fill a tray with the chemicals and soak your material in it. Let the material dry in total darkness (if you are in a hurry, you can speed up the drying with an electric hair dryer; this can be done under very dim light). Once dry, the emulsion will appear a yellowish-green.

To make an image on the coated material, bring a Kodalith negative in contact with it and press together with a sheet of glass. Strong sunlight, carbon arc lamps or fluorescent "black light" tubes can all be used as light sources. The light from your enlarger, or tungsten light sources will not work well because their output is not intense enough for reasonably short exposure times. Make tests to determine the optimum exposure time for whatever light source you decide upon. Sunlight will usually produce sufficient exposure in about 1 minute; carbon arc sources require at least three time that amount. (If you use a carbon arc light source, MAKE SURE OF GOOD VENTILATION, and keep out of the area during exposure. Carbon arc gives off dangerous fumes.)

During exposure the emulsion will turn a bluish green in color. Fixing is not necessary—just wash the print until the yellow stain (which appears as you begin to wash) is gone, then air-dry.

You can intensify the blue color by dripping the print into a solution of 1 part Clorox bleach to 32 parts water. Immerse the print for 15 seconds, then rinse for at least 15 minutes. The print will darken as it dries.

If the blue image disappears during washing, you have underexposed your print (sufficient exposure causes the blue image to "set"—less than enough will cause it to remain water soluble). If, on the other hand, you find blue stains in the highlight areas of your print, you have overexposed, or the emulsion was fogged.

Photograms work very well as blueprints. Try combining a large negative with variously placed objects on the same print. Bold shapes and graphic images will work best.

VANDYKE (BROWN) PRINTS

This process is similar in many respects to the cyanotype: It is easily done and provides an excellent medium for the making of images for combined negatives. It differs from the cyanotype in that the final image is sepia colored, fixation of the image is required, and the materials are more expensive. (The process makes use of silver nitrate, which is not cheap.)

The chemical formula for Vandyke is as follows:

Ferric Ammonium Citrate (green) . .	90 grams (2-2/5 oz)	
to		
Distilled water	237 ml (8 oz)	
Tartaric Acid	15 grams (2/5 oz)	
to		
Distilled water	237 ml (8 oz)	
Silver Nitrate	37.5 grams (1 oz)	
to		
Distilled water	237 ml (8 oz)	

Mix the chemicals separately. Combine the ferric ammonium citrate and tartaric acid first, then add the silver nitrate solution. WEAR RUBBER GLOVES. SILVER NITRATE WILL BURN AND STAIN SKIN.

When all the chemical solutions have been combined, add distilled water to bring the total volume to 1 liter (34 oz). This stock solution will keep for several months in a tightly stoppered brown bottle if kept away from light and at average room temperature (cooler is okay; overly warm conditions may shorten the lifespan of the working solution).

The emulsion can be brushed or soaked onto paper or cloth in the same way as blueprint emulsion. Exposure will vary from about one to five minutes, depending on the light source used. As with blueprint, sunlight will do the job fastest, but any really intense artificial light source can be used as well.

Fixing. Vandyke prints should be fixed, but not in the conventional way. After exposure and a 5 minute wash, fix in a solution of 1 part ordinary fixer to 20 parts water. This will darken the color to a deep sepia and will brighten the highlights. The emulsion will begin to "set" while fixing, and will become hard. Check after a minute or two, and remove the print as soon as it has hardened. After fixing, treat the print with hypo clearing agent and wash for 30 minutes.

GUM PRINTING

The Gum Dichromate process was described as early as the mid-1850's and is one of the oldest methods of achieving color in photography. Gum arabic is mixed with a combination of pigment and a light-sensitive potassium dichromate solution. The solution is applied to paper and allowed to dry. A negative (the size of the image desired) is then laid in contact with the sensitized surface; an exposure is made using a high-ultra-violet light source. Wherever the light hits the emulsion, the gum arabic hardens and will not dissolve, thereby trapping the pigment. The unexposed areas will float off the page when the paper is washed in water.

Many papers can be used for gum printing but they should be slightly textured and of sufficient strength to withstand repeated soakings. Most papers should be treated with size before printing. Sizing will keep the whites in the highlight areas from staining and will also prevent the solution from penetrating too deeply into the paper. Various kinds of sizing can be used. Fabric spray starch can simply be sprayed onto the paper and allowed to dry. Acrylic gesso diluted 1:5 with water can be coated onto the paper with a brush. Some prefer gelatin (Knox), diluted 28 grams to a liter of water: Immerse the paper, then hang it to dry after pressing out excess gelatin with a squeegee. When dry, harden the sheet in a weak solution of formaldehyde (25 ml to 1 liter of water) to keep the gelatin from dissolving when the image is developed.

Pure gum arabic for the gum-pigment mixture can be purchased in either powdered or liquid form. Fourteen-Baumé gum should be used. The pigment can be either dry or tube watercolor; though certain pigments such as viridian, cobalt violet, and chrome colors will not work because of their inherent makeup. On the other hand, the cadmium colors, thalocyanine greens (and blues), Alizarin crimson, and the earth colors will work very well.

Whatever pigment you use, begin with the basic formula of 1 small tube of pigment (or its equivalent) to 100 ml of gum arabic. More or less pigment can be used, but there is a saturation point at which the addition of more pigment will render the mixture too dense to expose properly and will cause staining. Run a test of your mixture by exposing a small piece of coated paper, allow it to dry, then wash it. If the pigment stains, add more gum arabic and test again.

The gum-pigment mixture is made light sensitive by adding a prescribed amount of ammonium dichromate or potassium dichromate. Potassium dichromate is less likely to stain, but is rather slow. Ammonium dichromate is best if you plan to use an artificial light source, but the risk of staining is markedly higher.

SENSITIZER FOR GUM PRINTING

Dissolve:

Ammonium or Potassium dichromate	29 grams
in hot water .	75 ml
and add	
Cool water to make	100 ml

Mix equal parts of gum-pigment mixture with the dichromate, or add 1 part dichromate to 2 parts gum pigment. Apply the solution to prepared paper with a soft bristle brush. The mixture should go on smoothly—if it is too thick for even application, it is either over-pigmented or under-dichromated.

Let the paper dry in the dark (the emulsion becomes light sensitive as it dries). To expose, use a medium contrast negative—this is a contact printing method, so the image has to be as big as you want the final product to be (see page 000).

Direct sunlight, black-light fluorescent tubes, 2500W-photofloods, commercial sun lamps, carbon arc and mercury-vapor lamps can all be used as light sources. The light source (other than the sun!) should be about two feet from the printing paper, with the exception of fluorescent, which can be as close as 10cm (4 in.). Too much heat, such as a

The Picture Book, 1902 by Gertrude Kasebier (Collection, Library of Congress). The top photograph is a straight print, the bottom one is a gum print

hot summer sun, will make the gum arabic insoluble, and the image cannot be developed.

Exposure to a black-fluorescent tube will take about 7 minutes. Other light sources will vary according to intensity.

Develop the exposed image by first submerging the image face down in a tray of *cool* water 20°C (68°F). Make sure that the back of the paper is covered, to avoid dichromate staining. The yellow overall color of the emulsion will wash out after about 15 minutes in this first bath. Once it is gone, place the print into a second water bath, this time a warm one. Be careful—the image will be soft at this stage and can be damaged easily. This is the stage at which the image "develops". Once it has done so, place the print into a third, *cold*, bath of water for 5 minutes, to help harden the emulsion.

If yellow stains get trapped in the paper, they can be removed by soaking it for five minutes in a bath of potassium alum diluted 30 grams to 1 liter of cool water.

Wash the print under running water for 15 minutes, then dry. When your first color has dried, you can prepare a new sensitive coating with another color, make a second exposure, and develop/harden again; or you can add several colors at once and expose them together. Gum printing requires patience, but many believe the results to be well worth the difficulties involved.

Gum printing is but one of the early processes that are receiving a renewed interest from contemporary photographers. For an in-depth look at this and other early processes, with explicit how-to directions, see *The Keepers of Light* by William Crawford (Morgan & Morgan, 1979).

For using photographic imagery in combination with other art forms such as applications on ceramics, glass, fabric, wood, plastic and stone; photoetching, silkscreen, color copier, photo-offset and so on, see *Alternative Photographic Process* by Kent E. Wade (Morgan & Morgan 1978).

LIQUID LIGHT

The Rockland Colloid Corporation manufactures various products for the experimentally inclined photographer. Of particular interest to the darkroom worker is their multi-purpose photoemulsion called *Liquid Light*. This emulsion can be applied to a wide variety of surfaces such as wood, metal, glass, cloth, leather and ceramics—and to either flat or dimensional objects. After the emulsion has been applied to the surface, it is exposed and developed in much the same manner as conventional photographic paper.

Different surfaces require different preparations for successful application: Wood and paper can be coated directly; metals, plastic, and glass must be specially treated first to help the emulsion stick and to prevent fogging. Surfaces needing special preparation are the extremes of nonporous or/and highly porous, and those that would affect the emulsion chemically. Liquid Light comes with a *subbing* solution to apply to any surface that is not compatible with the emulsion. Other surfaces can be prepared with a thin coat of polyurethane. Instructions for every type of surface are enclosed with the product.

Liquid Light is sensitive to blue light only, so it can be handled under almost any safelight—amber, red, yellow, or green. It is important to have good ventilation in the darkroom because the emulsion contains phenol as a preservative.

Since the emulsion should be stored in a cool place, preferably refrigerated in which state it will turn solid, it needs to be liquified before use. Place the bottle briefly in a container of hot water (do not heat the emulsion above 105°F [40.5°C]) and do not shake the bottle—this will result in bubbles that will interfere with an even coating.

Liquid Light needs to undergo two tests before use. One is to determine the sensitivity of the batch (the sensitivity of this product is at its lowest when manufactured—and increases as the emulsion ages); the other to check for fogging. The sensitivi-

Coat the surface

face. Leave the object flat in a dark place, well ventilated, for a least twenty minutes. One of the most common reasons for failure with this emulsion is inadequate drying.

Large, flat surfaces, such as stretched canvas, can be coated with a brush. Use a wooden-handled brush because metal will react with the emulsion. Dimensional objects such as rocks, shells, or sculpture can be dipped in the emulsion, then dried.

When the emulsion is completely dry, and you are ready to print, set up your negative in the enlarger, and arrange conventional black-and-white chemicals as if for paper printing. Refer to your sensitivity test for the proper exposure or make a new test on a coated index card.

If you are exposing something three-dimensional, be aware that you must focus the negative at the

ty test is done like a normal, conventional print exposure-strip test, except that it is done on an index card coated with the emulsion, then developed for the *minimum* time suggested by the developer manufacturer (1 minute in Dektol 1:2, for example). If you insert the negative that you plan to use, this test can double as your exposure test.

The fogging test is done the same way, except the index card is developed without having been exposed. After 5 minutes in a hardening fixer, the test card is examined—if the emulsion is not absolutely transparent, some antifoggant needs to be added to it. This antifoggant is supplied, along with complete instructions for its use, with each container of Liquid Light.

To coat small, flat surfaces, pour off some emulsion and spread it quickly with a fingertip, tilting the surface so that the emulsion covers it completely.Then, before the liquid sets, pour the excess off one corner, through a funnel, back into the bottle. Next, put the coated object down flat with a slight rap. This will break up any air bubbles on the sur-

Expose

Develop as you would a regular print

correct height to allow for fall-off. Use the red filter on your enlarger to prevent fogging while you check the proper focus.

Expose and develop in any paper developer (such as Dektol diluted 1:2 or Selectol diluted 1:1). Use a stop bath, but not an indicator stop bath, since the indicating dye may stain the emulsion. White vinegar diluted 1:1 makes a good "stop" for Liquid Light. Fix in a hardening fixer for at least ten minutes. Wash as you would an ordinary print for at least one-half hour, preferably after using a hypo-clearing agent. Dry in a clean area because the emulsion will be soft when wet, and dust particles will easily imbed in the emulsion.

Rockland Colloid also manufactures a silver toner and colorants. The silver toner, called Halo-Chrome, can produce silver-on-white metallic prints or black-on-silver prints (you actually wind up with a metallic print). Halo-Chrome can be used in conjunction with the colorants, called Prin-Tint, to achieve a variety of effects. For those interested in pursuing this direction write Rockland Colloid Corporation for more information (see List of Suppliers).

Fine Tuning the Chemicals

The following listing of chemical formulations is comprised of various general and special purpose developing compounds, fixers, toners and the like. Some of these are currently being used with contemporary photographic emulsions, while others are old formulas, and it ought to be emphasized; *they may or may not produce desirable results when used with current materials.* Those formulas considered obsolete are indicated with an * next to the formula heading. They are included because many photographers are interested in old compounds and processes.

Pre-packaged, commercially available formulas offer many advantages not the least of which is convenience: Also, all other factors being equal, the end result is consistent and dependable. However, to the photographer inclined toward a better understanding of the photographic process or — experimentation — concocting one's own formulary can be a rewarding experience.

A word of caution: If you alter the amount of *any one* compound in a formula, do it in *very* moderate steps and keep accurate records, so results can be duplicated and mistakes avoided next time.

Lastly, never — never — run a roll of, possibly irreplaceable, negatives through an untested film developer.

MIXING CHEMICALS

It has been said throughout this text, but it bears repeating: Always mix chemicals in the order given (this includes water — it is, after all, a chemical compound).

- *Never* pour water on an acid — always add acid to water, to avoid splattering.
- If the instructions say "stir rapidly" or, "stir vigorously", then do so — otherwise, precipitates may form (some of these can be put back into solution by restirring, others cannot — avoid the risk by stirring vigorously the first time).
- Pay strict attention to temperature, where indicated, not only in processing, but in mixing the chemicals as well.
- If the formula includes strong alkalines or acids, wear rubber gloves. A rubber apron would not be a bad idea either.
- *Never* mix chemicals in your kitchen.
- Do not lean over the container you are mixing in. None of the fumes or airborne particles of photographic chemicals is particularly pleasant, and some are dangerous. If you don't hover over the containers, you will run less of a risk of inhaling harmful substances.
- Always mix in a well ventilated area.
- Measure chemical amounts carefully. For solid substances use a laboratory scale only. Your kitchen scale won't do, for two reasons: First, because of the potential health hazard this poses, and second, because the average kitchen scale is neither sensitive nor accurate enough.
- Clean all beakers, graduates, containers and so on scrupulously, as soon after using as possible — and wash them again before each use just to be sure.

- To avoid difficulty in mixing, make sure containers and measuring surfaces are dry before measuring out powders or crystals onto them.

- Pay attention to the chemical names. For example, do not confuse sulf*ate* with sulf*ite*, or chlor*ate* with chlor*ide*. The very least that will happen if you are careless is that your formula will not do what you want it to. At worst, you might inadvertently cause a dangerous chemical reaction.

- If there are young children around, be sure to take *extra* precautions. A solution stored in a *familiar*, brown apple juice bottle, for example, can only invite disasters. Store out of reach of children.

Metric. In this chapter, metric measurements are given, *only*. Accurate measuring aids — scales and graduates — are necessary if you mix your own formulas; laboratory quality is required (i.e., a kitchen or diet scale won't do). Most, if not all, of these measuring aids are now all metric or give metric as well as avoirdupois measurements.

If you need to convert a formula, conversion tables, and conversion calculation factors, can be found at the end of this chapter.

PERCENTAGE SOLUTIONS

Certain chemicals used in the compounding of photographic formulas are best kept in *percentage solution.* Percentage solutions are made by dissolving amounts of the substance (in the percentage indicated) in water or, in some cases, alcohol. Percentage solutions make the measuring out of extremely small amounts of a chemical far easier — you can drive yourself to distraction trying to measure out 1/8 gram of a crystalline chemical, for example.

To prepare a percentage solution of a liquid chemical, take the *same number of ml* of the substance as the percentage number indicated in the formula, and dilute it into about 50 ml of water. Then add enough water to bring the total volume to 100 ml. For solid chemicals, dissolve as many

grams as the percentage figure given in the formula. For example, if a 5% solution of a liquid is asked for, dissolve 5 ml of the liquid into 50 ml of water, then add 45 ml of water $(5+50+45=100)$ to bring the total volume to 100 ml. If the chemical is solid, dissolve 5 grams of it into 50 ml water, then add enough water to bring total volume to 100 ml.

Figuring Dilutions. To achieve a desired dilution, use the following criss-cross method based on the accompanying diagram.

At *A* place the percentage of the solution that is to be diluted to some lesser concentration. (Example, in diluting 99% acetic acid, place 99% at A.)

At *B* place the percentage of the solution you will use to make the dilution; usually this is water, which has a percentage strength of 0.

At *W* place the percentage strength that you want in the final solution.

Subtract *W* from *A;* place the result at *Y.*

Subtract *B* from *W;* place the result at *X.*

Mix *X* parts of *A* with *Y* parts of *B;* the result is a solution of *W* strength.

For example, using 99% Acetic Acid (*A*), to dilute it with water (0, *B*) to 28% (*W*), take 28 parts of 99% acid and 71 parts water.

DEVELOPERS

In order to put the developer formulas contained in this chapter to their most productive use, it is useful to understand the nature of photographic developers, and the role that each of their component chemicals plays. It makes little sense to change or adjust existing formulations haphazardly; whereas a general knowledge of the job of each part of a developer compound will help you to make sensible decisions should you decide to formulate your own developer, or modify the ones you are presently using.

Developer ingredients fall into 6 categories. These are: developing agents; activators; preservatives; restrainers; solvents; and miscellaneous additives.

Developing Agents. The developing agent in a developer formula is that chemical which changes exposed silver salts of the emulsion into metallic silver, while leaving the unexposed ones relatively unaffected.

The two most commonly used developing agents are metol (also known as Elon) and hydroquinone. Metol produces softer contrast while hydroquinone, a more vigorous developer, produces higher contrast. Either agent can be used by itself or in combination of varying concentrations to produce any contrast desired.

Other developing agents are: Pyro, amidol, catechol, and glycin.

Activators. Developing solutions need to be alkaline to work properly. Since almost all developing agents are not sufficiently alkaline by themselves, some sort of alkaline substance must be added to the formula in order to produce the right environment for proper development to take place. The alkalis used in developer formulas are, from the most to the least alkaline: Sodium hydroxide; sodium carbonate; Kodalk (a proprietary alkaline compound made by Eastman Kodak); and borax.

Preservatives. Photographic developers and the dissolved developing agents in them have a tendency to react with oxygen in the air, producing products that color and cloud the solution. If this is allowed to happen to any great degree, the developer becomes useless. Therefore, most developer formulas call for the addition of sodium sulfite, which combines with the oxidation product in such a way that the solution stays clear longer. Sodium sulfite also reduces the rate of oxidation, giving the developer longer life.

Restrainers. Restrainers, such as potassium bromide, are added to further reduce the possibility of unexposed silver halides becoming affected by the developing agents in the formula. The more effectively this is done, the less "chemical fog" will appear on the clear portions of the emulsion. (Strictly speaking, such formulations as benzotriazole and *Kodak* Anti-Fog #1 are also restrainers—see the paragraph on miscellaneous additives.)

Solvents. A solvent is that which places a chemical formula into solution. Being photographically neutral, water is the ideal solvent for photographic formulas; though some very concentrated liquid formulas call for additional solvent compounds, most commonly diethyleneglycol.

In addition to its role as the medium for developer solutions, water also plays a second, equally important role—it swells the gelatin of photographic emulsions, so that the developer can more easily go to work.

Try at all times to use distilled water when mixing chemicals. If you can't find any, boil your tap water and use that—but distilled water is infinitely preferable.

Miscellaneous Additives. There are a number of other chemicals which, when judiciously added to a developer formula, can adjust it for use under special conditions. For example, if you find yourself needing to process photographic emulsions at extremely high temperatures, you will probably look up the formula for a "tropical" developer, and you will notice that it contains an ingredient not found in a more conventional developing compound. This ingredient is sodium sulfate (not to be

confused with the preservative sodium sulf*ite*). Sodium sulf*ate* retards swelling of the gelatin in photographic emulsions, thereby allowing films and papers to safely endure processing at higher than normal temperatures.

Sodium thiocyanate is another additive that is put into certain developers, for the purpose of dissolving some of the silver halide crystals during development. The effect of this is to make the grain structure of the emulsion less noticeable. Most "extra-fine grain" developers contain small amounts of sodium thiocyanate, or similar compounds.

Benzotriazole and *Kodak* Anti-Fog are chemical additives used to boost the restraining action of potassium bromide. They extend the life of outdated photographic papers and films to a degree.

One more additive worth a mention is water softener, such as *Kodak* Anti-Calcium. This additive is used when distilled water is not available, and when the tap water is especially hard. Hard water tends to cause sludging in developers, and water softening agents will, when added, effectively neutralize the sludge-causing calcium in hard water.

FILM DEVELOPERS

Normal Contrast Glycin Developer Agfa #8

Warm water 52°C	750	ml
Sodium Sulfite, desiccated	12.5	grams
Glycin	2.0	grams
Potassium Carbonate	25.0	grams
Add cold water to make	1.0	liter

Development time for ASA 100-125 films is 10-12 min. at 20°C.

Fine Grain, Soft Working, Metol/Sulfite Agfa #14

Warm water 52°C	750	ml
Metol (Elon)	4.5	grams
Sodium Sulfite, desiccated	85.0	grams
Sodium Carbonate, monohydrated	1.2	grams

Potassium Bromide	0.5	gram
Add cold water to make	1.0	liter

Development time, at 20°C is best determined by testing—but will range between 10 and 20 minutes. The longer the development time, the more contrast.

For High Contrast Results with Sheet Film and Plates Agfa #40

Warm water 52°C	750	ml
Metol (Elon)	1.5	grams
Sodium Sulfite, desiccated	18.0	grams
Hydroquinone	2.5	grams
Potassium Carbonate	18.0	grams
Add cold water to make	1.0	liter

Develop for 4-5 minutes at 20°C.

Agfa #12*

Fine grain film developer with a long life (intended primarily for tank use).

Warm water 52°C	1.0	liter
Sodium Sulfite (anhydrous)	8	grams
Sodium Carbonate (monohydrated)	5.75	grams
Potassium Bromide	2.5	grams

Use undiluted, at 18°C for 8-12 minutes.

Agfa #16

A film developer that substitutes Borax for Sodium Carbonate in order to produce a slow, soft-working and fine grained development.

Warm water 52°C	1.0	liter
Metol (Elon)	1.5	grams
Sodium Sulfite (anhydrous)	80	grams
Hydroquinone	3	grams
Borax	3	grams
Potassium Bromide	0.5	gram

Use undiluted, at 18°C, for 10-15 minutes.

M-H Tank Developer Agfa #42*

A long lasting efficient tank developer yielding negatives of high contrast.

Water	1.0	liter
Metol	0.8	grams
Sodium Sulphite (anhydrous)	45	grams

Hydroquinone	1.2 grams
Sodium Carbonate (monohydrated)	8.0 grams
Potassium Metabisulphite	4.0 grams
Potassium Bromide	1.5 grams

Do not dilute for use. Develop 15 to 20 minutes at 18°C.

Metol-Pyro Developer — Agfa #46*

A developer which gives brilliant printing quality to the negative.

Solution A:

Water	1.0	liter
Sodium Bisulphite	7.5	grams
Metol	7.5	grams
Pyro	30	grams
Potassium Bromide	4.2	grams

Solution B:

Water	1.0	liter
Sodium Sulphite (anhydrous)	150	grams

Solution C:

Water	1.0	liter
Sodium Carbonate (monohydrated)	80	grams

Tank development: take one part each of solutions A, B, and C, and 13 parts of water. Develop 8 to 10 minutes at 18°C.

Tray development: take one part each of solutions A, B, C, and 8 parts of water. Develop 5 to 7 minutes at 18°C.

Agfa #72*

This is a soft working developer built around glycin (rather than the currently more common Metol). It produces gently graded results in either tank or tray.

Water 52°C	1.0	liter
Sodium Sulfite (anhydrous)	125	grams
Glycin	50	grams
Potassium Carbonate	250	grams

For tank development, dilute the above stock solution 1 part to 10 parts water, and develop at 18°C for 15-20 minutes.

For tray development, dilute 1:4 and develop at 18°C for 5-7 minutes.

Fine-Grain Tank Developer — GAF-12

An excellent tank developer; keeps well.

Water 52°C	750.0	ml
Metol	8.0	grams
Sodium Sulfite (anhydrous)	125.0	grams
Sodium Carbonate (anhydrous)	5.75	grams
Potassium Bromide	2.5	grams
Cold water to make	1.0	liter

Do not dilute; develop 9-16 minutes at 20°C.

Fine-Grain Borax Tank Developer — GAF-17

Recommended for all 35mm films.

Water 52°C	750.0	ml
Metol	1.5	grams
Sodium Sulfite (desiccated)	80.0	grams
Hydroquinone	3.0	grams
Borax (granular)	3.0	grams
Potassium Bromide	0.5	gram
Cold water to make	1.0	liter

Do not dilute; develop fine-grain films 10-15 minutes at 20°C.

Replenisher for GAF-17 — GAF-17a

Water 52°C	750.0	ml
Metol	2.2	grams
Sodium Sulfite (desiccated)	80.0	grams
Hydroquinone	4.5	grams
Borax (granular)	18.0	grams
Cold water to make	1.0	liter

Add 15-20 ml replenisher for each 36-exposure roll developed. Maintain original volume of developer by discarding some used developer, if necessary, to add full amount of replenisher. No increase in developing time for subsequent rolls is required.

Fine-Grain Metaborate Tank Developer — GAF-17M

Similar to GAF-17, but permitting shorter developing times by varying the amount of metaborate.

Water 52°C	750.0	ml
Metol	1.5	grams
Sodium Sulfite (desiccated)	80.0	grams
Hydroquinone	3.0	grams
Sodium Metaborate	2.0	grams

Potassium Bromide 0.5 gram
Cold water to make 1.0 liter

Do not dilute; develop fine-grain films 10-15 minutes at 20°C. To reduce developing times, increase the amount of metaborate; up to 10 grams metaborate may be used, with a developing time of 5 minutes. Slightly coarser grain will result.

Replenisher for GAF-17M GAF-17M-a

Water 52°C 750.0 ml
Metol . 2.2 grams
Sodium Sulfite (desiccated) 80.0 grams
Hydroquinone 4.5 grams
Sodium Metaborate 8.0 grams
Cold water to make 1.0 liter

Note: If an increased amount of metaborate is used, the replenisher should obtain four times the amount used in the developer.

Add 15-20 ml replenisher for each 36-exposure roll developed. Maintain original volume of developer by discarding some used developer, if necessary, to add full amount of replenisher. No increase in developing time for subsequent rolls is required.

Gevaert GD-17*

(Non-staining Formula)

Make up two solutions according to the following formulas:

Solution A:

Sodium Sulfite 200.0 grams
Potassium Metabisulfite 50.0 grams
Pyro . 50.0 grams
Water to make 3.0 liters

Solution B:

Sodium Carbonate 225.0 grams
Water to make 3.0 liters

Mix A, 1 part; B, 1 part; water, 2 parts.

In making the "A" solution the sulfite and metabisulfite should be mixed together into hot water. When they are dissolved, the solution should preferably be brought to a boil and boiled for about a minute. After the solution has cooled, the pyro is added. The boiling greatly improves the keeping qualities of the solution.

This developer will produce negatives free from pyro stain, and 4 to 6 minutes development at normal temperature with full exposure will yield negatives which are well suited to enlarging. The advantages of the developer are its cleanliness and the extraordinary keeping qualities of the "A" solution, which must be made up as directed above.

Gevaert GD-36

Metol . 1.9 grams
Sodium Sulfite 35.0 grams
Adurol . 1.4 grams
Hydroquinone 6.2 grams
Potassium Carbonate 27.0 grams
Potassium Bromide 1.7 grams
Water to make 1.0 liter

For tray use, take one part of stock solution and two parts of water. Develop 3-4 minutes.

For tank development, use one part to eight parts of water. Develop 12-14 minutes.

Gevaert GD-202*

Metol . 1.0 gram
Sodium Sulfite 32.0 grams
Glycin .5 gram
Hydroquinone5 gram
Sodium Carbonate 28.0 grams
Potassium Bromide 1.5 grams
Citric Acid . 1.0 gram
Water to make 1.0 liter

If exposure has been correct, the film will be properly developed in 10-12 minutes.

Three-Solution Pyro Developer *Kodak D-1**

This developer is intended for general tank or tray use.

Stock Solution A:

Sodium Bisulfite (anhydrous) 9.8 grams
Pyro (pyrogallol) 60.0 grams
Potassium Bromide (anhydrous) 1.1 grams
Water to make 1.0 liter

Stock Solution B:

Water . 1.0 liter
Sodium Sulfite (anhydrous) 105.0 grams

Stock Solution C:

Water . 1.0 liter
Sodium Carbonate 90.0 grams

For tank use, take 1 part of Stock Solution A, 1 part of Stock Solution B, 1 part of Stock Solution C, and 11 parts of water. Develop for approximately 12 minutes at 18°C.

For tray use, take 1 part of Stock Solution A, 1 part of Stock Solution B, 1 part of Stock Solution C, and 7 parts of water. Develop for approximately 6 minutes at 18°C.

Prepare fresh developer for each batch of film.

Kodak-D8

An extremely active developer, producing very high contrast results. It is primarily designed for use with line-copy materials.

Water 32°C . 750 ml
Sodium Sulfite (anhydrous) 90.0 grams
Hydroquinone 45.0 grams
Sodium Hydroxide (granular) 37.5 grams
Potassium Bromide 30.0 grams
Add cold water to make 1.0 liter

To use, mix 2 parts stock solution to 1 part water, and develop at 20°C for about 2 minutes. Developer must be used immediately after diluting, since it has a very short tray life.

Kodak D-11

An active, high contrast developer with better keeping qualities than D-8. Can be used with most films, if very high contrast results are needed, although its primary use is for development of photographic records of line drawings and the like.

Water 50°C . 500 ml
Elon (Metol) 1.0 gram
Sodium Sulfite 75.0 grams
Hydroquinone 9.0 grams
Sodium Carbonate (monohydrated) 30.0 grams
Potassium Bromide (anhydrous) 5.0 grams
Add cold water to make 1.0 liter

For line subjects, use undiluted; continuous tone subjects require a 1:1 dilution with water. Develop for 5 minutes in a tank or about 4 minutes in a tray at 20°C.

Kodak D-19

Less contrasty than D-8 or D-11, this developer produces brilliant higher than normal contrast negatives of continuous tone subjects. The solution keeps well and is clean working.

Water 50°C . 500 ml
Elon (Metol) 2.0 grams
Sodium Sulfite (anhydrous) 90 grams
Hydroquinone 8.0 grams
Sodium Carbonate (monohydrated) 52.5 grams
Potassium Bromide (anhydrous) 5.0 grams
Add cold water to make 1.0 liter

Tank development is for 6 minutes, tray development 5 minutes at 20°C undiluted.

Kodak DK-20

A fine-grain developer, using sodium thiocyanate which acts as a silver halide solvent (it breaks down the silver salt crystals somewhat, giving the negatives a less prominent grain pattern).

Water 50°C . 750 ml
Elon (Metol) 5.0 grams
Sodium Sulfite (anhydrous) 100.0 grams
Kodalk Balanced Alkali 2.0 grams
Sodium Thiocyanate (liquid) 1.5 ml
Potassium Bromide (anhydrous) 0.5 gram
Cold water to make 1.0 liter

Average tank development time at 20°C is 15 minutes.

Glycin Negative Developer Kodak D-78*

Water . 750 ml
Sodium Sulfite (anhydrous) 3.0 grams
Glycin . 3.0 grams
Sodium Carbonate (monohydrated) 7.2 grams
Water to make 1.0 liter

The average development time is 15 to 25 minutes at 18°C.

Pyro Tank Developer *Kodak D-79**

Water	750	ml
Sodium Sulfite (anhydrous)	25.0	grams
Pyrogallol	2.5	grams
Sodium Carbonate (monohydrated)	6.0	grams
Potassium Bromide (anhydrous)	0.5	gram
Water to make	1.0	liter

The average development time is 9 to 12 minutes at 18°C. The solution oxidized rapidly; use it within one hour after mixing.

Maximum Energy Developer *Kodak D-82**

This developer is intended for use with badly underexposed films.

Water 50°C	750	ml
Methyl Alcohol	48	ml
Elon	14.0	grams
Sodium Sulfite (anhydrous)	52.5	grams
Hydroquinone	14.0	grams
Sodium Hydroxide (granular)	8.8	grams
Potassium Bromide (anhydrous)	8.8	grams
Cold water to make	1.0	liter

Use without dilution. Develop for 4 to 5 minutes in a tray at 18°C. The prepared developer does not keep for more than a few days. If methyl alcohol is not added, and the developer is diluted, the solution is not as active as in the concentrated form.

Tropical Developer *Kodak DK-15**

This developer is intended for film and plate developing under tropical conditions.

Water 50°C	750	ml
Elon	5.7	grams
Sodium Sulfite (anhydrous)	90.0	grams
Kodalk Balanced Alkali	22.5	grams
Potassium Bromide (anhydrous)	1.9	grams
*Sodium Sulfate (anhydrous)	45.0	grams
Cold water to make	1.0	liter

*If crystalline sodium sulfate is preferred to the anhydrous form, use 105.0 grams instead of 45.0 grams listed.

The average time for tank development is about 10 minutes at 20°C and 2 to 3 minutes at 32°C. These times apply when the developer is fresh. Vary the time to produce the desired contrast.

When you are working at temperatures below 24°C, you may omit the sodium sulfate in order to obtain a more rapidly acting developer. The developer time *without* the sodium sulfate is approximately 6 minutes at 20°C.

When you are developing film in trays, shorten the developing times given above by about 29 percent.

When development is completed, rinse the film or plate for just 1 or 2 seconds, and then immerse it in *Kodak* Hardening Bath SB-4 for 3 minutes. Omit the rinse if you find that the film tends to soften. Fix the film for at least 10 minutes in an acid hardening fixing bath, such as *Kodak* Fixing Bath F-5, and wash for 10 to 15 minutes in water not over 35°C.

PAPER DEVELOPERS

Artura Developer Defender
Stock Solution

Water 52°C	500	ml
Metol	1.5	grams
Sodium Sulfite	22.5	grams
Hydroquinone	6.3	grams
Sodium Carbonate (desiccated)	15.0	grams
Cold water to make	1.0	liter

Working Solution. Dissolve each chemical thoroughly before another is added. Keep working solution at 18°C because the formula works best at this temperature.

For use, use equal parts of developer and water. Add 0.7 gram of Potassium Bromide to each liter of working solution.

Artura Variable Contrast Paper Developer
Stock Solution

Solution No. 1:

Water 52°C	500	ml
Metol	3.0	grams
Sodium Sulfite	22.5	grams
Hydroquinone	3.0	grams
Sodium Carbonate (desiccated)*	15.0	grams
Potassium Bromide	0.7	gram
Cold water to make	1.0	liter

Solution No. 2:

Water 52°C . 500 ml
Sodium Sulfite 22.5 grams
Hydroquinone 9.3 grams
Sodium Carbonate (desiccated)* 15.0 grams
Potassium Bromide 0.7 gram
Cold water to make 1.0 liter

*If monohydrated carbonate is used, the quantity must be increased to 17.5 grams in each solution.

Working Solution

(Temperature 18°C)

For **Normal** results:

Solution No. 1 1 part
Solution No. 2 1 part
Water . 2 parts

For **Soft** results:

Solution No. 1 3 parts
Solution No. 2 1 part
Water . 4 parts

For **Contrasty** results:

Solution No. 1 1 part
Solution No. 2 3 parts
Water . 4 parts

Soft-Working Paper Developer GAF-120

Stock Solution:

Water 52°C . 750.0 ml
Metol . 12.3 grams
Sodium Sulfite (desiccated) 36.0 grams
Sodium Carbonate (monohydrated) 36.0 grams
Potassium Bromide 1.8 grams
Cold water to make 1.0 liter

Dilute 1:2 with water; develop 1-1/2 to 3 minutes at 20°C.

Note: GAF-120 is an excellent developer for two-tray print development, which permits control over print gradation that cannot be obtained by usual variations of exposure and developing time.

The two-tray procedure uses two separate developing solutions: a soft-working developer such as GAF-120, and a brilliant-working developer such as GAF-130. Development is begun in one solution and completed in the other; the first developer used has the greater effect. This procedure is particularly helpful in producing full-scale prints which exhibit well modulated gradation in both highlights and shadows.

Metol-Hydroquinone Developer GAF-125

Recommended for development of standard papers. May also be used to develop films.

Stock Solution:

Water 52°C . 750.0 ml
Metol . 3.0 grams
Sodium Sulfite (desiccated) 44.0 grams
Hydroquinone 12.0 grams
Sodium Carbonate (monohydrated) 65.0 grams
Potassium Bromide 2.0 grams
Cold water to make 1.0 liter

Paper development: dilute 1:2 with water, develop 1-2 minutes at 20°C. For softer, slower development, dilute 1:4 with water, develop 1-1/2 to 3 minutes at 20°C. For greater brilliance, shorten exposure and lengthen development time; for greater softness, lengthen exposure and shorten development time.

Film development: dilute 1:1 with water, develop 3-5 minutes at 20°C. For softer results, dilute 1:3 with water, develop 3-5 minutes at 20°C.

Universal Paper Developer GAF-130

For all projection and contact papers. Gives rich black tones with excellent brilliance and detail; provides unusual latitude in development, and is clean-working even with long developing times.

Stock Solution:

Water 52°C . 750.0 ml
Metol . 2.2 grams
Sodium Sulfite (desiccated) 50.0 grams
Hydroquinone 11.0 grams
Sodium Carbonate (monohydrated) 78.0 grams
Potassium Bromide 5.5 grams
Cold water to make 1.0 liter

Note: The prepared stock solution is clear but slightly colored. This coloration does not indicate

that the developer has deteriorated or is unfit for use.

Dilute 1:1 with water, develop most papers 1-1/2 to 3 minutes at 20°C. For greater contrast, use stock solution full strength. For softer results, dilute 1:2 with water. See formula for GAF-120 for use in two-tray development.

Warm Tone Paper Developer GAF-135

For rich warm-black tones with chloride and bromide papers.

Stock Solution:

Water 52°C	750.0 ml
Metol	1.6 grams
Sodium Sulfite (desiccated)	24.0 grams
Hydroquinone	6.6 grams
Sodium Carbonate (monohydrated)	24.0 grams
Potassium Bromide	2.8 grams
Cold water to make	1.0 liter

Dilute 1:1 with water. A properly exposed print will be fully developed in 1-1/2 to 2 minutes at 20°C. For greater softness, dilute up to a maximum of 1:3 with water. For increased warmth of tones, increase the amount of bromide, up to a maximum of 5.6 grams.

For Vigorous Effects with Bromide Papers Gevaert GD-4

Metol	.7 gram
Sodium Sulfite	10.7 grams
Hydroquinone	2.3 grams
Sodium Carbonate	14.2 grams
Potassium Bromide	.7 gram
Water to make	1.0 liter

For Softer Effects with Bromide Papers Gevaert GD-5

Metol	3.3 grams
Sodium Sulfite	17.8 grams
Hydroquinone	1.0 gram
Potassium Carbonate	12.0 grams
Potassium Bromide	.7 gram
Water to make	500.0 ml

Print of any desired degree of contrast may be made by mixing GD-4 and GD-5 in suitable proportions. For a normal developer, use equal parts of GD-4 and GD-5.

Gevaert GD-31

Metol	.7 gram
Sodium Sulfite	23.0 grams
Hydroquinone	3.0 grams
Sodium Carbonate	17.0 grams
Water to make	1.0 liter

Add enough potassium bromide to keep whites clean.

Developer for Production of Very Soft Prints or High Key Effects Gevaert GD-67

Metol	2.0 grams
Sodium Sulfite	28.5 grams
Sodium Carbonate	42.5 grams
Potassium Bromide	.3 gram
Water to make	500.0 ml

For use, dilute with four parts of water.

Metol-Hydroquinone Developer For Bromide Papers Ilford ID-20

Stock Solution:

Water 52°C	750.0 ml
Metol	1.5 grams
Sodium Sulfite (desiccated)	25.0 grams
Hydroquinone	6.0 grams
Sodium Carbonate (monohydrated)	35.0 grams
Potassium Bromide	2.0 grams
Cold water to make	1.0 liter

Dilute: 1:1 with water; develop 1-1/2 to 2 minutes at 20°C.

Metol-Hydroquinone Developer For Papers and Films Ilford ID-36

Stock Solution:

Water 52°C	750.0 ml
Metol	1.5 grams
Sodium Sulfite (desiccated)	25.0 grams
Hydroquinone	6.3 grams
Sodium Carbonate (monohydrated)	40.5 grams
Potassium Bromide	0.4 grams
Water to make	1.0 liter

For contact papers: do not dilute; develop 45-60 seconds at 20°C.

For enlarging papers: dilute 1:1 with water; develop 1-1/2 to 2 minutes at 20°C.

For films: dilute 1:3 with water, develop 6-10 minutes at 20°C.

Amidol Developers for Bromide Papers *Kodak* D-51

Stock Solution:

Water 50°C	750.0 ml
Sodium Sulfite (anhydrous)	120.0 grams
Di-Aminophenol Hydrochloride (Acrol; Amidol)	37.5 grams
Cold water to make	1.0 liter

Take 180 ml stock solution, 3 ml 10% potassium bromide solution, and 750 ml water. Mix only enough for immediate use, as this developer oxidizes rapidly when exposed to air.

Note: This developer is well-suited to re-development of negatives following the use of stain remover such as *Kodak* S-6. This method will usually also remove marks caused by water drops drying on the negative, as well as stains, unless the water marks are of long standing.

Kodak D-52

For warm tone papers; equivalent to *Kodak* Selectol developer.

Stock Solution:

Water 50°C	500.0 ml
Metol	1.5 grams
Sodium Sulfite (anhydrous)	22.5 grams
Hydroquinone	6.0 grams
Sodium Carbonate (monohydrated)	17.0 grams
Potassium Bromide	1.5 grams
Cold water to make	1.0 liter

Dilute 1 part stock solution with 1 part water; develop about 2 minutes at 20°C. For warmer tones, increase the amount of potassium bromide.

Kodak D-72

Universal paper developer; equivalent to *Kodak* Dektol developer.

Stock Solution:

Water 50°C	500.0 ml
Metol	3.0 grams
Sodium Sulfite (anhydrous)	45.0 grams
Hydroquinone	12.0 grams
Sodium Carbonate (monohydrated)	80.0 grams
Potassium Bromide	2.0 grams
Cold water to make	1.0 grams

Dilute 1 part stock solution with 2 parts water; develop 1 minute at 20°C. For warmer tones on Kodabromide paper, dilute 1:3 or 1:4 with water, add 8 ml of 10% potassium bromide solution for each 1.0 liter of working developer solution, and develop 1-1/2 minutes.

Kodak DK-93

P-Aminophenol Hydroquinone developer, recommended as a substitute for Metol-Hydroquinone developers for those subject to skin irritation due to *Kodak* Elon (Metol).

Water 52°C	500.0 ml
P-Aminophenol Hydrocholoride	5.0 grams
Sodium Sulfite (anhydrous)	30.0 grams
Hydroquinone	2.5 grams
Kodalk Balanced Alkali (or Sodium Metaborate)	20.0 grams
Potassium Bromide	0.5 gram
Cold water to make	1.0 liter

For warm tones, do not dilute; develop 2 minutes at 20°C. For colder tones, double the amount of *Kodalk*; develop 1-2 minutes. In either case, this developer gives slightly warmer tones than those normally given by D-52 and D-72.

STOPBATHS AND FIXERS

Tropical Hardener Bath *Kodak* SB-4

Recommended for use in conjunction with *Kodak* DK-15 Tropical Developer when working above 24°C.

Water	1.0 liter
Potassium Chrome Alum (crystals; dodecahydrated)	30.0 grams
Sodium Sulfate (anhydrous)	60.0 grams
or	
Sodium Sulfate (crystals)	140.0 grams

After development immerse films directly in SB-4; agitate 30-45 seconds immediately; leave in bath 3 minutes. If temperature is *below* 29°C, rinse films 1-2 seconds in plain water before using SB-4. This bath is violet-blue when fresh; it turns

yellow-green and must be replaced when the hardening properties are lost. An unused bath will keep indefinitely, but the hardening properties of a partially-used bath fall off rapidly on standing for a few days.

Non-Swelling Acid Rinse Bath *Kodak* SB-5

Water . 500.0 ml
Acetic Acid, 28% 32.0 ml
Sodium Sulfate (anhydrous) 45.0 grams
 or
Sodium Sulfate (crystals) 105.0 grams
Water to make 1.0 liter

Immerse films directly after development; agitate immediately; leave in bath about 3 minutes. This bath is satisfactory for use at temperatures up to 27°C. Capacity is approximately 100 rolls per 4 liters. *Do not revive used bath with acid.* At temperatures *below* 24°C, life of bath may be extended by rinsing films for a few seconds in plain water before immersion.

Acid Hardening Fixing Bath *Kodak* F-5
 DuPont 1-F

For films and papers.

Water 50°C . 600.0 ml
Sodium Thiosulfate (Hypo) 240.0 grams
Sodium Sulfite (desiccated) 15.0 grams
Acetic Acid, 28% 45.0 ml
Boric Acid (crystals) 7.5 grams
Potassium Alum (fine granular) 15.0 grams
Cold water to make 1.0 liter

Do not use powdered boric acid; it dissolves only with great difficulty. Do not dilute for use. Films are fixed in a fresh bath in 10 minutes. F-5 remains clear and hardens well throughout its useful life. Capacity is approximately 20-24 rolls per liter; discard before that time if fixing time reaches 20 minutes.

Acid Hardening Stock Solution *Kodak* F-5a
 DuPont 1-FH

Water 50°C . 600.0 ml
Sodium Sulfite (anhydrous) 75.0 grams

Acetic Acid, 28% 235.0 ml
Boric Acid (crystals) 37.5 grams
Potassium Alum (fine granular) 75.0 grams
Cold water to make 1.0 liter

For use, slowly add one part of cool stock hardener solution to four parts of cool 30% hypo solution, while stirring hypo rapidly.

30% Sodium Thiosulfate (Hypo) Solution

Water 52°C . 750.0 ml
Sodium Thiosulfate (Hypo) 300.0 grams
Cold water to make 1.0 liter

Odorless Acid Hardening
Fixing Bath *Kodak* F-6

For film and papers. This bath eliminates the odor of sulfur dioxide common to freshly mixed F-5 by substituting *Kodalk* Balanced Alkali (sodium metaborate) for the boric acid.

Water 50°C . 600.0 ml
Sodium Thiosulfate (Hypo) 240.0 grams
Sodium Sulfite (anhydrous) 15.0 grams
Acetic Acid, 28% 48.0 ml
Kodalk Balanced Alkali
 (or Sodium Metaborate) 15.0 grams
Potassium Alum (fine granular) 15.0 grams
Cold water to make 1.0 liter

The ingredients other than hypo may be compounded as a stock hardener solution to be added to a 30% hypo solution; see *Kodak* Formula F-6a.

Acid Hardener Stock Solution *Kodak* F-6a

Water 50%C . 600.0 ml
Sodium Sulfite (anhydrous) 75.0 grams
Acetic Acid, 28% 235.0 ml
Kodalk Balanced Alkali
 (or Sodium Metaborate) 75.0 grams
Potassium Alum 75.0 grams
Cold water to make 1.0 grams

For use, slowly add one part of cool stock hardener solution to four parts of cool 30% hypo solution, while stirring hypo rapidly. The combined solution is *Kodak* F-6 Fixing Bath.

Rapid Fixing Bath Kodak F-7

For negative films. This bath can be used with papers but has no advantage over other formulas which do not contain ammonium chloride. If used with papers, it must be used in conjunction with an acid stop bath; otherwise dichroic fog may result.

This formula clears most films in less time and has approximately 50% longer life than Kodak F-5.

Water 50°C	600.0 ml
Sodium Thiosulfate (Hypo)	360.0 grams
Ammonium Chloride	50.0 grams
Sodium Sulfite (anhydrous)	15.0 grams
Acetic Acid, 28%	47.0 ml
Boric Acid (crystals)	7.5 grams
Potassium Alum (fine granular)	15.0 grams
Cold water to make	1.0 liter

It is essential to add the ammonium chloride after the hypo, but before the other ingredients to avoid possible sludge formation. It is also possible to make up the hypo-plus-chloride solution as a stock solution and add stock hardeners solution Kodak F-5a (1 part hardener to 4 parts hypo-plus-chloride) for use.

Do not prolong fixing times for fine-grain films or for any paper prints—especially warm-tone papers. The image may have a tendency to bleach; the effect is great above 20%C.

Rapid Fixing Bath Kodak F-9

If corrosion of metal tanks is encountered when using Kodak F-7, it can be minimized by substituting 60 grams of Ammonium Sulfate for the 50 grams of Ammonium Chloride for in F-7. This change is known as Kodak Rapid Fixing Bath F-9.

Non-Hardening Acid Fixing Bath Kodak F-24

For films or paper when no hardening is desired.

Water 50°C	500.0 ml
Sodium Thiosulfate (Hypo)	240.0 grams
Sodium Sulfite (anhydrous)	10.0 grams
Sodium Bisulfite (anhydrous)	25.0 grams
Cold water to make	1.0 liter

Use only when temperature of developer, rinse bath, fixer and wash water is not higher than 20°C, and when ample drying time can be allowed so that relatively cool drying air can be used.

Acid Hardening GAF 201
Fixing Bath DuPont 2-F

For use with either film or paper. May be stored indefinitely and used repeatedly until exhausted. If bath froths, turns cloudy, or takes longer than 10 minutes to fix completely, it must be replaced by a fresh solution.

Solution 1:

Water 52°C	500.0 ml
Sodium Thiosulfte (Hypo)	240.0 grams

Solution 2:

Water 52°C	150.0 ml
Sodium Sulfite (desiccated)	15.0 grams
Acetic Acid, 28%	45.0 ml
Potassium Alum	15.0 grams

Mix solutions separately; stir rapidly while adding 2 into 1; add water to make total volume of 1 liter. Do not dilute for use. Normal fixing time is 5-10 minutes at 20°C.

Chrome Alum GAF 202
Fixing Bath DuPont 3-F

A hardening fixing bath for use with films in hot weather, it must be used fresh, as it does not retain its hardening action.

Solution 1:

Water 52°C	2.5 liters
Sodium Thiosulfate (Hypo)	960.0 grams
Sodium Sulfite (desiccated)	60.0 grams
Cold water to make	3.0 liters

Solution 2:

Water (not more than 65°C)	1.0 liter
Potassium Chrome Alum	60.0 grams
Sulfuric Acid, C.P.	8.0 ml

Mix solutions separately; stir rapidly while slowly pouring 2 into 1. Rinse films thoroughly before fixing. Normal fixing time is 5-10 minutes at 20°C.

Non-Hardening Metabisulfite Fixing Bath GAF 203

Recommended for use when hardening is not desired.

Stock Solution:

Water, 52°C	740.0 ml
Sodium Thiosulfate (Hypo)	475.0 grams
Dissolve thoroughly; when solution cools, add:	
Potassium Metabisulfite	67.5 grams
Cold water to make	1.0 liter

Dilute 1 part stock solution with 1 part water for use. Normal fixing time is 5-10 minutes at 20°C. Do not use above 21°C, or in conjunction with solutions containing hydrogen peroxide, such as *Kodak* Hypo Eliminator HE-1.

Acid Hardening Fixing Bath GAF 204

For use with either films or papers; may be stored indefinitely and used repeatedly until exhausted.

Water 52°C	750.0 ml
Sodium Thiosulfate (Hypo)	240.0 grams
Sodium Sulfite	15.0 grams
Acetic Acid, 28%	75.0 ml
Borax	15.0 grams
Potassium Alum	15.0 grams
Cold water to make	1.0 liter

Do not dilute for use. Normal fixing time is 5-10 minutes at 20°C.

INTENSIFIERS

Negatives can be intensified by adding silver (or another metal) to the silver in the image, or by making the existing image less transparent to actinic light. In either case, the density increase in each area of the image is in *direct* proportion to the amount of developed silver present. Highlights will therefore be intensified more than shadow areas, resulting in an overall contrast increase.

Chemical intensifiers won't add much density to faint images; they correct underdevelopment, but not underexposure. Almost all intensifiers increase

graininess. For permanent intensification, use a chromium or silver intensifier.

Caution: The metallic compounds used in intensifier formulas are poisonous. Mercuric chloride and mercuric iodide are deadly.

Negatives must be completely fixed and washed before treatment. They must be wet and free of scum and stains (soak dry negatives for 20-30 minutes in water). Treat films in a formalin hardening bath before intensification (see *Kodak* SH-1 under hardeners).

Mercuric Iodide Intensifier DuPont 2-1

Water	1.0 liter
Mercuric Iodide	20.0 grams
Potassium Iodide	20.0 grams
Sodium Thiosulfate (Hypo)	20.0 grams
Water to make	2.0 liter

Use undiluted. Intensification is proportional to the time of treatment; it may be observed visually. Maximum effective treatment time is 15-20 minutes. After treatment, wash for 20 minutes in running water. The image is not permanent unless redeveloped in an ordinary non-staining developer (e.g., DuPont 53-D or its equivalent, *Kodak* D-76), or unless bathed in a 1% sodium sulfide solution *before* washing.

Mercury Intensifier GAF 330

Recommended for increasing the printing density of thin, flat negatives.

Water	750.0 ml
Potassium Bromide	10.0 grams
Mercuric Chloride	10.0 grams
Cold water to make	1.0 liter

Use undiluted. Immerse *thoroughly washed* negatives; when image is completely bleached, wash in water containing a few drops of hydrochloric acid. Redevelop in a 5% sodium sulfite solution or a standard non-staining developer (e.g., *Kodak* D-76). Scum formed on solution during storage does not affect working properties, but should be removed before treating negatives.

Chromium Intensifier GAF 332

Convenient to use, gives permanent results. Intensification can be controlled to some extent by varying time of redevelopment.

Cold water	1.0 liter
Potassium Bichromate	9.0 grams
Hydrochloric Acid, C.P.	6.0 ml

Bleach negatives thoroughly in this solution, wash for 5 minutes in running water, redevelop in bright, diffused light (use standard developer: GAF 47 or *Kodak* D-72). Wash for 15 minutes. Repeat treatment for increased effect, if desired.

If film base has any blue coloration after treatment, remove it by washing film briefly in (1) water with a few drops of ammonia, or (2) a 5% solution of potassium metabisulfite, or (3) a 5% solution of sodium sulfite. Follow with a thorough wash in water.

Mercuric Chloride Intensifier Ilford I.In-1

Water 52°C	750.0 ml
Mercuric Chloride	25.0 grams
Ammonium Chloride	25.0 grams
Cold water to make	1.0 liter

Bleach *thoroughly washed* negative in this solution, then redevelop in one of the following:

(1) 1 part ammonia (sp.gr. 0.800) in 100 parts water. This gives maximum intensification, but image is not permanent.

(2) Any standard developer (e.g., Iford ID-36, *Kodak* D-52). This gives less intensification than (1), but may be repeated if more density is required.

(3) A 20% sodium sulfite solution.

Wash thoroughly after redevelopment.

Silver Intensifier Kodak In-5
DuPont 3-1

Intensifiers for both negative and positive black-and-white film images without change in coloration. Provides proportional intensification which may be controlled by varying treatment time.

Stock Solution 1 (store in brown bottle):

Silver Nitrate (crystals)	60.0 grams
Distilled water to make	1.0 liter

Stock Solution 2:

Sodium Sulfite (anhydrous)	60.0 grams
Distilled water to make	1.0 liter

Stock Solution 3:

Sodium Thiosulfate (Hypo)	105.0 grams
Water to make	1.0 liter

Stock Solution 4:

Sodium Sulfite (anhydrous)	15.0 grams
Metol	26.0 grams
Water to make	3.0 liters

Prepare intensifer as follows:

(a) Slowly add 1 part solution 2 to 1 part solution 1, stirring constantly to mix thoroughly. A white precipitate will form.

(b) Stir in 1 part solution 3. The precipitate will dissolve. Let solution stand until clear.

(c) Stir in 3 parts solution 4.

Use intensifier immediately; the mixed solution is stable for approximately 30 minutes at 20°C. Treatment should not exceed 25 minutes; observe progress visually. After treatment, immerse film in a 30% plain hypo solution and agitate constantly for 2 minutes, then wash thoroughly.

Quinone-Thiosulfate Intensifier Kodak In-6

For use with very weak negatives. Produces the greatest degree of intensification of any single-solution formula when used with high speed negative materials. Image is brownish, and is not indefinitely permanent. The intensification is destroyed by acid hypo; under no circumstances should the intensified negatives be placed in a fixing bath or in wash water contaminated with fixing bath.

It is essential to mix the formula with water which has no greater than 15 parts chloride per million (about 25 parts sodium chloride per million). *Distilled water is recommended.*

Solution A:

Water 21°C	750.0 ml
Sulfuric Acid (concentrate)	30.0 ml
Potassium Dichromate (anhydrous)	22.5 grams
Water to make	1.0 liter

Solution B:

Water 21°C . 750.0 ml
Sodium Bisulfite (anhydous) 3.8 grams
Hydroquinone . 15.0 grams
Photo-Flo 200 3.8 ml
Water to make 1.0 liter

Solution C:

Water 21°C . 750.0 ml
Sodium Thiosulfate (Hypo) 22.5 grams
Water to make 1.0 liter

Prepare intensifier as follows. Stir 2 parts B into 1 part A. Then stir in 2 parts C. Finally stir in 1 part A. The order of mixing is important. Mix freshly before use; the solution is stable for 2-3 hours without use. Discard after one use. Stock solutions will keep for several months in stoppered bottles.

Do not touch film emulsion with fingers before or during treatment, or surface markings will be produced. Wash and harden negatives (in *Kodak* SH-1) before treatment. Agitate frequently during treatment; maximum effect is obtained in about 10 minutes at 20°C. Wash 10-20 minutes after intensification.

TONERS

Prints to be toned must be thoroughly fixed and washed. Use a hypo neutralizing bath first. Any traces of fixer or other processing chemicals in the paper may cause uneven toning stains.

Prints to be toned may need increased exposure, (10-15% more) and/or increased development (up to 50% more). Some recommendations are given with various formulas, but make a series of tests for the best results. Tests should also be made to determine whether your printing paper accepts proper toning by a particular formula—some paper-toner combinations produce unpleasant changes in tone.

Use nonmetallic (e.g., plastic or hard rubber) tanks and trays. *Do not* mix solution with metallic stirrers.

Redevelopment Sepia Tone DuPont 4a-T

Bleaching Solution:

Water not over 27°C 750.0 ml
Potassium Ferricyanide 25.0 grams
Potassium Bromide 27.4 grams
Ammonium Hydroxide (28%) 2.0 ml
Water to make 1.0 liter

Use undiluted. Bleach thoroughly fixed and washed prints until image is only faintly visible—about 1 minute. Wash thoroughly until no trace of yellow stain remains. Redevelop in following solution until desired tone is obtained.

Redeveloping Stock Solution:

Sodium Sulfide 50.0 grams
Water . 1.0 liter

Dilute 1 part stock with 8 parts water. After redevelopment, wash prints thoroughly and dry as usual.

Sepia Toner GAF 221

Solution 1 (Bleach):

Water 52°C . 750.0 ml
Potassium Ferricyanide 50.0 grams
Potassium Bromide 10.0 grams
Sodium Carbonate (monohydrated) 20.0 grams
Cold water to make 1.0 liter

Use undiluted to bleach thoroughly fixed and washed prints until image is very light brown, about 1 minute. Wash prints 10-15 minutes, then redevelop in Solution 2.

Solution 2 (Redeveloper):

Sodium Sulfide (desiccated) 45.0 grams
Water . 500.0 ml

Dilute 1 part solution 2 with 8 parts water. Redevelopment should be complete in about 1 minute. Wash about 30 minutes after redevelopment; dry as usual. If toner leaves sediment which causes streaks or finger marks on paper, immerse print for a few seconds in a 3% acetic acid solution, then wash for 10 minutes.

Hypo Alum Toner GAF 222

For reddish-brown tones.

Solution 1:

Water . 2350.0 ml
Sodium Thiosulfate (Hypo) 450.0 grams

Solution 2:

Water . 30.0 ml
Silver Nitrate 1.3 grams

Solution 3:

Water . 30.0 ml
Potassium Iodide 2.7 grams

Stir solution 2 into solution 1 and mix thoroughly. Then stir in solution 3. Then dissolve 105 grams of potassium alum into the mixed solutions. Heat the entire bath to the boiling point or until sulfurization takes place (indicated by milky appearance of the solution). Tone prints 20-60 minutes at 43-52°C. Agitate prints occasionally until toning is complete. Be sure that black print tones are fully converted before removing prints from bath, otherwise double tones may result.

Gold Toner GAF 231

Produces red tones on prints that have previously been sepia toned. Produces deep blue tones in prints that have not been previously toned. Produces mixed tones of blue-black shadows and soft reddish highlights in prints that have been partially toned in a hypo alum toner.

Water 52°C 750.0 ml
Ammonium Thiocyanate 105.0 grams
 (or Sodium Thiocyanate) (110.0 grams)
 (or Potassium Thiocyanate) (135.0 grams)
Gold Chloride (1% solution) 60.0 ml
Water to make 1.0 ml

Red tones: Tone prints in sepia-sulfide redevelopment toner (GAF 221). Wash. Tone in above solution 15-45 minutes. For redder tones, use half the amount of thiocyanate.

Deep blue tones: Place well-washed black-and-white prints directly in above solution.

Mixed tones: Give prints incomplete toning in a hypo alum toner (GAF 222) and wash well before treating in above solution.

Iron Blue Toner GAF 241

Produces brilliant blue tones.

Distilled water, 53°C 500.0 ml
Ferric Ammonium Citrate 8.0 grams
Potassium Ferricyanide 8.0 grams
Acetic Acid, 28% 265.0 ml
Distilled water to make 1.0 liter

Use undiluted. Fix prints in plain, non-hardening hypo bath. Keep fixer at 20°C or less to avoid undue swelling. Prints fully toned in above solution will be greenish, but will wash out to a clear blue in running water. The depth of toning depends somewhat on original print depth; light-toned black-and-white prints produce light blue tones. Some intensification of the print usually occurs in toning, so prints should be slightly lighter than desired density of final toned print.

Wash water should be acidified slightly with acetic acid; alkaline water will weaken the blue tones. Tone variations can be obtained by bathing washed prints in a 0.5% solution (5 grams per liter) of borax; this produces softer, blue-gray tones which vary according to length of treatment.

Green Toner GAF 251

Produces rich green tones by combining the effects of iron blue toning and sulfide sepia toning. It must be employed carefully, with special attention to the directions below and to clean handling of the prints. Not all papers will tone well in this formula.

Solution 1:

Potassium Ferricyanide 40.0 grams
Water . 1.0 liter
Ammonia (0.91 S.G.; 25% in weight) . . . 15.0 ml

Solution 2:

Ferric Ammonium Citrate 17.0 grams
Water . 1.0 liter
Hydrochloric Acid (concentrated) 40.0 ml

Solution 3:

Sodium Sulfide 2.0 grams
Water . 1.0 liter
Hydrochloric Acid (concentrated) 10.0 ml
 Add acid only immediately before use.

Prepare all solutions within 24 hours of use. Avoid contaminating solution 2 with solution 1; even *slight traces* of 1 carried on hands or prints into 2 can cause blue stains. Use solution 3 in a well-ventilated room, preferably near an open window or with an exhaust fan to lessen the chance of inhaling hydrogen sulfide formed in the solution.

Black-and-white prints to be toned should be darker and softer than a normal print. Use approximately 25% overexposure on the next softer grade of paper. Develop carefully, avoiding over- or underdevelopment. Fix, wash thoroughly, and dry before toning.

Soak prints in cold water until limp, then place in solution 1 until bleached. Transfer immediately to running water and wash thoroughly — at least 30 minutes.

Place bleached prints in solution 2 for 45 seconds to 1 minute, until the deepest shadows are completely toned. Then wash prints briefly (4-6 minutes). Avoid over-washing or alkaline water; either will weaken the blue tones. Acidify wash water with a small amount of acetic acid if necessary.

Immerse blue-toned prints in solution 3 until green tone is sufficiently strong (usually about 30 seconds). Wash 20-30 minutes in neutral or acidified water. Dry *without* heat.

Sulfide Toner Ilford IT-1

For sepia tones.

Stock Ferricyanide Solution:

Water 52°C	750.0 ml
Potassium Ferricyanide	100.0 grams
Potassium Bromide	100.0 grams
Cold water to make	1.0 liter

Dilute 1 part solution with 9 parts water for use. Immerse fixed and thoroughly washed prints until completely bleached. Wash for about 10 minutes, then redevelop in following sulfide solution. For warmer tones, use only 25 grams of potassium bromide in above formula.

Stock Sulfide Solution:

Sodium Sulfide	50.0 grams
Water to make	1.0 liter

Dilute 1 part solution with 9 parts water for use. Redevelop bleached prints to desired sepia tonality. Wash thoroughly and dry as usual.

Hypo Alum Toner Ilford IT-2

Hot water	1.0 liter
Sodium Thiosulfate (Hypo)	150.0 grams
Dissolve hypo completely then add:	
Potassium Alum	25.0 grams

Until ripened, this bath has a reducing action on prints. To ripen, immerse some spoiled prints in the solution, or add 0.12 grams of silver nitrate prepared by dissolving a small amount in water and adding, drop by drop, sufficient strong ammonia to form and redissolve the precipitate. The toner lasts for years, and improves with keeping. It should be kept up to level by adding fresh solution as necessary. For warmer tones add 1 gram of potassium bromide to each liter of toner.

Develop prints a bit more than for usual black-and-white purposes, fix and wash thoroughly. Tone in above solution at 50°C for about 10 minutes. Lower temperatures unduly prolong toning; warmer temperatures produce colder tones. Wash prints thoroughly and swab off excess moisture before drying.

Selenium Toner Ilford IT-3

For purple to reddish-brown tones.

Stock Bleaching Solution:

Potassium Ferricyanide	100.0 grams
Potassium Bromide	100.0 grams
Water to make	1.0 liter

For use, dilute 1 part solution with 9 parts water. Bleach fixed and thoroughly washed print in this solution, then redevelop in selenium-sulfide solution.

Selenium-Sulfide Stock Solution:

Water 52°C	750.0 ml
Sodium Sulfide	104.0 grams
Dissolve sulfide completely, warm the solution, and add:	

Selenium Powder 6.8 grams
 Continue warming solution until
 selenium is completely dissolved,
 then add:
Water to make 1.0 liter

For use, dilute 1 part stock solution with 10 parts water. Tone bleached prints 2-3 minutes with continuous agitation. Wash thoroughly before drying.

Gold Toner Ilford IT-4

For red tones.

Water 52°C . 750.0 ml
Ammonium Thiocyanate 20.0 grams
Gold Chloride 1.0 gram
Water to make 1.0 gram

First tone prints in a sulfide (Ilford IT-1) or hypo alum (Ilford IT-2) toner. Then immerse washed prints in above solution. Tones will change to reddish-brown, then to red; about 10 minutes is required for a red tone. After toning, refix prints in a 10% solution of plain hypo (sodium thiosulfate) for 5-10 minutes, then wash thoroughly and dry as usual.

Ferricyanide-Iron Toner Ilford IT-6

For blue tones on bromide papers.

Solution A:

Water 52°C . 750.0 ml
Potassium Ferricyanide 2.0 grams
Sulfuric Acid (concentrated) 4.0 ml
Cold water to make 1.0 liter

Solution B:

Water 52°C . 750.0 ml
Ferric Ammonium Citrate 2.0 grams
Sulfuric Acid (concentrated) 4.0 ml
Cold water to make 1.0 liter

Note: Add acid to water, while stirring, in both solutions. *Do not* add water to acid.

For use, mix 1 part A with 1 part B just before use. Prints for toning should be slightly lighter than normal, and thoroughly washed. Immerse print in toning solution until desired tone is reached. Wash until the yellow stain is removed from the whites. Alkaline wash water may bleach the image; acidi-

fy wash water with a few drops of sulfuric or acetic acid.

Hypo Alum Sepia Toner *Kodak* T-1a

For sepia tones on warm tone papers.

Cold water . 2.8 liters
Sodium Thiosulfate (Hypo) 480.0 grams
 Dissolve hypo completely, then
 add the following solution:
Water 70°C . 640.0 ml
Potassium Alum 120.0 grams
 Then slowly add the following
 solution* (including its precipitate)
 while stirring rapidly:
Cold water . 64.0 ml
Silver Nitrate (crystals)* 4.0 grams
Sodium Chloride 4.0 grams
 Then add:
Water to make 4.0 liters

*Note: Silver nitrate should be dissolved completely before adding sodium chloride; immediately afterward add this milky white solution to the hypo-alum solution. The formation of a black precipitate in no way impairs the toning action of the bath if prints are then rinsed clean.

For use, pour toner into a tray in a water bath and heat to 49°C. Prints will tone in 12-14 minutes at this temperature; do not prolong time beyond 20 minutes. Do not use higher temperatures, or blisters and stains may result.

Prints for toning should be exposed to be slightly darker than normal when normally developed. They must be thoroughly fixed and washed. Soak dry prints in plain water to soften them before washing.

After toning, wipe prints clean of any sediment, then wash 1 hour in running water.

Sulfide Sepia Toner *Kodak* T-7a

For cold tone papers.

Stock Bleaching Solution A:

Water . 1.5 liters
Potassium Ferricyanide (anhydrous) 75.0 grams
Potassium Bromide (anhydrous) 75.0 grams
Potassium Oxalate 195.0 grams
Acetic Acid, 28% 40.0 ml
Water to make 2.0 liters

For use, dilute 1 part A with 1 part water. Bleach thoroughly washed print until only a faint yellowish image remains—about 1 minute. Then tone in diluted solution B.

Stock Toning Solution B:

Sodium Sulfide (anhydrous) 45.0 grams
Water . 500.0 ml

For use, dilute 124 ml of B with 1.0 liter water. After bleaching, rinse print *thoroughly* in running water—at least 2 minutes. Treat print in diluted solution B until original detail returns—about 30 seconds. Immediately rinse print thoroughly, then treat 2-5 minutes in a solution of 2 parts *Kodak* Hardener F-5a stock solution (see Fixer formulas) and 16 parts water. After hardening, wash print at least 30 minutes in running water before drying.

Polysulfide Toner *Kodak* T-8

For darker sepia tones than redevelopment-sulfide toners produce.

Water 750.0 ml
Sulfurated Potassium
 (Liver of Sulfur) 7.5 grams
Sodium Carbonate (monohydrated) 2.5 grams
Water to make 1.0 liter

Use undiluted. Immerse thoroughly washed print for 15-20 minutes at 20°C (or 3-4 minutes at 38°C), with continuous agitation.

After toning, rinse print briefly in running water, then place about 1 minute in a fresh solution of *Kodak* Hypo Clearing Agent kept only for this purpose, or in a solution of 30 grams of sodium bisulfite in 1 liter of water. Then treat print 2-5 minutes in a solution of 2 parts *Kodak* Hardener F-5a stock solution (see Fixer formulas) and 16 parts water. Wipe any sediment from print, then wash at least 30 minutes before drying.

Nelson Gold Toner *Kodak* T-21
 GAF 223

For warm black to neutral brown tones on warm-tone papers; has little effect on cold-tone papers. Tones both highlights and shadows of a print at a uniform rate.

Stock Solution A:

Water 50°C . 4.0 liters
Sodium Thiosulfate (Hypo) 960.0 grams
Potassium Persulfate 120.0 grams

Dissolve the hypo completely before adding the persulfate, while stirring vigorously. If the solution does not turn milky, increase the temperature until it does so.

Cool the solution to about 27°C and add the solution below, including the precipitate, slowly and with constant stirring. *These two solutions must be cool when added together.*

Cold water . 64.0 ml
Silver Nitrate (crystals) 5.0 grams
Sodium Chloride 5.0 grams

Dissolve the silver nitrate completely before adding the sodium chloride.

Stock Solution B:

Water . 250.0 ml
Gold Chloride . 1.0 grams

Note: Gold Chloride will liquefy rapidly in a normal room atmosphere. Store the chemical in a tightly stoppered bottle in a dry atmosphere.

For use, pour 125 ml of B slowly into the entire volume of A while stirring rapidly. Let the combined solution stand about 8 hours, until a yellow precipitate has formed and settled to the bottom of the container. Then carefully pour off the clear solution for use and discard the precipitate.

Pour the solution into a tray in a water bath and heat to 43°C; maintain this temperature during toning. Wash prints fixed before placing them in the toner. Soak dry prints thoroughly in water before toning.

Keep an untoned black-and-white print on hand for comparison during toning. If sediment forms in the toning tray, it will not affect the results, but may form a scum on the print surface. If so, wipe the print clean with a soft sponge immediatley after toning.

Tone 5-20 minutes, until desired tone is obtained, then remove print and rinse in cold water. More than one print at a time may be toned; if they

are kept separated. After toning, wash prints thoroughly and dry.

Revive the bath at intervals by adding Stock Solution B. The quantity to be added will depend upon the number of prints toned and the time of toning. For example, when toning to a warm brown, add 4 ml of B after each 50 20×25cm prints, or equivalent, have been toned.

Red Toner Gevaert-15
Solution A:
Potassium Citrate 100.0 grams
Water to make . 500.0 ml

Solution B:
Copper Sulfate . 7.5 grams
Water to make . 250.0 ml

Solution C:
Potassium Ferricyanide 6.5 grams
Water to make . 250.0 ml

Mix solution B into solution A, then slowly add solution C, stirring well. Remove prints from toning bath when desired tone is obtained and wash thoroughly.

Green Toner Gevaert-16
Solution A:
Oxalic Acid . 7.8 grams
Ferric Chloride 1.0 gram
Ferric Oxalate 1.0 gram
Water to make . 285.0 ml

Solution B:
Potassium Ferricyanide 2.0 grams
Water to make . 285.0 ml

Solution C:
Hydrochloric Acid 28.4 ml
Vanadium Chloride 2.0 grams
Water to make . 285.0 ml

In solution C the acid is first added to the water; the solution is then heated almost to the boiling point before the vanadium is added.

Mix solution B into A, then introduce solution C, stirring well.

Tone in the mixed solution until the prints are deep blue. Remove and place in wash until tone changes to green.

If there is any yellowish stain in the whites it may be removed by immersion in the following solution:

Ammonium Sulfocyanide 1.6 grams
Water to make . 285.0 ml

STAIN REMOVERS AND CLEANERS
Tray Cleaner *Kodak* TC-1
DuPont 1-TC
To remove developer oxidation stains, and some silver and dye stains.

Water . 1.0 liter
Potassium Dichromate (anhydrous) 90.0 grams
Sulfuric Acid . 96.0 ml

Add acid to solution, while stirring. Never add solution to acid.

Pour a small amount of TC-1 into vessel to be cleaned, rinse around so that it has access to all parts, then pour it out and wash the vessel 6 or 8 times with water until all traces of the cleaning solution disappear. *Do not* use TC-1 to clean the hands; use *Kodak* TC-3.

Tray Cleaner *Kodak* TC-3
To remove stains due to silver, silver sulfide, and many dyes.

Solution A:
Water . 1.0 liter
Potassium Permanganate 2.0 grams
Sulfuric Acid (concentrated) 4.0 ml

Add acid to solution, while stirring. Never add solution to acid. Store solution A in a stoppered glass bottle, away from the light.

Solution B:
Water . 1.0 liter
Sodium Bisulfite (anhydrous) 30.0 grams
Sodium Sulfite (anhydrous) 30.0 grams

To use, pour a small quantity of A into the vessel being cleaned and leave it for a few minutes.

Pour out A, rinse the vessel well, then pour in an equivalent amount of B. Agitate until the brown stain is completely cleared, then wash the vessel thoroughly. Several vessels can be cleaned consecutively without making up new solutions. However, do not store used solutions for repeated use.

May be used as described to clean hands; remove all jewelry. Wash thoroughly after use.

Stain Remover *Kodak* S-6

To remove developer or oxidation stains from film.

Stock Solution A:

Potassium Permanganate 5.0 grams
Water to make 1.0 liter

Be sure that all particles of permanganate dissolve completely.

Stock Solution B:

Cold water . 500.0 ml
Sodium Chloride 75.0 grams
Sulfuric Acid (concentrated) 16.0 ml
Water to make 1.0 liter

Add acid to solution, while stirring. Never add solution to acid.

Harden film to be treated 2-3 minutes in *Kodak* SH-1, and wash 5 minutes. Mix equal parts of A and B *immediately* before use; keep them at 20°C. Immerse film in this solution 3-4 minutes; a brown stain of manganese dioxide will form on the film. To remove the stain, immerse film in a 1% sodium bisulfite solution (10 grams bisulfite in 1 liter water). Remove, rinse well, and develop in strong light (preferably sunlight) in a non-staining developer such as *Kodak* Dektol or D-72. *Do not* use slow-working developers such as *Kodak* D-76, Microdol-X, or DK-20; they tend to dissolve the bleached image before the developing agents are able to act on it.

Stain Remover for Hands DuPont 1-SR

To remove almost all developer and ink stains.

Solution A:

Water . 1.0 liter
Potassium Permanganate 15.0 grams

Sulfuric Acid (concentrated) 5.0 ml

Add acid to solution, while stirring. Never add solution to acid.

Solution B:

Water . 1.0 liter
Sodium Bisulfite 50.0 grams

Bathe hands in A, rinse in water, and bathe in B. If one treatment is not sufficient, wash hands with soap and water before repeating. Wash hands thoroughly when finished.

Developer Stain Remover for Films Ilford

Water 52°C . 750.0 ml
Potassium Permanganate 6.0 grams
Sodium Chloride 13.0 grams
Acetic Acid (99% Glacial) 50.0 ml
Cold water to make 1.0 liter

Add acid to solution, while stirring. Never add solution to acid.

Harden negative 3-5 minutes in a 1% potassium chrome alum solution (10 grams alum in 1 liter water) and rinse before treatment. Immerse negative in stain remover about 10 minutes with constant agitation. Then remove brown stain by immersing negative in a 5% potassium metabisulfite solution (50 grams bisulfite in 1 liter water). Redevelop in any ordinary developer, such as Ilford ID-36, and wash thoroughly.

Developer Stain Remover for Prints Ilford

To remove stains from bromide paper prints.

Potassium Alum (saturated solution) 250.0 ml
Hydrochloric Acid (concentrated) 6.0 ml

Pour the acid slowly into the alum solution while stirring constantly.

Wash prints thoroughly after treatment.

Tank and Reel Cleaner

Sodium Sulfite 60.0 grams
Sodium Carbonate 90.0 grams
Hot water . 4.0 liters

Soak equipment overnight in this solution, rinse thoroughly, dry immediately.

CONVERSION CHARTS

Compound Conversions. When converting a formula given in metric terms to the U.S. system, or vice versa, it is essential to remember that formulas represent a proportion of x amount of each chemical in y volume of total solution. You cannot accurately convert only the amount of chemical, you must convert the volume of solution as well. For example, in terms of weight, 1 ounce equals 28.35 grams; but in terms of solution strength, 1 *ounce per quart* equals 30.0 *grams per liter.*

The factors and tables below will make formula conversion relatively painless.

Mass (Weight) Factors

Grains per quart	$\times\ 0.068 =$	grams per liter
Ounces per quart	$\times\ 29.96 =$	grams per liter
Pounds per quart	$\times\ 479.3 =$	grams per liter

Grams per liter	$\times\ 14.60 =$	grains per quart
Grams per liter	$\times\ 0.033 =$	ounces per quart
Grams per liter	$\times\ 0.002 =$	pounds per quart

Grains per quart		Grams per liter	Grams per liter		Grains per quart
5	=	0.3	0.5	=	7.3
10	=	0.7	1.0	=	14.6
15	=	1.0	1.5	=	21.9
20	=	1.4	2.0	=	29.2
25	=	1.7	2.5	=	36.5
30	=	2.1	3.0	=	43.8
40	=	2.7	3.5	=	51.1
50	=	3.4	4.0	=	58.4
60	=	4.1	4.5	=	65.7
70	=	4.8	5.0	=	73.0
80	=	5.5	6.0	=	87.6
90	=	6.2	7.0	=	102.2
100	=	6.8	8.0	=	116.8
150	=	10.3	9.0	=	131.4
200	=	13.7	10.0	=	146.0
300	=	20.5	20.0	=	292.0
400	=	27.4	25.0	=	365.0
500	=	34.2	30.0	=	438.0
600	=	41.1	40.0	=	584.0
700	=	47.9	50.0	=	730.0

Ounces per quart		Grams per liter	Grams per liter		Ounces per quart
0.1	=	3	1.0	=	.03
0.2	=	6	5.0	=	.17
0.3	=	9	10.0	=	.33
0.4	=	12	20.0	=	.67
0.5	=	15	25.0	=	.83
0.6	=	18	30.0	=	1.00
0.7	=	21	35.0	=	1.17
0.8	=	24	40.0	=	1.34
0.9	=	27	45.0	=	1.50
1.0	=	30	50.0	=	1.67
2.0	=	60	60.0	=	2.00
3.0	=	90	70.0	=	2.34
4.0	=	120	80.0	=	2.67
5.0	=	150	90.0	=	3.00
6.0	=	180	100.0	=	3.34
7.0	=	210	150.0	=	5.00
8.0	=	240	200.0	=	6.68
9.0	=	270	250.0	=	8.34
10.0	=	300	300.0	=	10.00

Mass (Weight) Measure

Grams		Grains	Grains		Grams	Grams		Ounces	Ounces		Grams
1	=	15.4	1	=	0.065	5	=	0.18	1/4	=	7.0
2	=	30.9	2	=	0.130	10	=	0.35	1/2	=	14.1
3	=	46.3	3	=	0.194	15	=	0.53	3/4	=	21.2
4	=	61.7	4	=	0.249	20	=	0.71	1	=	28.3
5	=	77.1	5	=	0.324	25	=	0.88	2	=	56.7
6	=	92.8	6	=	0.389	35	=	1.23	3	=	85.0
7	=	108.1	7	=	0.453	50	=	1.76	4	=	113.4
8	=	123.5	8	=	0.518	100	=	3.53	5	=	141.7
9	=	138.9	9	=	0.583	150	=	5.29	6	=	170.1
10	=	154.3	10	=	0.648	200	=	7.05	7	=	198.4
20	=	308.6	20	=	1.296	250	=	8.81	8	=	226.8
30	=	463.0	30	=	1.944	300	=	10.58	9	=	255.1
40	=	617.3	40	=	2.592	350	=	12.34	10	=	283.5
50	=	771.5	50	=	3.240	400	=	14.10	11	=	311.8
60	=	925.6	60	=	3.888	450	=	15.87	12	=	340.2
70	=	1080.0	70	=	4.536	500	=	17.63	13	=	368.5
80	=	1235.0	80	=	5.184	600	=	21.16	14	=	396.9
90	=	1390.0	90	=	5.832	800	=	28.21	15	=	425.2
100	=	1543.0	100	=	6.480	1000	=	35.27	16	=	453.6

Mass (Weight) Conversion

g (grams)	× 15.432	= grains
	× 0.564	= drams
	× 0.035	= ounces
	× 0.002	= pounds
	× 1000	= milligrams
	× 0.001	= kilograms

kg (kilograms)	× 15432.4	= grains
	× 564.383	= drams
	× 35.274	= ounces
	× 2.2046	= pounds
	× 1000	= grams

gr (grains)	× 0.365	= drams
	× 0.0023	= ounces
	× 0.00014	= pounds
	× 64.799	= milligrams
	× 0.0648	= grams
	× 0.00006	= kilograms

oz (ounces)	× 437.5	= grains
	× 16	= drams
	× 0.0625	= pounds
	× 28.349	= grams
	× 0.02834	= kilograms

lb (pounds)	× 7000	= grains
	× 256	= drams
	× 16	= ounces
	× 453.59	= grams
	× 0.4536	= kilograms

Liquid Capacity Measure

Milliliters		Ounces		Ounces		Milliliters		Milliliters		Ounces		Ounces		Milliliters
15	=	0.5		1/2	=	15		500	=	16.91		10	=	296
22	=	0.75		3/4	=	22		600	=	20.29		11	=	325
30	=	1		1	=	30		700	=	23.67		12	=	355
50	=	1.69		2	=	59		800	=	27.05		13	=	384
75	=	2.54		3	=	89		900	=	30.43		14	=	414
100	=	3.38		4	=	118		1000	=	33.80		15	=	444
150	=	5.07		5	=	148		1100	=	37.18		16	=	473
175	=	5.92		6	=	177		1200	=	40.56		24	=	710
200	=	6.76		7	=	207		1300	=	43.94		32	=	946
300	=	10.14		8	=	237		1400	=	47.32		64	=	1892
400	=	13.52		9	=	266		1500	=	50.70		128	=	3785

Liquid Conversion

ml (milliliters)
\times 0.0338 = ounces
\times 0.0021 = pints
\times 0.0010 = quarts
\times 0.0010 = liters

l (liters)
\times 33.814 = ounces
\times 2.1133 = pints
\times 1.0566 = quarts
\times 0.2642 = gallons
\times 1000.0 = milliliters

oz (ounces)
\times 0.0625 = pints
\times 0.0312 = quarts
\times 0.0078 = gallons
\times 29.573 = milliliters
\times 0.0296 = liters

pt (pints)
\times 16 = ounces
\times 0.5 = quarts
\times 0.125 = gallons
\times 473.17 = milliliters
\times 0.4731 = liters

qt (quarts)
\times 32 = ounces
\times 2 = pints
\times 0.25 = gallons
\times 946.34 = milliliters
\times 0.9463 = liters

gal (gallons)
\times 128 = ounces
\times 8 = pints
\times 4 = quarts
\times 3785.4 = milliliters
\times 3.7854 = liters

U.S.		U.S.		Metric
1 dram	=	1/8 ounce	=	3.7 milliliters
1/2 pint	=	8 ounces	=	237 milliliters
1 pint	=	16 ounces	=	0.473 liter
1 quart	=	32 ounces	=	0.946 liter
1/2 gallon	=	64 ounces	=	1.9 liters
1 gallon	=	128 ounces	=	3.79 liters

Liquid Factors

Fluid oz. per quart \times 31.25 = ml per liter

Milliliters per liter \times 0.032 = fl. oz. per quart

Fluid oz. per quart	Milli-liters per liter	Milli-liters per liter	Fluid oz. per quart		Fluid oz. per quart	Milli-liters per liter	Milli-liters per liter	Fluid oz. per quart
1/8 (1 fl dr) =	3.9	1.0 =	.032 (0.25 fl dr)		1 (8 fl dr) =	31.2	40.0 =	1.280
1/4 (2 fl dr) =	7.8	5.0 =	.160 (1.25 fl dr)		2 =	62.5	50.0 =	1.600
3/8 (3 fl dr) =	11.7	10.0 =	.320 (2.50 fl dr)		3 =	93.8	100.0 =	3.200
1/2 (4 fl dr) =	15.6	15.0 =	.480 (3.80 fl dr)		4 =	125.0	110.0 =	3.520
5/8 (5 fl dr) =	19.5	20.0 =	.640 (5.10 fl dr)		5 =	156.3	120.0 =	3.840
3/4 (6 fl dr) =	23.4	25.0 =	.800 (6.40 fl dr)		6 =	187.5	130.0 =	4.160
7/8 (7 fl dr) =	27.3	30.0 =	.960 (7.70 fl dr)		7 =	218.8	140.0 =	4.480
					8 =	250.0	150.0 =	4.800
					9 =	281.3	200.0 =	6.400
					10 =	312.5	300.0 =	9.600
					12 =	375.0	400.0 =	12.800
					16 =	500.0	500.0 =	16.000

$$°C = \frac{(°F - 32) \times 5}{9}$$

$$°F = \frac{°C \times 9}{5} + 32$$

°C	°F	°C	°F	°C	°F	°C	°F		°F	°C	°F	°C	°F	°C	°F	°C
0	=32															
1	=33.8	16	=60.8	31	=87.8	46	=114.8		31	=-0.6	51	=10.6	71	=21.7	91	=32.8
2	=35.6	17	=62.6	32	=89.6	47	=116.6		32	=0.0	52	=11.1	72	=22.2	92	=33.3
3	=37.4	18	=64.4	33	=91.4	48	=118.4		33	=0.6	53	=11.7	73	=22.8	93	=33.9
4	=39.2	19	=66.2	34	=93.2	49	=120.2		34	=1.1	54	=12.2	74	=23.2	94	=34.4
5	=41.0	20	=68.0	34	=95.0	50	=122.0		35	=1.7	55	=12.8	75	=23.9	95	=35.0
6	=42.8	21	=69.8	36	=96.8	60	=140.0		36	=2.2	56	=13.3	76	=24.4	96	=35.6
7	=44.6	22	=71.6	37	=98.6	70	=158.0		37	=2.8	57	=13.9	77	=25.0	97	=36.1
8	=46.4	23	=73.4	38	=100.4	80	=176.0		38	=3.3	58	=14.4	78	=25.6	98	=36.7
9	=48.2	24	=75.2	39	=102.2	90	=194.0		39	=3.9	59	=15.0	79	=26.1	99	=37.2
10	=50.0	25	=77.0	40	=104.0	100	=212.0		40	=4.4	60	=15.6	80	=26.7	100	=37.8
11	=51.8	26	=78.8	41	=105.8				41	=5.0	61	=16.1	81	=27.2	110	=43.3
12	=53.6	27	=80.6	42	=107.6				42	=5.6	62	=16.7	82	=27.8	115	=46.1
13	=55.4	28	=82.4	43	=109.4				43	=6.1	63	=17.2	83	=28.3	120	=48.9
14	=57.2	29	=84.2	44	=111.2				44	=6.7	64	=17.8	84	=28.9	125	=51.7
15	=59.0	30	=86.0	45	=113.0				45	=7.2	65	=18.3	85	=29.4	130	=54.4
									46	=7.8	66	=18.9	86	=30.0	140	=60.0
									47	=8.3	67	=19.4	87	=30.6	150	=65.6
									48	=8.9	68	=20.0	88	=31.1	175	=79.4
									49	=9.4	69	=20.6	89	=31.7	200	=93.3
									50	=10.0	70	=21.1	90	=32.2	212	=100.0

The Tailor-Made Darkroom

A workable darkroom can be set up almost anywhere—a kitchen, bathroom, closet, or spare room can be converted for photographic use quite easily. Most photographers who have gotten beyond the "drugstore development" stage eventually set up some kind of darkroom at home, yet many soon revert to sending their film out for processing. In most cases, this "dropping out" is due to a lack of planning or of common sense, rather than to any difficulties in doing photographic work at home. The better thought-out your darkroom is in terms of the space you have and the kind of work you plan to do, the more easily that work can be accomplished. An awkward darkroom can soon dampen any desire to pursue the art and skill of photographic printing. Systematic planning can give you a comfortable and efficient darkroom. This applies to both, temporary or permanent, set-ups.

Start by making a list of the areas in your home where there is enough space to set up the darkroom. If you have to use space that serves other purposes, as well, you will have to face certain compromises.

For example, bathrooms may be far less than ideal in a household with a reasonably large family: The constant interruptions may eventually put a damper on your photographic enthusiasm. In this case a spare closet might be a better darkroom site, with prints or films washed elsewhere afterward.

There may be hazards there, too, though: Say you have a large walk-in closet that looks perfect for a small darkroom. You put in your enlarger, trays, safelight, and so on and start making prints, with the added bonus of musical sound coming down the walls from your upstairs neighbor's speaker system. Your prints may be disappointingly fuzzy, especially if the speaker is located directly overhead. The sound will vibrate your enlarger making sharp prints impossible. Heavy traffic—especially trucks—may have the same effect. With an understanding neighbor some sort of arrangement might be possible; with traffic, either find another area for your printmaking or put a half-inch thick sheet of foam rubber under the enlarger to damp vibrations.

Checklist. All efficient darkrooms, no matter what the size or description have certain things in common:

- they are light tight
- they have access to electrical current
- they have a water supply nearby
- they have space to accommodate all materials needed for making photographic prints with enough room left for fairly comfortable movement of the worker
- they are well ventilated

If you plan a temporary setup in an area used for nonphotographic purposes, make your darkroom equipment as portable as possible. Enlarger, trays, and other materials could be stored on a roll-around table, tea cart, or trolley in a closet, for example, and easily wheeled out and set up for use (see illustration). An arrangement of this sort will only work if the equipment can be assembled and dismantled quickly and conveniently. Restaurant-supply houses and hospital-equipment stores sell

trolleys in a wide range of sizes. Some are equipped with locking wheels making them useful stands for enlargers. Most have built-in shelves at various heights giving you convenient storage space for paper when printing. Be sure the working height is convenient and the unit is sturdy enough to support the weight of your enlarger without vibrating; if it is to be used for an actual working stand.

For other than trolley set ups, try to arrange your storage space close to the working area to keep preparation time at a minimum. An under-the-counter cabinet in the kitchen or a linen closet in the bathroom could be used. Be sure to wrap enlarger heads, lenses, safelights, times and so on if these items are to be stored where cooking fumes or condensed moisture can get at them: Use plastic only if a package of silica gel is also enclosed, otherwise cloth is better — plastic can seal moisture *in* as well as out. A divided drawer or box is useful for small items — scissors, thermometers, tongs, and so

Seeing How Others Have Done It. A useful way to spend a few days before beginning to arrange your own darkroom area is by visiting other peoples' darkrooms.

Many schools, social organizations, and commercial photography houses will invite you to see their facilities if you explain that you are looking for information about darkrooms. When you go — whether to full-fledged laboratories or simple, temporary areas set up in the home of friends — ask about the type of work done there; pay close attention to the amount of human engineering that has been attempted; especially important, make notes and sketch diagrams. You will be able to adapt many of the things you see to your own situation, and you will learn to avoid mistakes made by the people whose facilities you visited, when you compare notes on one operation with those about another.

Start With a Floor Plan. To lay out your own darkroom start with paper and pencil.

1. List all equipment to be used in the darkroom.

2. Using quarter-inch-squared graph paper, draw a scale outline of the area where your darkroom is to be. Measure the area carefully, then transfer your measurements onto the graph paper. A scale of two squares (one-half inch) to one foot will produce a plan in a convenient size.

3. Using another sheet of the same graph paper, and the same half-inch-to-a-foot scale, draw a bird's-eye-view of each important item for the darkroom area and cut it out. Make one of these templates for both permanently installed and large movable items: enlarger, trays, washer, dryer, and so on.

4. Now you can lay each template on the outline of the area and move them around until you arrive at the most convenient and efficient placement for all items to be used. Remember to leave enough space to move around comfortably and to separate "wet" and "dry" working areas.

5. Once the arrangement feels comfortable, tape the templates in place and then plan placement of lighting fixtures, and — if you are adding permanent facilities — outlets, faucets, drains, and ventilators.

Applying Common Sense. Are you right-handed or left handed? It will make no difference if you follow the standard darkroom layout: Put the developing tray nearest to the enlarger, the stop bath beyond it, and the fixer next. Once you get used to this layout you can find your way in any darkroom.

Still, the distribution of space and equipment has a great psychological effect on the darkroom worker and must be allowed for if planning is to be

effective. Also, are you tall, of middle height, or short? Your counterspace, sinks and enlarger baseboards should be built up to an appropriate height, so that your back and neck do not suffer during extended printing sessions.

Do you foresee using film formats that are larger than the one you are currently using? If so, then plan your darkroom accordingly, allowing space on the countertops for the bigger trays that will become necessary. It is a good idea to provide for eventual expansion in other ways, too; for instance, better image sharpness can be almost guaranteed by using one of the larger, sturdier enlargers—especially if you use 35mm film. So think about allowing enough space to house one when that time comes.

If you assess your needs and your photographic goals carefully, keeping in mind your environment and your physical makeup, you will find that the darkroom area you eventually construct will be a pleasure to work in.

POWER

Electrical power requirements for normal (one-or two-person) darkroom use are not overly demanding; a large safelight, two timers, and two enlargers all operating at once will draw a little less than 1000 watts. This amount of energy can be safely handled by a normal 15-ampere household circuit, provided it is well grounded; so added electrical service would be unnecessary. Four outlets are the minimum for darkroom use. If your temporary darkroom has less, you can get a grounded outlet strip or you can use extension cords to bring in additional power from elsewhere. Just be careful not to overload the house circuit. If you decide to use extension cords avoid the thin "household" type and get heavy duty three wire cords instead. Get the self-grounding type or add self-grounding plugs. These wires come in various thicknesses, the best for darkroom use being the 14-gauge or 16-gauge. Extension cords of this sort can be found at any

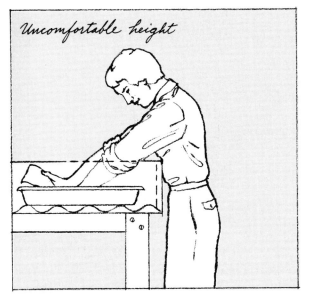

Uncomfortable height

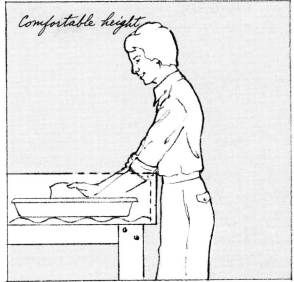

Comfortable height

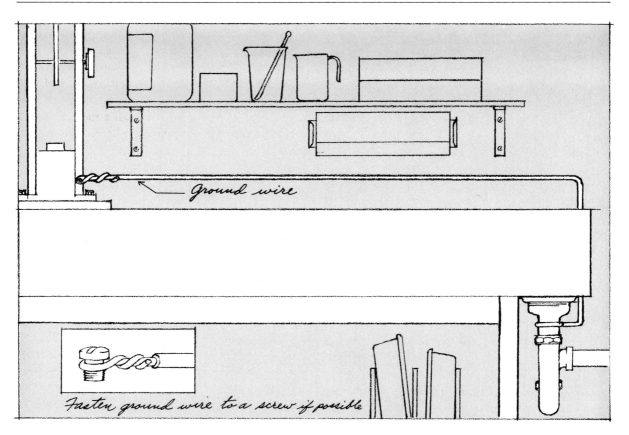

Ground wire

Fasten ground wire to a screw if possible

well-stocked hardware store. Buy the shortest length that will do the job, and attach to a fused plug box, or "spider" box (see illustrations) or to self-grounding plugs.

For the permanent darkroom, *do not attempt to install additional outlets yourself* unless you are a licensed electrician. Just about every community has strict codes governing the installation of electrical fixtures. These regulations specify that any electrical work to be undertaken in a household should be done only by a licensed electrician. If there is plumbing installed, a ground-fault detector must be in the circuit ahead of all power lines feeding the darkroom, and this calls for professional installation too. Having a specialist do the job will also keep you from making mistakes that might cause fires and other mishaps.

Make sure that *all circuits are grounded.* If this is not possible, or if you are not sure, run ground wires from *each* piece of equipment (see illustration of how to run a ground wire from your enlarger). The ground wire will keep the risk of electrical shock to a minimum. It also has another, more observable benefit: It will prevent dust build-up caused by static electricity.

SAFELIGHTS

Safelights are available in a variety of shapes and sizes to fit the need of any darkroom set-up. However, safelights are only "safe" if installed at the proper distance and, in size and level of illumination, appropriate to the size of your darkroom. Nevertheless, photographic paper should never be

exposed longer than necessary, because fogging will inevitably result after a few minutes.

Kodak manufactures several types of safelights, from the *Kodak* Brownie Darkroom Lamp, which is best suited for the small and temporary darkrooms, to a 10 × 12" unit which can illuminate a large room: Inbetween are the cone-shaped models, either stationary or with positional adjustment. All units use standard lightbulbs; the density and safety of the illumination is controlled by interchangeable filters. Follow the manufacturer's recommendation for the type of filter, and safe bulb wattage, for their products. Also see chart beginning on page 108.

Sodium Vapor Safelights. This type of safelight emits its illumination through a vapor discharge tube, instead of a filament lamp. The sodium used produces a "narrow band" light that makes this light source brighter than conventional safelights. The light emitted is so easy to see by, that at first you may become convinced that your paper will be fogged—but, if properly mounted and at the proper distance, sodium vapor lights are safe.

When first lit, the sodium will require a few minutes to heat up to the point where the lamp gives off its full illumination. The light will at first give off a dull red glow, then progress through orange until it glows brightly yellow: Make allowances for this when you get ready to print by turning on the safelight before you begin to set up your chemicals; by the time you are set to start, the safelight should be ready as well.

One manufacturer of this type of safelight is the Thomas Instrument Company, 331 Park Avenue, New York, New York 10010. Their model, the Thomas Duplex Super Sodium Vapor Safelight, is designed to be hung from the ceiling, so that the light reflects down into the darkroom. The Duplex has filtered "barndoors" which can be opened or closed to control the intensity of the light reflected, and to match the sensitivity of the paper you are using. For example: The unit can be used at full opening with most bromide enlarging papers, such

as Kodabromide and Ilfobrom; Polycontrast-Rapid and such papers are much more sensitive and you will have to close down the barndoors to prevent fogging. The filters are interchangeable, and are available in various colors and degrees of density, for additional control and safety. If a special filter is required, the unit is operated with the barndoors fully closed.

In spite of its sterling qualities, the sodium vapor lamp is not for everyone. The unit is expensive (Thomas's sells for somewhat more than $200.00); heavy, making it difficult to install in a room with plaster ceilings; and the lamps used in it can be dangerous if not handled and/or disposed of properly. Sodium is a highly volatile metal that will react violently when brought into contact with moisture. Old, burned out sodium vapor tubes must be carefully disposed of, by being broken in a strong metal container, with water poured on the broken remains so that all of the residual sodium is burned up before it can do any uncontrolled damage. If the lamps are disposed of in a careless way, they may explode violently, setting fire to their surroundings in the process.

Full and detailed instructions for handling and disposal of these tubes are included with each one. Pay strict attention to them.

Fluorescent Safelights. There is at least one company currently manufacturing a fluorescent safelight. The benefits are obvious—since fluorescent tubes ignite almost instantly, there is no warm-up period; and since they are long and narrow, they can illuminate large areas without too much trouble.

The Chemical Products Co., PO Box 337, No. Warren, Pennsylvania 16365, are the makers of the CP fluorescent safelight, which is claimed to be safe will all standard enlarging papers, including Polycontrast-Rapid. This product is supplied with a specially painted housing that will prevent unwanted reflections in your darkroom. Contact the manufacturer for current prices and the address of the distributor nearest you; but don't ask them

about the coating on their lamps—they're not telling. Apparently, it is no mean feat to produce a fluorescent lamp that is safe for use with photographic papers, and they are keeping the secret to themselves.

Many other manufacturers produce conventional, incandescent-type safelights of many types and sizes and common sense should be applied when choosing from among them. All of the ones produced by reputable manufacturers will do the job. Don't buy more or less safelight than you need, make sure that any unit you are considering, conventional or otherwise, is UL approved (look for the sticker or read the specification sheet), and take along a note reminding you of the dimensions of your darkroom.

WATER SUPPLY

Water can easily be carried into the darkroom area with a bucket or large jug and carried out after use. Prints can be kept in a holding tray until it is about half full, when they can be removed to a sink or bathtub for washing. But if you can have running water and drainage in the darkroom area itself, your work will naturally go a lot more smoothly and comfortably. Existing hot and cold faucets in the bathroom, kitchen sink, or laundry facility will suffice in most cases.

If you are more adventurous or ambitious, you might consider installing full darkroom plumbing facilities, complete with filters, temperature control units, and pressure regulators.

If you need to install a complete darkroom plumbing system, do so only with the help of a professional plumber. While water will not generally cause as much physical damage as electrical current, the problems caused by incorrect plumbing can be extremely wet and very expensive.

All sinks and counters should be planned and laid out before any plumbing fixtures are installed. Keep lengths of uninsulated pipe as short as possible, or fluctuations in water temperature will be a constant problem. Plan your sinks so that their

faucets stand at least 46cm (18 in.) above the sink base. This height will allow you to place one-gallon jugs under the spigots easily.

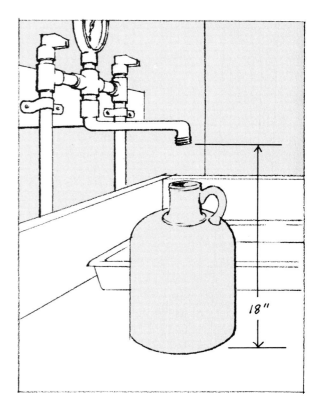

Water Filters. If the water supply to your darkroom is rusty or especially hard (i.e., full of minerals), you may find that good photographic work is difficult or impossible, due to stains caused by contaminants in the water. A simple way to get around some water problems is to mix your chemicals in distilled water (a procedure many manufacturers recommend). However, it would be very inconvenient, and expensive, to use distilled water through each step of the process, especially washing. Other solutions will have to be found.

Water impurities are either of a physical or chemical nature. Rust coming from old pipes, for

example, discharges a sediment into the water supply. This sediment, if severe enough, can render water undrinkable. It can also cause your photographs to become inundated with brown spots and stains. Luckily, a problem of this nature is rather easily solved by attaching a filter to the incoming water supply. Many companies, most notably Leedal, and Pako, manufacture water filters with interchangeable filtering elements. These filters are easily attached to existing plumbing, and will take care of most sediment problems. The units range in price from about $25.00 to $100.00

Chemical water impurities can be much more tricky to deal with. Not all of these chemicals are solids; in fact, most of the various substances that can adversely affect photographic use of water are in solution—that is, they have chemically combined with the water. This makes them extremely difficult to remove by physical filtration. Fortunately, very few of the things found in water supplies are photographically active—most of the minerals and other substances are *inert*, and will not react with photographic materials in an adverse fashion. However, if you find that there *is* something wrong with your water supply, and that it cannot be fixed by filtration, send a sample of your water to a lab for analysis. In some localities, this analysis will be done by the utility supplying the water, or by the municipal government. Some universities have facilities for this kind of testing as well.

One you have obtained the analysis, send a copy of it to Kodak, Ilford or whichever company whose product you are using. Also enclose a sample of the stains or describe the problem that you are having. A solution, or suggestions, should be forthcomimg.

A high level of alkalinity in your water supply will not do any damage to your photographs as such. However, it might cause your developer to respond more quickly than normal. In such a case a few developing tests, and adjustments of your developing time, should take care of the problem.

WORK AREAS AND SINKS

Size of Surface. When drawing up your darkroom plans, do yourself a favor, and allow for plenty of counter space. Measure all your equipment and plan enough counter space for all your materials *plus* working space. For instance, even though your enlarger (or the big one you plan to have eventually) may need $51 \times 76cm$ (20×30 in.) of space, you will have to leave enough extra space beside it for printing paper, focusing aid, dodging tools—all the items you use while printing.

Height. Counter and sink height is important too. Before making any installation, set up a mock work table and sink and act out the motions made during developing and printing. Sit or stand for as long as you would during a normal darkroom session. This will soon tell you if the height and the layout are comfortable.

Work counters should be covered with epoxy-base paint or Formica. Both are resistant to moisture and chemical damage and are easily cleaned.

Sinks can be purchased in a variety of shapes and sizes or can be constructed from plywood and Fiberglas or epoxy paint.

Building a Darkroom Sink. One problem encountered while installing a darkroom is that sinks which are large enough to hold several printing trays and a print washer, and fits your space, are often hard to find and expensive. You can, of course, use a normal household sink and put your trays on a counter; but the ideal working situation places trays in the sink.

Building a darkroom sink doesn't require any great knowledge of carpentry and will allow you to fit your available space perfectly without spending a lot of money. The simplest method is to construct it from plywood and cover it with a Fiberglas resin or epoxy paint to make it waterproof.

After you have decided on the size, build the sink of half-inch or three-quarter-inch plywood. Marine or exterior-grade plywood is recom-

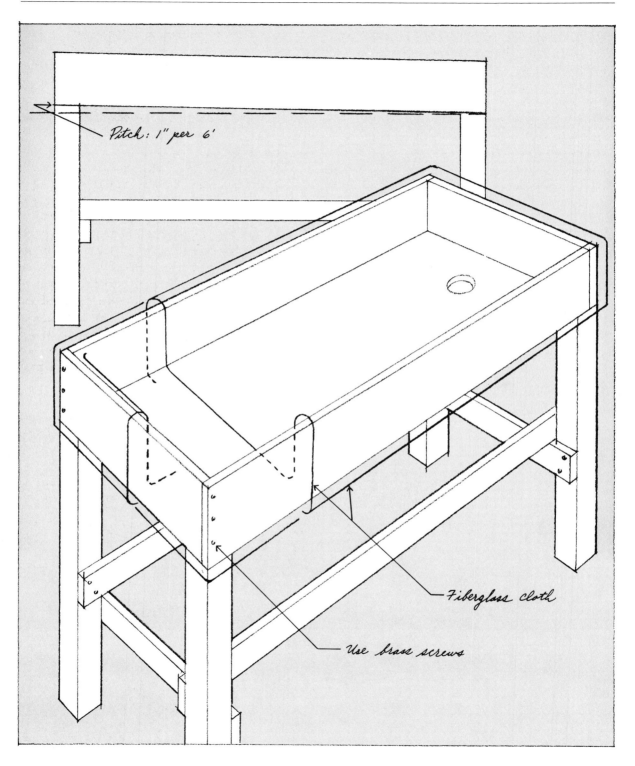

Pitch: 1" per 6'

Fiberglass cloth

Use brass screws

mended. Double check all inside and outside measurements, remembering to allow for the thickness of the wood, especially at joints. If possible have a friend skilled in carpentry check your plans before you order the wood. Measure and cut carefully, or have the lumber yard precut the wood to your specifications. Assemble the sink, making all joints with *brass* screws. Remember to plan for and to cut a drain hole. After assembly, caulk the interior with three or four coats of epoxy paint or two coats of polyester bond-coating resin. (Any large paint store or hardware shop can supply these.)

If you decide to coat the sink with resin, work outdoors or in a well-ventilated area. Mix the resin and its catalyst according to the manufacturer's directions. You will not need to apply Fiberglas cloth to the sink because the plywood should provide ample structural strength. You can add pigment to the resin to color it. Sinks are generally colored white, gray, or deep red. Mix no more than 8-10 ounces of resin with catalyst at a time because the mixture will jell in about fifteen or twenty minutes. Clean brushes and tools with acetone before the resin has a chance to start setting.

After the sink has been coated with resin or painted with epoxy paint and is thoroughly dry, install the drain and set the sink into place. Do not forget to *tilt* the sink a little *towards the drain* to allow water to run out. One inch of tilt per six feet of sink should suffice.

Storage Space. A clutter free darkroom makes life a lot easier, and the more storage space is provided the better. The area underneath the counterspace can be used for shelving, to hold boxes of paper, and the paraphernalia that one accumulates over years of darkroom work. The space underneath the sink can be divided into shelving, for storing chemical supplies, and vertical dividers for storing trays. If space allows, a shelf/splash-board running the length of the sink is ideal for holding bottles of mixed chemicals. Studying the illustration in this chapter will give you ideas on how other photographers have solved their storage problems within the space available.

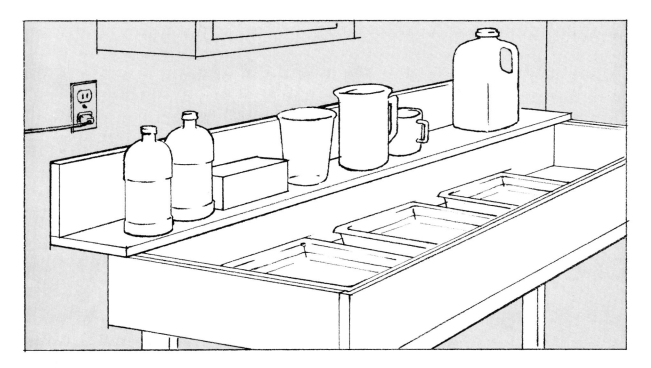

Two variations of lighttraps

VENTILATION AND AIR CONDITIONING

Adequate ventilation of the darkroom is imperative. Fumes and odors given off by chemicals are unpleasant, and the high humidity can become uncomfortable. In a permanent darkroom, both fresh-air input and exhaust fan should be installed. Light-proof fans and air inlets are available from most photo stores. Light traps can easily be constructed to permit circulation of air without allowing light to enter, as shown in the illustration.

In some regions you may want or need to heat or cool the darkroom. Usually a small electric space heater would do. The illumination from these heaters is generally safe for use when developing prints *if the printing paper is not directly exposed to them.* Test the "safeness" of your heater as you would a safelight, substituting the heater for the safelight. *Make sure the heater does not get wet;* keep it as far away from the "wet side" of your darkroom as possible.

If air cooling is needed, a small portable air conditioner will do the job and will also help to control dust and humidity.

In damp locations, such as basements, it may be necessary to use a dehumidifier, such as an ordinary domestic room dehumidifier available through appliance and hardware stores. If you must work in a damp location and don't have a dehumidifier, store your film, paper, and chemicals in a part of your home that is the coolest and driest you can manage, bringing them into the darkroom only when needed, and place packets of silica gel dehumidifying crystal in the storage area as well.

STORING CHEMICALS

Almost all chemicals used in photography will keep well for a long time, provided they are stored properly.

Powders and Other Solid Chemicals. Leave these in their original packages until used. Dry chemicals should be kept in a different place, away from liquid chemicals and solutions, to avoid damage from spills or breakage.

Manufacturers seal their prepared chemicals in airtight containers and usually package them in quantities that make convenient amounts of working solution, and so the average darkroom worker seldom has to bother with leftover chemical compounds. But, if you mix developers from scratch it is not likely that you would make up enough working solution at one time to use up entire containers of the various ingredients, even if you buy them in the smallest amounts available. In this case, make sure to reclose the various containers securely and to store all dry compounds in a cool, dry place where the humidity level is low. Packets of silica gel in corners of the shelves may help reduce humidity.

Liquid Chemicals. Some liquids used in the photographic process will lose their effectiveness quickly if left open to air and or exposed to light. Film and paper developers are especially prone to such weakening and oxidation. When you have mixed your gallon or lesser quantity of developer, pour it into a container especially designed for storing photographic solutions. There are good, shatterproof, storage bottles made of opaque brown polyethylene with built-in handles and plastic caps. There are containers with flexible or even accordian sides, which allow you to squeeze the air out of the container when the level of the solution drops as you use it up. The less air comes in contact with the solution, the longer that solution will be useable. Another way to keep the solution up to the mouth of a partly emptied bottle is to drop glass marbles in; but this can also make the container

clumsy to handle. A better way is to store developers in smaller quantities: Mix your usual full or half gallon, then divide it among pint-or-quart size containers, which can be sealed closed until needed.

You may have friends who use old brown cider or juice bottles (usually with metal caps) to store their chemicals in. This practice is fine — as long as you line the metal caps with plastic wrap. It is surprising how fast stop bath and fixer can eat their way through metal; developers will take longer but they, too, will react with the metal and become contaminated. A better source would be your local druggist, who often has to dispose of half-gallon brown glass bottles with screw-on bakelite caps. Plastic containers are easy to find at your photo shop. If you clean the containers thoroughly before each new batch of solution is placed in them, they will last indefinitely; and plastic, if inadvertently dropped, will not shatter. Glass will. There is a slightly greater chance of oxidation with plastic, but most of your solution will not be stored long enough for this to be a problem. If you are storing certain developers for a long period, then use dark amber glass bottles in order to lessen the chance of oxidation.

Labels and Storage Space. Keep all mixed chemicals within easy reach: Use the shelf under the sink, a low cupboard, the lower trolley shelf. Avoid storing them on shelves that have to be reached up to and you will not have to worry about pouring solutions all over yourself.

Do not store chemicals in your kitchen, even if you print there, and especially not if you use cider or juice bottles — this for obvious reasons. Make absolutely sure that all chemicals in your house are kept out of reach of children.

Rinse and dry the outside of each bottle as you put it away.

Label every bottle plainly: Note contents and date the solution was mixed. Use a waterproof pen, or cover the label with lacquer or clear tape.

SHELF LIFE OF COMMON DARKROOM CHEMICALS

The following is a list of commonly used prepared chemicals, indicating their respective shelf life under various conditions. These times are approximate, and will vary according to humidity, brightness and temperature of the area in which they are stored. (For example, an open tray of developer will become more quickly exhausted in a warm, humid room than in a cool dry one.)

While the chart below gives keeping-times for working solutions it is generally recommended that working solutions are used right after preparation; this will ensure more consistent and dependable results.

Lastly, become aware of the color and smell of your chemical preparations; despite all precautions contaminations can result. If anything seems "off" it is best to discard that batch and start fresh.

FILM DEVELOPERS

| | Stock Solution | | Working Solution |
Solution	(Full, stoppered bottle)	(Half-full stoppered bottle)	(Tank or tray, full, with lid)
Kodak			
DK-50	6 months	2 months	24 hours
DK-50 1:1	6 months	2 months	12 hours
D-76	6 months	2 months	24 hours
D-76 1:1	— — Mix only what you need, and use immediately — —		
Microdol X	6 months	2 months	24 hours
HC-110 Dilution A	6 months	2 months	24 hours
HC-110 Dilution B	6 months	2 months	12 hours
Agfa			
Rodinal — Any dilution	— — Mix only what you need and use immediately — —		
Ilford			
ID-11	6 months	2 months	24 hours
Edwal			
FG-7	— — Varies with dilution — — 6 months to 1 year		use immediately
Beseler			
UltraFin FD1 FD2 FD5	— — Concentrates come in 1 oz. — — containers for one-time dilution and use.		2 hours
Ethol			
Blue	1 year plus	4 to 5 months	use immediately
H&W			
Control 4.5	— — Indefinitely in original container — —		use immediately

PAPER DEVELOPERS

	Stock Solution		Working Solution
Solution	(Full, stoppered bottle)	(Half-full stoppered bottle)	(Tank or tray, full, with lid)
Kodak			
Dektol	6 months	2 months	12 hours
Selectol	4 months	6 weeks	12 hours
Selectol-Soft	4 months	6 weeks	12 hours
Versatol	— — Indefinitely in original container — —		12 hours
Ilford			
Bromophon	6 months	2 months	10-12 hours
Ilfospeed Concentrate	— — Indefinitely in original container — —		8-10 hours

STOP BATHS

All prepackaged stop baths will last indefinitely if left, tightly closed, in their original containers. Working solutions will keep for about 3 days, or until they turn purplish (in the case of indicator baths). *Kodak* Stop Baths SB3 and SB4 will keep for one day in their diluted state; but to be on the safe side, make a fresh working solution for each printing session. Discard after last print, or sooner if exhaustion point has been reached.

FIXER

Concentrated liquid fixers will keep for a long time if kept in their original containers, tightly closed. They should be diluted just before using. It is best to discard working dilutions immediately after use.

Powdered fixers will, in most cases, last about 2 months in stock solution if kept in a full, tightly stoppered bottle. Working dilutions will last about 1 week in a covered tray; but, unless you have a large, well-ventilated darkroom, you will probably find it more pleasant and convenient to dilute when needed and discard immediately after use (for prints) or to use stock solution directly (for films).

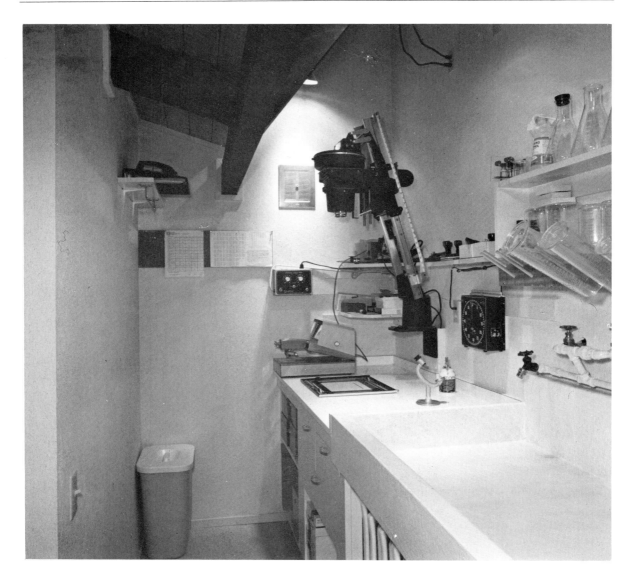

Built into a five by fourteen space this is the beautifully designed and immaculate darkroom of Henry Gilpin, a West Coast photographer.

The darkroom is built in at the end of a garage but with entree and exit into a studio (where the finishing work is done).

The counter (lengthwise) and sink are 30" deep. The sink, 84" long, is 3/4" plywood covered with fiberglass. The counter at the narrow end is 24" deep. Counters are covered with Formica. Paper storage is in the drawers underneath the enlarger. The space underneath the sink is divided into vertical slots for tray storage, and shelves for mixed chemicals and containers

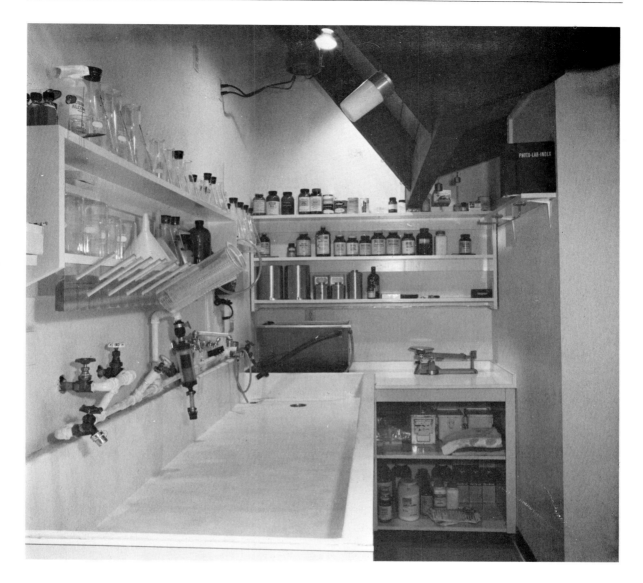

storage.

Shelves above the sink and counters hold mixing beakers, dry chemicals, film reels, tanks, etc. Also, note the dowels installed at an angle to hold graduates while draining. (The dowels can also be used for regular storage of graduates, funnels and the like.)

An interesting feature is the mounting of the enlarger: The machine is mounted about 10" above the counter on a 6" steel channel iron which is bolted to the concrete wall; it makes for a very sturdy installation, and with the enlarger not resting on the counter it leaves that space available for other uses.

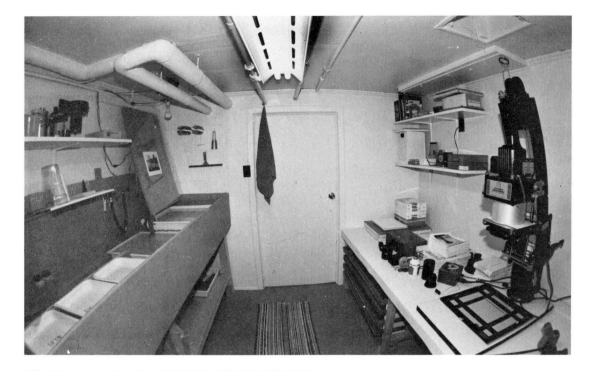

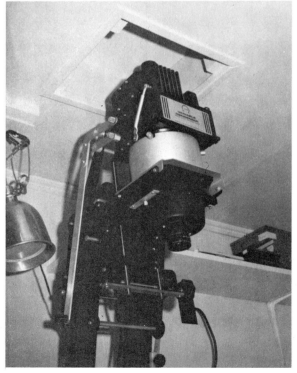

Above the darkroom of Arno Minnkinen, note the drying racks built in under the counter. Because of the low ceiling an opening was cut, in the ceiling, to allow for full extension of the enlarger.

Right, top: Wooden runners keep the trays suspended. Bottom: A wet, squeegeed, print will adhere to a sheet of plexiglass and allow for a more objective evaluation of print tones.

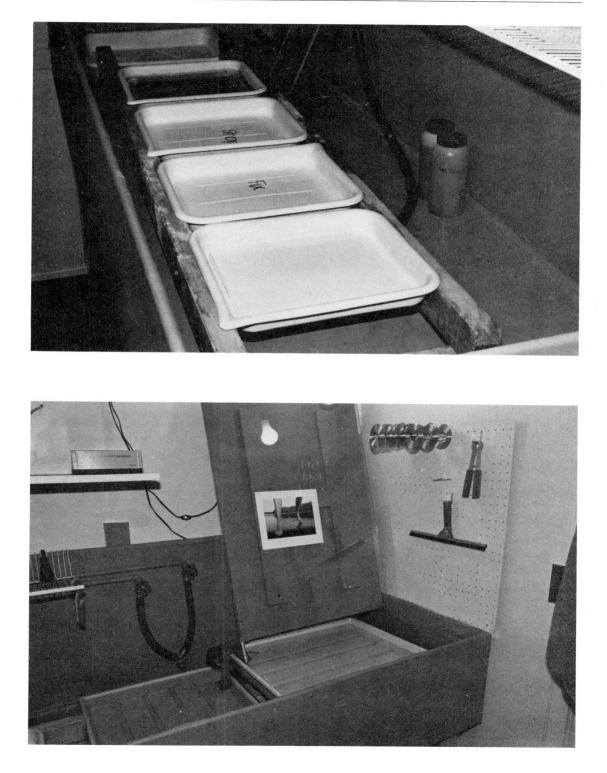

Pages 193 through 197 show the general layout and construction details from the compact and efficient home darkroom of Eugene Ostroff, Curator of Photography at the Smithsonian Institute, Washington, D.C.

Pages 198 through 202 show the plans of a more elaborate home darkroom. It was designed and constructed by Norman Sanders, photographer, author, and teacher.

26"

60"

24"

72"

D.

130"

72"

C.

10"

36"

E.

30"

20"

B.

A.

24"

25"

F.

Plan layout

A. Enlarger stand
B. Wood housing covering house drain
C. Counter top resting on two storage cabinets
D. Stainless steel sink
E. Shelves
F. Exhaust fan

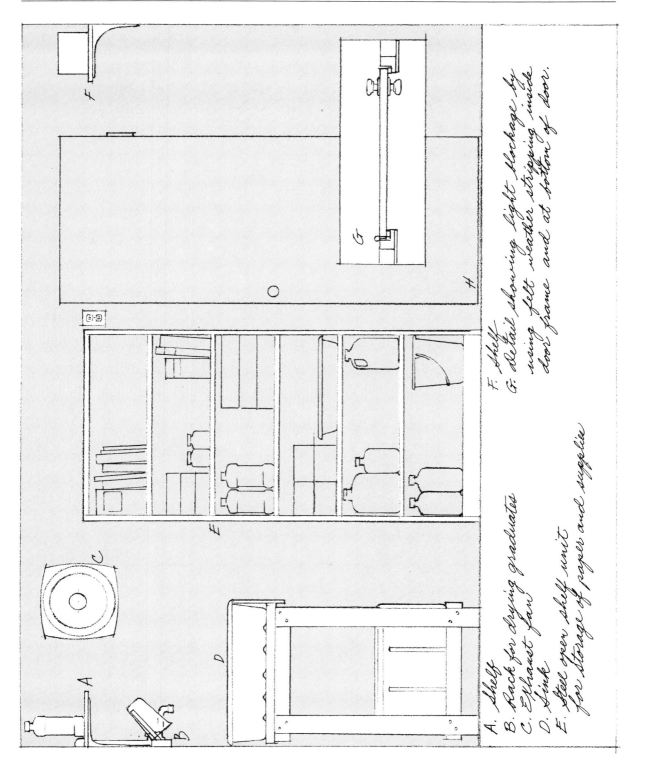

A. Shelf
B. Rack for drying graduates
C. Exhaust fan
D. Sink
E. Steel open shelf unit
 for storage of papers and supplies

F. Shelf
G. Detail showing light blockage by
 using felt weather stripping inside
 door frame and at bottom of door.

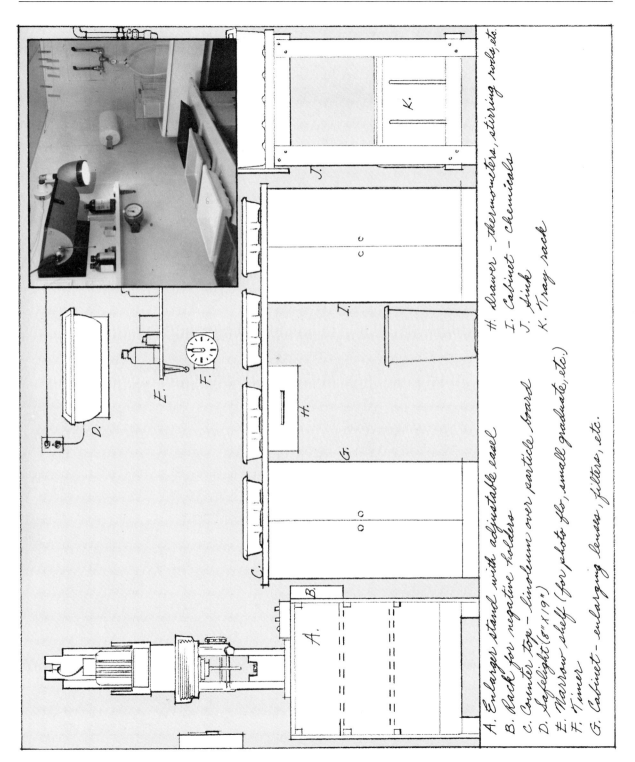

A. Enlarger stand with adjustable easel
B. Rack for negative holders
C. Counter top – linoleum over particle board
D. Safelight (8" x 9")
E. Narrow shelf (for photo flo, small graduate, etc.)
F. Timer
G. Cabinet – enlarging lenses, filters, etc.
H. Drawer – thermometers, stirring rods, etc.
I. Cabinet – Chemicals
J. Sink
K. Tray rack

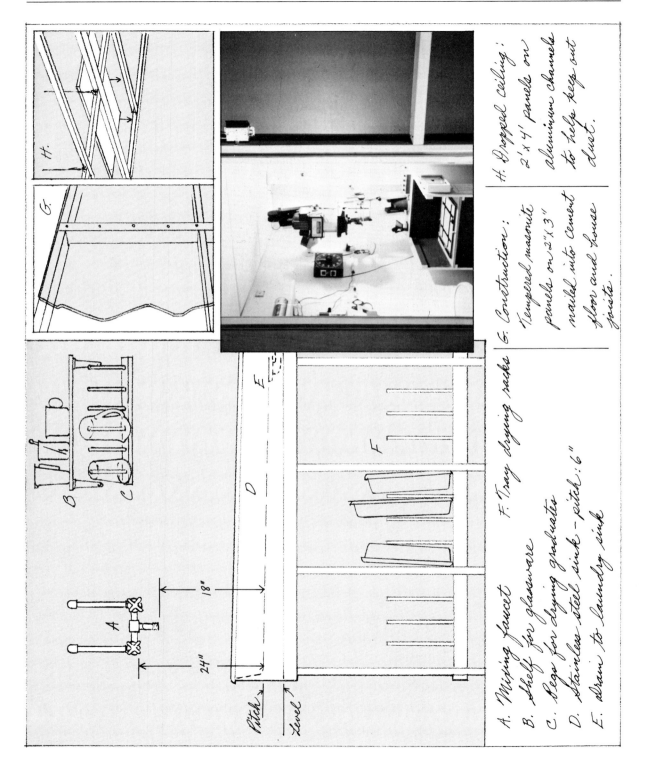

A. Wiping faucet
B. Shelf for glassware
C. Pegs for drying graduates
D. Stainless steel sink - pitch: 6"
E. Drain to laundry sink

F. Tray drying racks

G. Construction:
Tempered masonite
panels on 2"x 3"
panels on 2"x 3"
nailed into cement
floor and house
joists.

H. Dropped ceiling:
2' x 4' panels on
aluminum channels
to help keep out
dust.

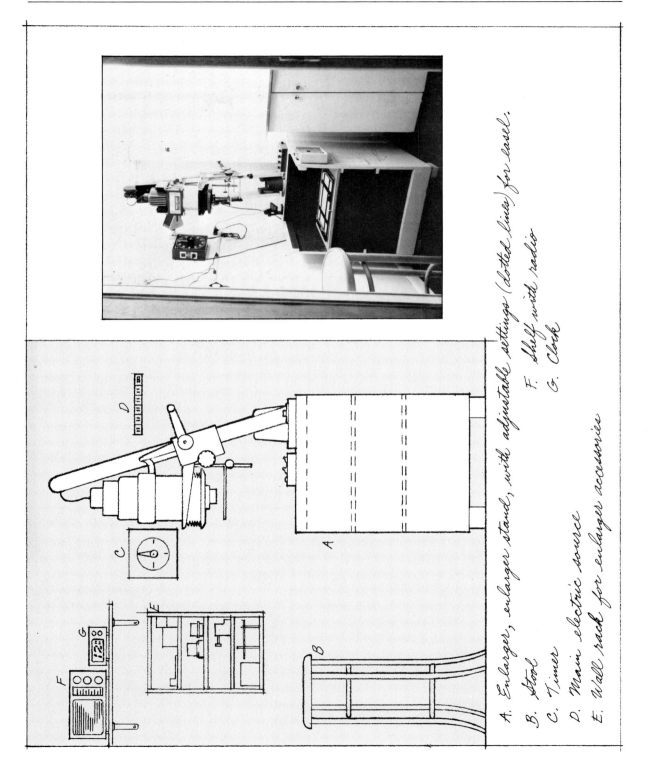

A. Enlarger, enlarger stand, with adjustable settings (dotted lines) for easel.
B. Stool
C. Timer
D. Main electric source
E. Wall rack for enlarger accessories
F. Shelf with radio
G. Clock

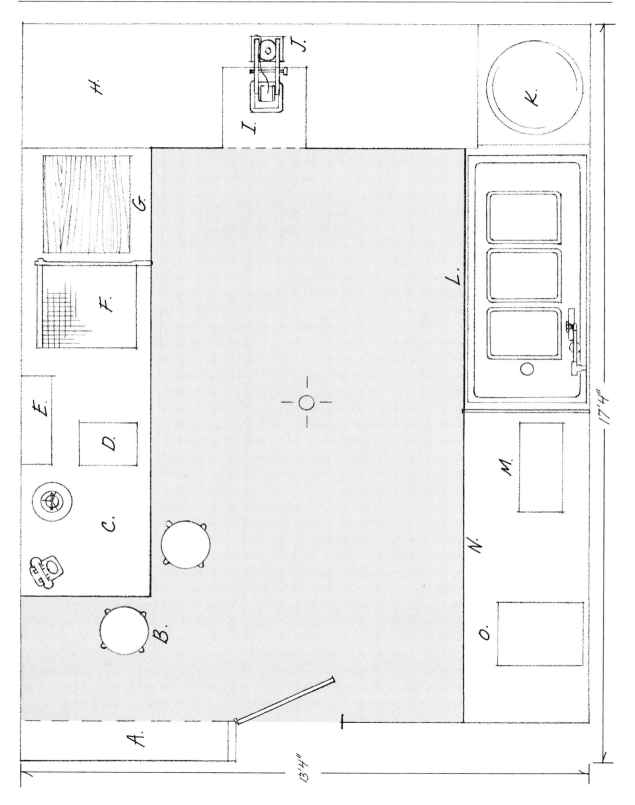

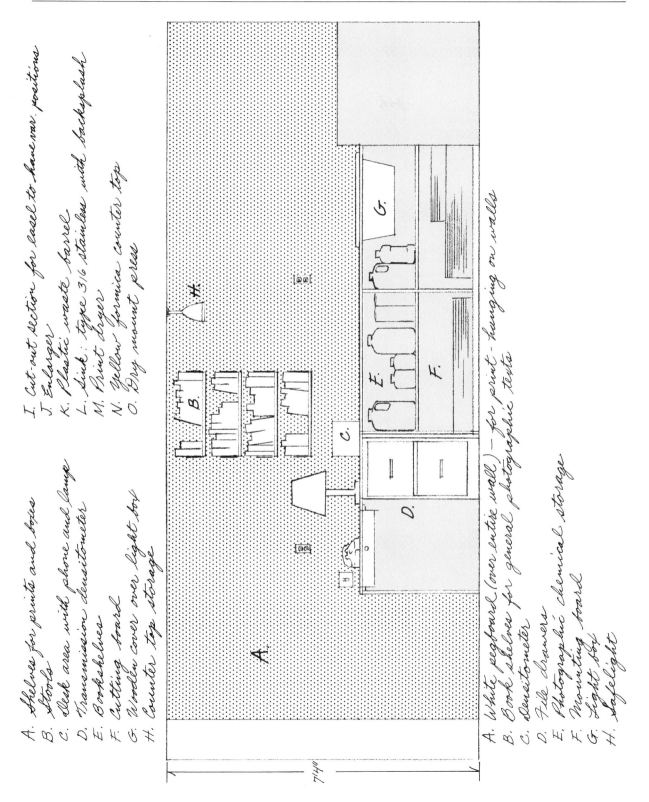

A. Shelves for prints and boxes
B. Stools
C. Desk area with phone and lamp
D. Transmission densitometer
E. Bookshelves
F. Cutting board
G. Wooden cover over light box
H. Counter top storage

I. Cut-out section for easel to have two positions
J. Enlarger
K. Plastic waste barrel
L. Sink: type 316 stainless with backsplash
M. Print dryer
N. Yellow formica counter top
O. Dry mount press

A. White pegboard (over entire wall) – for print hanging on walls
B. Book shelves for general photographic texts
C. Densitometer
D. File drawers
E. Photographic chemical storage
F. Mounting board
G. Light box
H. Safelight

7'4"

6'4"
figure

A. White pegboard
B. Safelight and white light switches
C. Negative file
D. Enlarger
E. Movable platform
F. Safelight
G. White light
H. Timer
I. Easel
J. Tape machine, etc.
K. Paper storage
L. 6'4" tall figure

N.B.
The desk height is 34" and counter height is 40". The sink ledge is 47" so that the elbows can be rested on it without strain on the back. Everything is a bit higher in this darkroom to allow for my height.

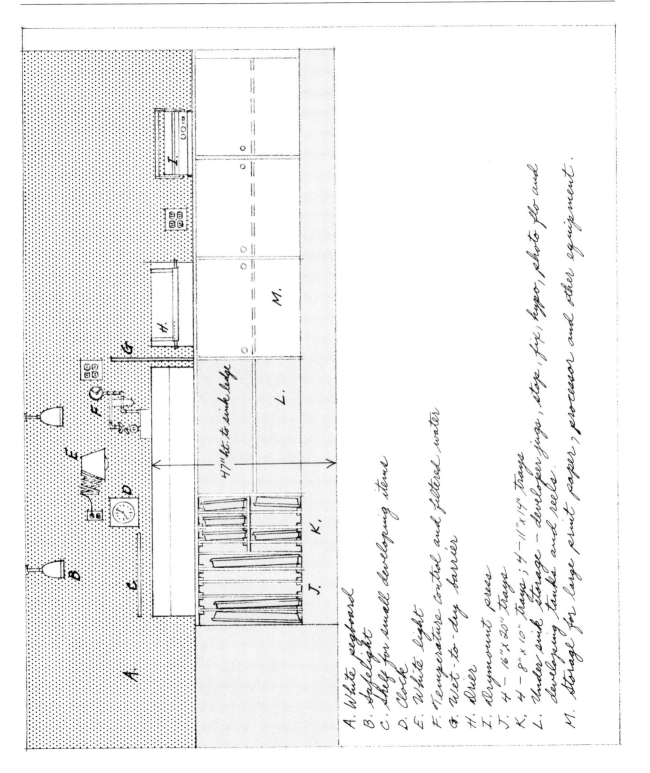

A. White pegboard
B. Safelight
C. Shelf for small developing items
D. Clock
E. White light
F. Temperature control and filtered water
G. Wet-to-dry barrier
H. Drier
I. Drymount press
J. 4 – 16"x 20" Trays
K. 4 – 8" x 10" Trays ; 4 – 11"x14" Trays
L. Under sink storage – developer jugs, stop, fix, hypo, photo flo and developing tanks and reels.
M. Storage for large print paper, processor and other equipment.

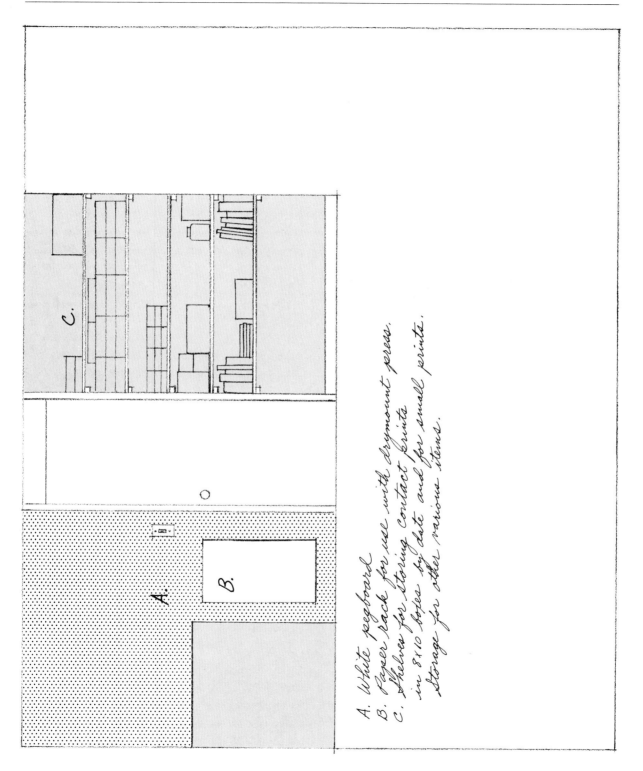

A. White pegboard
B. Paper rack for use with drymount press.
C. Shelves for storing contact prints
 in 8×10 boxes by date and for small prints.
 Storage for other various items.

Glossary

Aberration—a lens defect which causes a deviation of rays, resulting in imperfect image focus.

Accelerator—a component of a developer, usually an alkali, that increases the rate of development. Examples are sodium carbonate and borax.

Acetic Acid—a comparatively weak acid, usually supplied in 28% strength, which is one of the main ingredients of a stop bath.

Acid—a substance which neutralizes alkalis and which, in water solution, produces a pH below 7. Stop baths and fixers are usually acid solutions.

Actinic Light—light that has a chemical effect on photosensitive substances. The photographic effect varies according to the wavelength of the light, and the sensitivity characteristic of the emulsion.

Acutance—an objective measure of edge sharpness in a photographic image.

Agitate, Agitation—the systematic, repetitive movement of a photographic emulsion through processing solutions. Agitation is necessary to bring new areas of solution in contact with the emulsion.

Alkali, Alkaline—any substance with a pH value over 7. Most developers are alkaline solutions. (See **pH**.)

Ammonium Thiosulfate—the main ingredient of rapid-acting fixers. More gentle working fixing agents usually employ sodium thiosulfate instead.

Anhydrous—word used by chemists to indicate a substance containing no water, similar to "dessicated."

ANSI—(American National Standards Institute) an organization which establishes methods of procedure and measurement in a variety of fields, including photographic testing. (You will find ANSI speed rating numbers listed on printing paper boxes.) Formerly known as American Standards Association (ASA); the speed numbers of film are still preceded by the initials ASA.

Antifoggant—any of a number of chemicals used in emulsions or developers to reduce the rate of development of unexposed (as compared with that of exposed) portions. Examples are potassium bromide and benzotriazole. Also called restrainers.

Antihalation Layer—on a piece of photographic film, the layer that absorbs light once it has gone through the emulsion. This prevents stray light from bouncing back onto the emulsion and degrading the image.

Aperture—the opening of a lens through which light reaches the film. Generally known as an "f-stop", even though this term more accurately describes the way an aperture is measured, rather than the aperture itself. The word aperture, literally translated from the French, means "opening".

ASA—see **ANSI**.

Available Light—a common term used by photographers to describe low-light situations.

Avoirdupois—a system of weights commonly used in the United States, in which grams, ounces and pounds are units.

Autofocus—applied to projection printers which contain a cam or other mechanical device that adjusts the position of the lens to maintain a sharp im-

age as the positions of other parts of the systems are altered.

Baryta—the barium sulfate layer applied to the paper base before the light sensitive emulsion is coated.

Base—the part of the photographic paper, film, or plate onto which the light-sensitive emulsion is attached.

Base Tint—the hue of photographic paper bases. This color, depending on the type of paper, falls within a range from pure white to a yellowish, creamy tone.

Bas-relief—a special raised effect obtained by making a contact positive transparency from a negative, binding the two together, slightly out of register, and printing from the combination.

Benzotriazole—see **Antifoggant.**

Bleach—in photography, the common term for potassium ferricyanide, which is used to selectively lighten areas of a photographic print.

Blocked Up—overexposed or overdeveloped highlights on film. Blocked up highlights cannot be printed properly.

Brightness—subjective term applied to the degree of light intensity given off by an object. Brightness is perceived, rather than measured (see **Luminance**).

Brilliance, Brillant—otherwise known as "lively" or "snappy", this term applies to a negative, transparency, or print that has a crisp look due to a large range of tones and bright highlight areas, usually with strong gradation.

Bromide Paper—high speed photographic paper for projection printing. The main light-sensitive ingredient in the emulsion is silver bromide.

Burning In—the procedure of allowing more light than the initial exposure to affect selective areas of a print.

Centigrade, Celsius—system of temperature measurement widely used throughout the world.

Compatible with the metric system, since it uses 100° as its boiling point and 0° as freezing, it is somewhat less precise a system of measurement than the Fahrenheit system, because there are fewer steps between the two extremes of freezing and boiling.

Chloride Paper—photographic paper using silver chloride as its sensitive medium. Most contact papers are made this way. Though very slow, chloride papers produce an excellent tonal scale.

Chlorobromide (Bromochloride) Paper—photographic paper the emulsion of which is made up of both silver chloride and silver bromide. A medium speed paper for enlarging.

Clump, Clumping—the tendency of silver salt particles in photographic emulsions to "migrate" toward one another and form groups of grains is commonly referred to as clumping, also known as agglomeration, this tendency is most likely to occur during vigorous or overdevelopment.

Code Notches—on sheet films, indentations along one edge which can be felt in the dark to identify the type of film and locate the emulsion side.

Collimated Light—light passing through an optical system which causes the rays to be parallel.

Cold Tone—term used for photographic paper that has intense, bluish blacks and clean, pure whites.

Condenser—in enlarger heads, the lens or lenses *above* the negative carrier. The condenser gathers rays of light coming from the enlarging lamp, concentrates them to evenly illuminate the negative, then passes them through the negative and the enlarging lens onto the paper.

Contact Print, Printer—a photographic print by bringing the film and photographic paper into emulsion-to-emulsion contact, flattening them out with a piece of clean, scratch-free glass, and exposing to light; a machine used for this purpose, usually consisting of a light box with a hinged lid which, when closed, assures firm contact of negative and paper.

Contaminate—to introduce an impurity. A developing solution could be contaminated, for example, by allowing drops of fixing solution to fall into it.

Contrast—the term used to describe the range, from dark to light, that a photographic emulsion can record, and how this ability manifests itself with regard to the scene being recorded. Print contrast usually refers to how many distinct tonal steps are possible between the lightest and darkest tones the paper can produce. A high contrast paper compresses the tonal scale into few but distinct steps of gray from white to black; a low contrast paper will produce more gray tones between black and white, and will record a number of discrete steps of tonal range, producing subtle changes in gray. Contrasty negatives usually print best on low contrast paper, and low contrast negatives will generally give more pleasant results on paper of high contrast.

Densitometer—an instrument used to determine the degree of light that will pass through (transmission densitometer) or reflect from (reflectance densitometer) an exposed photographic emulsion.

Density—the degree of transparency/opacity of a negative.

Desiccated—applied to chemicals from which all or almost all water has been removed.

Developer—a formulated chemical solution that causes the latent image of an exposed photographic emulsion to become visible.

Developing Agent—a chemical (e.g, metol, hydroquinone) that reduces exposed silver halides to metallic silver in a shorter time than unexposed silver halide, normally used in a water solution together with other ingredients.

Development—the process of converting a latent image into a visible one.

Diaphragm, Iris Diaphragm—the part of a lens that controls the amount of light passing through the lens.

Diffusion Enlarger—a projection printer that uses diffuse light, not collimated light.

Dilution—adding water to a stock or other solution for use. The volume ratio of stock solution to water is expressed, for example as 1:2.

DIN—Deutsche Industrie Norm. A standard established by the German counterpart of ANSI which see.

Dodging—the technique of blocking light from portions of a print during exposure.

Double Weight—the base thickness of photographic paper is expressed in terms of "weight". Double weight is the thickest available and is preferred by many printers because of its resistance to creasing and other physical damage. Single weight papers are made as well. The terms double and single weight apply to fiber-based papers; resin coated papers are usually somewhere between these in thickness and are referred to as being "medium weight".

Easel—a device used to center and hold a piece of photographic paper flat during exposure.

Elon—Kodak's trade name for the developing agent also known by its proprietary name, metol.

Emulsion—a dispersion of silver halide crystals in gelatin or other suitable material; the part of photographic paper or film that is sensitive to light.

Emulsion Side—the side of a photographic film or paper on which the emulsion is coated. In film typically the dull side and concave as the film curls.

Enlarger—an optical device containing a light source used to project an image onto sensitized material. Also called a projection printer.

Enlarger Head—the part of a projection printer comprising the light source, the negative carrier, and the lens.

Enlarging Lens—a lens designed for use on a projection printer. The lens is mounted in a barrel without a shutter; the diaphram is equipped with click stops.

Enlarging Meter—a light meter designed to be

used as an aid in determining the correct contrast grade and exposure settings for projection printing.

Exposure Index (E.I.)—a self-imposed film speed setting determined by making tests of one's equipment, film, and developing technique. Sometimes this rating agrees with the normal rating established by the film manufacturer. Variable factors in equipment or technique may require deviations from the manufacturer's rating.

Exposure Meter—a device used to measure light and to determine the shutter speed/aperture combination necessary to produce a good negative. Some exposure meters are designed to measure the light falling on an object (*incident light* meters); others measure the light reflecting from an object (*luminance* or *reflected light* meters). All in-camera meters are reflected light meters.

F-stop—the aperture setting of a photographic lens.

Fahrenheit—until recently, the standard system of temperature measurement in the U.S. and England. Based on a table that indicates freezing temperature of water at sea level to be 32° and boiling point to be 212°. Now largely replaced by the Celsius, or Centigrade system.

Farmer's Reducer—a solution of potassium ferricyanide and hypo, used to reduce the density of silver images.

Film Speed—the relative sensitivity of film to light. Generally expressed by manufacturers as an ASA (American Standards Association) number. The higher the number, the "faster", or more sensitive to light, the film.

Fixer (Hypo)—a chemical solution used to remove all unexposed silver salts from a developed photographic emulsion so that the image will be rendered permanent. Usually contains sodium thiosulfate.

Fog—unwanted density on photographic emulsions, caused by inadvertent exposure to stray light, by contaminated chemicals, or by the use of outdated film or paper.

Gelatin—the substance used to bind silver halide crystals to film and paper bases.

Gradation, Tonal—the degree and relationship of tones in photographic emulsions.

Grade, Graded Paper—photographic paper manufacturers express the relative degree of contrast in their various papers in terms of contrast *grades*. Low contrast papers are assigned low numbers, and contrasty ones are given higher numbers. These numbers range from 0 to 6, but there is no real standardization, so that one manufacturer's Grade 3 paper may be the equivalent of another's Grade 2 or 4. Papers that have no one grade but are capable of producing prints of various grades with the aid of specially colored filters, are known as *Variable Contrast* papers.

Grain—the noticeable pattern, or texture, or a developed piece of photographic film. One piece of visible grain is actually made up of thousands of grains of developed silver salt grains that have clumped together. (See **Clumping**.)

Gray Card—a neutral-color cardboard, typically having 18% reflectance, used as a standard artificial medium tone for luminance readings. In the Zone System, an 18% reflectance gray card corresponds to Zone V.

Gray Scale—a series of neutral tones arranged in sequence from dark to light, ideally with equal density difference between steps.

H and D—Hurter and Driffield, the originators of photographic sensitometry.

H and D Curve—a graph obtained by plotting the logarithms of a series of exposures received by a photographic material and the corresponding resulting densities.

Hardener—an additive used with fixer to make the soft, wet emulsion less physically delicate. Some hardeners contain alum and dilute sulfuric acid.

High-Contrast—applied to developer, film, or photographic paper, used to increase differentation of tones, either to achieve a desired contrasty effect

or to compensate for a low-contrast influence elsewhere in the process.

High Key—a photographic print in which most of the tones are light.

Highlight—a term loosely applied to any light-tone area on a positive image, or a corresponding dense area on a negative.

Hydroquinone—a highly active developing agent, used alone in high-contrast developers and in combination with metol for general-purpose developers.

Hypo—common name for sodium thiosulfate. Also called fixer.

Hypo-Clearing Agent—product used to neutralize the effects of hypo on emulsion once the process has gone to completion. Hypo must be removed, or it will attack developed silver in the image over a prolonged period of time.

Hypo Eliminator—a formula which chemically removes residual hypo from photographic emulsions.

Incident Light—light falling on an object.

Incident Light Meter—see **Exposure Meter**.

Intensification—a method of increasing image density by chemical means.

Intensifiers—chemical substances used to increase the density of a developed image. Intensifiers cannot place detail onto a negative where no detail is present; all they can do is make the exposed and developed part of the negative more opaque, thereby raising overall contrast. Grain increases with most intensifiers.

Latent Image—the invisible image that occurs on photogaphic emulsions when exposed to light, before development.

Latitude—the "margin of error" of photographic film is usually expressed in terms of latitude or the amount of over- or underexposure permissible without significant effect on image quality.

Luminance—the *measurable* degree of brightness, or light intensity, reflected from an object. Often, the word brightness (which is unmeasurable) is used incorrectly to mean luminance.

Luminance Meter—reflection type of light meter.

Metol—a gentle, slow-working developing agent, usually used together with the much more vigorous hydroquinone for general-purpose development.

Negative—a photographic image in which light subject tones are reproduced as dark (dense) and dark tones as light (thin).

Newton's Rings—faintly colored fringes caused by interference of light between two closely spaced reflecting surfaces; as when a negative is placed in a glass carrier for projection printing. The remedy is to use slightly roughened glass in the carrier, or to use a glassless carrier.

Normal Contrast—an acceptable degree of contrast which records tones in a "pleasing" way. A "normal" negative would be one which has enough tones between black and white to yield a pleasing print on Grade 2 paper.

Opaque—in retouching, to cover unwanted areas of a negative (background, defects) with pigment so that they will not appear in the print.

Orthochromatic—not sensitive to red, but sensitive to blue, green, and ultraviolet light. Many photographic papers and some special purpose films are orthochromatic.

Overdevelopment—developing for longer than recommended, increases contrast and graininess in films.

Overexposure—excessive exposure. When coupled with appropriate underdevelopment of films, will produce slightly less contrasty than normal negatives with increased shadow detail. Will reduce contrast slightly in prints, if development is shortened.

Panchromatic—sensitive to all colors of the visible spectrum and ultraviolet light. Most films and some papers are panchromatic.

pH—symbol of a measurement system used to gauge the relative alkalinity or acidity of substances. Water, which is used as a neutral standard, has a pH of 7. Acids have pH numbers lower than 7. Those of bases, or alkalis, are higher than 7. pH affects the activity of developing agents, most of which require pH values greater than 7 in order to function.

Photogram—a photographic image made by placing objects onto a piece of photographic paper, then exposing, so as to cause patterns where the light has been blocked.

Photography—broadly, the science, engineering, craft, and art of producing relatively permanent images by the action of light on sensitive materials.

Positive—a photographic image in which the tones are in approximately the same relationship as in the original; light tones are reproduced as light, and dark tones as dark (as opposed to negative, in which the original tones are reversed).

Postvisualization—an approach to photographic printing, especially of combination photographs and montages, in which the main decisions are made in the darkroom during the printing process.

Potassium Ferricyanide—see **Bleach.**

Preservative—a chemical, usually sodium sulfite, in developers added to retard oxidation.

Previsualization—in photography, a term connected with the Zone System; the mental process of the photographer by which the path to the desired print is controlled by exposure and development of the negative.

Rapid Fixer—fast acting hypo. See **Ammonium Thiosulfate.**

RC, Resin Coated—a term designating those photographic papers that have been coated with a water resistant resin or plastic, allowing very short processing, washing, and drying times.

Reducer—a chemical bath which is used to remove silver from a processed negative, or positive, to lower its density.

Resolution—the measurable ability of a film to record minute detail. Usually, the slower the film, the higher its resolving power. The same term applies both to lenses and to film.

Resolving Power—see **Resolution.**

Restrainers—see **Antifoggant.**

Sabattier Effect—partial image reversal associated with the following sequence: Primary exposure, partial development, fogging exposure, continued development, followed by completion of processing.

Safelight—a low wattage light that is fitted with a color filter to which photographic emulsions are not overly sensitive. Used in darkrooms during processing (of paper).

Spotting—a retouching method of removing unwanted white or light areas on a print surface, usually with special dyes and a fine-pointed brush.

Stop Bath—a solution of acetic acid, water and sometimes an exhaustion indicating dye, used to halt the effect of developer on paper and to neutralize the alkalinity of developing solutions.

Test Print, Strip—a print made by exposing sections of the paper to light for different lengths of time, in order to determine best exposure for the full image.

Underdevelopment—less development than normally required; sometimes quite useful. See **Overexposure.** Massive underdevelopment results in faint, unevenly recorded images that will not print properly, if at all. Underdeveloped prints look weak and washed out.

Underexposure—less exposure than normally required. Can be compensated for to some degree by subsequent overdevelopment, but only if the underexposure was slight. Image quality will generally suffer.

Variable Contrast Paper—see **Graded Paper.**

List of Suppliers

The following is a list of manufacturers of items discussed in this book. If you cannot find their products in your local camera store write to them for information, and nearest distributor. It is a help if you enclosed a stamped, self-addressed envelope with your query.

Acu-Fine, Inc.
439-447 E. Illinois Street
Chicago, IL 60644
Film developers

Agfa-Gevaert, Inc.
275 North Street
Teterboro, NJ 07608
Films, papers, film developers

Aristo Grid Lamp Product Company, Inc.
65 Harbor Road
Port Washington, NY 11050
"Cold light" enlarging heads

Arkay Corporation
228 S. First Street
Milwaukee, WI 53204
Washers, dryers, darkroom hardware

Beseler Photo Marketing Company
8 Fernwood Road
Florham Park, NJ 07932
Enlargers, times, thermometers, film developers, etc.

Braun North America
55 Cambridge Parkway
Cambridge, MA 02141
Distributor of darkroom products and numerous other photo items

Calumet Photographic, Inc.
1590 Touhy Avenue
Elk Grove Village, IL 60007
Sinks, washers, trays, temperature control units

Chemco Photo Products Company
(Division of Powers Chemco, Inc.)
Glen Cove, NY 11542
Various photo chemicals

Chemical Products Company
10 Bearn Street
North Warren, PA 16365
The CP flourescent safelight, and other darkroom lighting equipment

Clayton Chemical Company
Division of APECO
2100 Dempster Street
Evanston, IL 60204
Various photo chemicals

Dimco—Gray Company
207 E. Sixth Street
Dayton, OH 45402
Timers

Durst USA
(EPOI) 623 Stewart Avenue
Garden City, NY 11530
 Enlargers, timers, thermometers, various darkroom implements

Eastman Kodak Company
343 State Street
Rochester, NY 14650
 Everything photographic — films, papers, chemicals, thermometers, timers, etc., etc., etc...

Edwal Scientific Products Corporation
12120 S. Peoria Street
Chicago, IL 60643
 Photographic chemicals, wetting agents, anti-scratch solution, etc.

Ethol Chemicals, Inc.
1808 N. Damen Avenue
Chicago, IL 60647
 Developers for film and paper, various other chemicals

Oscar Fisher Corporation, Inc.
P.O. Box 2305
Newburgh, NY 12550
Print washers, containers for chemicals

FR Photo Products
420 Commercial Street
Cincinnati, OH 45202
 Chemicals, thermometers, film clips, etc.

Fujica Photo (EPOI)
623 Stewart Avenue
Garden City, NY 11530
 Fujinon enlarging lenses

GTE Sylvania
100 Endicott Street
Danvers, MA 01923
 Enlargers, and safelight lamps

Heico, Inc.
Delaware Water Gap
PA 18327
 Washing aids (Perma Wash)

The Hollinger Corporation
3810 S. Four Mile Run Drive
Arlington, VA 22206
 Acid free papers, mount boards, print storage boxes

The H+W Company
Box 332
St. Johnsbury, VT 05819
 H + W control films, developers

Hindemann (EPOI)
623 Stewart Avenue
Garden City, NY 11530
 Tanks, reels, film clips, etc.

Ilford, Inc.
West 10 Century Road
P.O. Box 288
Paramus, NJ 07652
 The British answer to Kodak. Everything — films, papers, chemicals, anti-static cloths, etc.

ITT Photo Lamp Products
133 Terminal Avenue
Clark, NJ 07066
 Enlarging and safelight lamps

Leedal, Inc.
2929 So. Halstead Street
Chicago, IL 60608
 Temperature control units, washers, sinks

E. Leitz, Inc.
Link Drive
Rockleigh Industrial Park
Rockleigh, NJ 07647
Focomat enlargers, easels, enlarging lenses

Light Impressions
Box 3012
Rochester, NY 14614
A mail-order source for everything archival and more, write for catalog.

John G. Marshall Manufacturing Company, Inc.
167 North 9th Street
Brooklyn, NY 11211
Retouching dyes

Minolta Corporation
101 Williams Drive
Ramsey, NJ 07446
CE—Rokkor enlarging lenses

Nega File, Inc.
P.O. Box 78
Furlong, PA 18925
Negative sleeves

Nikon, Inc. (EPOI)
623 Stewart Avenue
Garden City, NY 11530
EL—Nikkor enlarging lenses

Omega, Division Berkey Marketing
25-15 50th Street
Woodside, NY 11377
Enlargers, film tanks and reels, thermometers, etc.

Paterson Products, LTD.
2-6 Boswell Court
London WCIN 3PS England
Numerous darkroom supplies

Retouch Methods Company, Inc.
P.O. Box 345
Chatham, NJ 07928
SpoTone, Spot Off, other retouching materials for prints and film

Rockland Colloid Corporation
599 River Road
Piermont, NY 10968
Liquid photographic emulsion, and other special application kits

Rodenstock, Div. Berkey Marketing
25-15 50th Street
Woodside, NY 11377
Eurygon, Omegaron, Rodagon, Ysaron enlarging lenses

Rollei of America, Inc.
100 Lehigh Drive
Fairfield, NJ 07006
Enlargers, darkroom accessories

Seal, Inc.
550 Spring Street
Naugatuck, CT 06770
Dry mount presses and tissues

Schneider Corporation of America
154 Lodi Street
Hackensack, NJ 07601
Componon, Componar, Comparon enlarging lenses

Simmon Omega
25-50 Brooklyn-Queens Expressway
W. Woodside, NY 11377
Easels, tanks, reels, etc.

Spiratone, Inc.
135-06 Northern Boulevard
Flushing, NY 11354
 Various inexpensive pieces of photographic hardware. Filters, burning and dodging tools, easels, etc.

Testrite Instrument Company, Inc.
135 Monroe Street
Newark, NJ 07105
 Various darkroom products

Vue-All, Inc.
49 West 45th Street
New York, NY 10036
 Negative sleeves

Westinghouse Lamp Division
Westinghouse Plaza
Bloomfield, NJ 07003
 Enlarging and safelight lamps

Yankee Photo Products
244 Wiltshire Boulevard
Santa Monica, CA 90403
 Plastic tanks, reels, film drying clips, etc.

Zone VI Studios
Newfane, VT 05345
 Equipment and supplies; large-format cameras, chemicals, print washers, accessories. They are also starting to manufacture their own photographic paper described as the "silver-rich papers of bygone years". Write for catalog.

Suggested Reading

Adams, Ansel, *Basic Photo Series,* Boston, New York Graphic Society, 1975-1978. This series consists of five volumes: 1. Camera and Lens; 2. The Negative; 3. The Print; 4. Natural Light; 5. Artificial Light. The books are not for the casual photographer; they take discipline to comprehend and apply but the knowledge you gain, both of technique and the art of photography, makes it all worthwhile.

Crawford, William, *The Keepers of Light,* Dobbs Ferry, New York, Morgan & Morgan, 1979. A practical how-to source for photogra-pehrs who want to explore the processes early photographers used. Provides working details for Salted Paper, Ambrotype, Platinum, Palladium, Kallitype, Carbon, Carbro, Three-Color Carbro, Gum Dichromate, Oil, Photogravure, and Collotype. In addition this volume provides a unique and innovative account of photography dating back to the days of the daguerreotype and the first paper prints.

Dowdell, John J., and Zakia, Richard D., *Zone Systemizer,* Dobbs Ferry, New York, Morgan & Morgan, 1973. A large-format dial that helps the photographer to compute exposure and negative development. Comes with a 64-page workbook. A concise mini-course in the Zone System.

Eastman Kodak Company, Rochester, New York. Kodak publishes books and pamphlets, some general, some specialized, on just about every subject in photography. For what is available see Kodak Pamphlet No. L-5. This pamphlet can be found, or ordered, at your photo dealer.

Haist, Grant, *Monobath Manual,* Hastings-on-Hudson, New York, Morgan & Morgan, 1966. The only book available on this form of simplified processing in which developer and fixer are combined. This method can be used with both film and paper; the manual gives a number of formulas for mixing your own monobaths.

Horenstein, Henry, *Beyond Basic Photography,* Boston, Little, Brown and Company, 1977. As the title implies a working knowledge of photography is assumed by the author and he describes how to improve the quality of your negatives and prints. Also covered is the use of the view camera, lighting in portraiture, and the use of flash.

Kelly, Jain, ed., *Darkroom 2*, New York, Lustrum Press, 1978. See Lewis, Eleanor. More of the same, except that this volume covers the methods of, among others: Judy Dater, Lisette Model, Aaron Siskind, Doug Prince, and Cole Weston printing the negatives of his father Edward.

Lewis, Eleanor, ed., *Darkroom*, New York, Lustrum Press, 1977. Describes the personal working methods of photographers such as W. Eugene Smith, Jerry Uelsmann, Wynn Bullock, Ralph Gibson, Eikoh Hosoe, Linda Connor, and more. A sound darkroom knowledge is required to appreciate the details provided in this volume. If you do not have this knowledge you may wind up "emulating the masters" but without the basics it just will not improve your prints or photography.

Life Library of Photography, New York, Time-Life Books, 1970—and on. This series consists of 16 volumes, all profusely illustrated. Of particular use to beginning photographers and those who want to find information on darkroom techniques are the following: The Camera; Light and Film; The Print; and Frontiers of Photography.

Morgan, D.O., Vestal, D., Broecker, W.L., *Leica Manual, The Complete Book of 35mm Photography*, Dobbs Ferry, New York, Morgan & Morgan, 1973. The 15th revised edition of this classic volume first published in 1935. While a few chapters are devoted to the Leica camera system, the majority of chapters apply to 35mm photography in general no matter which camera you use. Some of the topics covered include: The Zone System for 35mm Photography; Infrared Photography; Portraiture; Closeup Photography; Getting the Most out of Black-and-White Film; Color Films; Developing and Printing, and more.

Newhall, Beaumont, *The History of Photography*, New York, The Museum of Modern Art, 1964. As of this writing this volume is in the process of an extensive revision. Originally published under this title, in 1949, and revised and reprinted many times—any edition you can find will give you the most thorough and readable overview of the history of photography.

Picker, Fred, *The Fine Print*, Garden City, New York, Amphoto, 1975. As with any book that describes a photographer's personal working methods, a working-knowledge by the reader is assumed. About 75 photographers are shown and the author describes how, and sometimes why, he made the photograph and how he arrived at the "fine print".

Pittaro, Ernest, M., ed., *Photo-Lab-Index*, Dobbs Ferry, New York, Morgan & Morgan, 1980. Now in its 41st year of publication this is *the standard* reference work of collected data of photographic materials, formulas, and processes. It is available in a loose-leaf Lifetime edition with quarterly supplements by annual subscription. Also available in a condensed and soft-bound edition.

Stroebel L., & Todd, H.N., *Dictionary of Contemporary Photography*, Dobbs Ferry, New York, 1974. Gives you 218 pages of authoritative, clear explanations of terms and definitions used in photography and related fields.

Sussman, Aaron, *The Amateur Photographer's Handbook*, New York, T.Y. Crowell, 1973 (8th revised edition). This manual covers a lot of ground: How to choose a camera; how to be sure of the sharp pictures; hints on composition; outdoors; indoors; action; flash; closeup; printing and a lot more. All-in-all a good underpinning on which to base further in-depth exploration.

Szarkowski, John, *Looking at Photographs,* New York, The Museum of Modern Art, 1973. Photography involves a lot more than a knowledge of technique. This volume will serve you well as an introduction to the aesthetics of photography. A hundred photographs are analyzed and placed in perspective as they relate to the evolution of photography.

Todd, Hollis N., Zakia, Richard D., *Photographic Sensitometry,* Dobbs Ferry, New York, Morgan & Morgan, 1969. Not a book for beginners but if you want to pursue the subject of sensitometry in depth, this volume will show you how.

Vestal, David, *The Craft of Photography,* New York, Harper & Row, 1974. A no-nonsense guide to selection of cameras, accessories, and darkroom equipment; developing and printing; what to do with your photographs; and what and how to photograph.

Wade, Kent E., *Alternative Photographic Processes,* Dobbs Ferry, New York, Morgan & Morgan, 1978. For the photographer who is ready to go past the boundaries of conventional photography. This volume provides detailed descriptions and step-by-step guidance for imaging photographs on virtually any non-paper surface, including cloth, clay, metal, wood, glass, leather, plastic, and stone.

White, M., Zakia, R., Lorenz, P., *The New Zone System Manual,* Dobbs Ferry, New York, Morgan & Morgan, 1976. This all-in-one manual shows you how to bring the variables of the photographic process under control through the use of the Zone System. Covers: Visualization—that is, to interpret the scene, or object, in front of your camera and how it will translate, or can be interpreted, in the final print; how to develop the negatives to arrive at your visualization and how to print that negative. Also gives a mini-course in sensitometry for additional control of all the above.

Index

Notes

Notes

Notes